Selling
Photographs

Selling Photographs

NEW EDITION
REVISED AND UPDATED

Lou Jacobs, Jr.

AMPHOTO
An imprint of Watson-Guptill Publications/New York

First published in New York by AMPHOTO, an imprint of
Watson-Guptill Publications, a division of Billboard
Publications, Inc., 1515 Broadway, New York, NY 10036.

Library of Congress Cataloging-in-Publication Data

Jacobs, Lou.
　　Selling Photographs: determine your rates and understand
　　　your rights.
　　Includes index and bibliography.
　　1. Photography, Commercial.　2. Photography—Marketing.
　　I. Title.
TR690.J33　　1988　　770.68—dc19　　87-30427
ISBN 0-8174-5828-X
ISBN 0-8174-5829-8 (pbk.)

Manufactured in the United States of America

1　2　3　4　5　6　7　8　9/93　92　91　90　89　88

Editorial concept by Marisa Bulzone
Edited by Liz Harvey
Designed by Areta Buk

My sincere thanks to the American Society of Magazine Photographers (ASMP) and to Advertising Photographers of America (APA), New York Chapter, for permission to quote from their books, ASMP's *Professional Business Practices in Photography* and APA's *Assigning Advertising Photography.* Thanks also to professional colleagues whose articles I have quoted or whose experiences I have tapped.

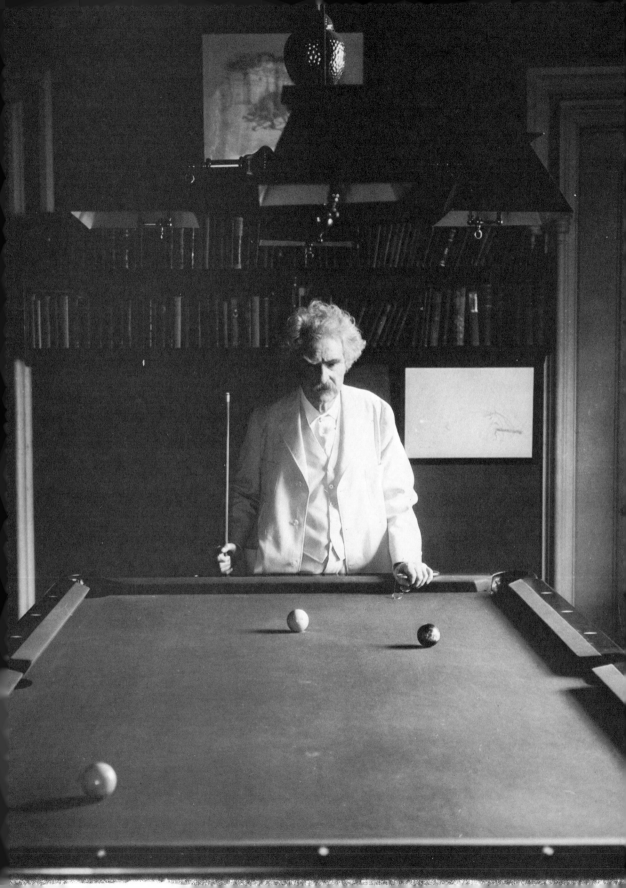

Contents

Introduction

The enthusiasm and experience that guide this book come from several sources. I went into the photography business as a freelancer in the early 1950s. Since then I have worked with dozens of magazines, for industry and ad agencies, and for book publishers. I have also sold fine-art images to individuals. But I have made several costly mistakes in the more than thirty years that I have been a freelance photographer, and I have learned what *not* to do.

As a professional photographer, I have been involved in selling pictures, getting along with clients, protecting rights, encouraging higher ethics for photographers, and trying to look ahead in a creative profession that demands an active sense of business. I have also written numerous books about magazine freelancing, as well as articles on photographic techniques for the *New York Times* and the *Los Angeles Times*.

My experience as an instructor at several colleges, including UCLA, Cal State-Northridge, and Brooks Institute of Photography, also played a part in the creating of this book. While teaching, I answered many questions and led many discussions about rates and rights; as a result, I understand clearly the troubles media photographers, especially newcomers, encounter.

During my career, I have advised other photographers on their professional problems. These discussions, the advice I have given, and the outcome of the problems provide case histories, which I have included.

Finally, my close involvement with the American Society of Magazine Photographers (ASMP) has been a strong influence and a source of enlightenment. ASMP has chapters all over the United States and educates photographers and helps them to improve their bargaining positions in the media photography field. Having served as president of ASMP for one year and currently sitting on the board of directors, I have watched ASMP grow. As its members gain stature, they realize the true value of their creative work in the marketplace.

My purpose in writing this book is to help other photographers to avoid costly business mistakes. Since 1979, when an earlier edition was published, photographers' rates have improved, competition has increased, and rights have eroded. To keep up with changes in the profession and to cover the latest developments in media photography, such as computer-devised photographs, my previous book has

Carefully composed photographs will always be salable.

been completely revised: the information presented here is new and current. I also want to explain how to establish reasonable prices for assignments and services, and how to negotiate them. I have included a wealth of material about copyright and how the law can work in the photographer's favor. A photographer's legal position in relation to clients is also covered. The information collected here will enable photographers to deal more effectively with a wide range of situations. Photographers will also discover that, while competition is healthy, if they don't hang together where rights are concerned, they will hang separately.

This book is intended for anyone who takes and sells photographs for reproduction in magazines, books, brochures, or other media. It will also be useful to photographers who sell images as fine art, on their own, or through a gallery.

BUSINESS STYLES

As photographers, you sell your photographic talent. Some of you "lease"—a more accurate term than "sell"—stock pictures or make them available as fine art. Some sell through picture agencies or have a photographic rep sell for you. Some of you work alone, some with one associate who may be your spouse. Others may run a studio with employees. The newcomers among you may have a limited knowledge of various business operations.

All of you can benefit from these pages. Since most photographers operate as individuals or in small groups, your clients are often larger and economically stronger. Even when you become successful and your pictures are sought after, the imbalance may affect you. Success breeds confidence; but for all of us, some basic needs—to make a living, to express ourselves, and to find recognition—may override our sense of self-protection. Euphoria or lack of awareness may lead you to sell pictures for what seem at the moment to be reasonable prices. Later you may discover that you should have charged more. Even worse, you may have also given away rights you should have charged for. You may have some money, but someone else owns some or all of the rights to your images.

PHOTOGRAPHS: MEDIA OR COMMERCIAL, SELLING OR MARKETING?

Although the emphasis in this book is on *media* photography—work shot for reproduction—there is also information about fine-art photography sales and exhibition. Commercial photography, such as portraits and wedding photography, is sold to individuals rather than to publications; as such, the principles of pricing, and probably of ownership, are different.

It is also important to understand the distinction between the terms "selling" and "marketing" in the context of this book. Selling, which includes leasing pictures, is covered here from the point of view of business self-protection. Once you discover and crack a market for photographs or assignment photography, self-protection is essential. You must understand how much your pictures are worth and also know how to negotiate ownership rights. If all the facets of

rates and rights were prefab walls, they could be used to erect a hundred-room hotel. Therefore, this book is kind of an "insurance policy" related to selling. It covers arrangements with publishers, ad agencies, business firms, galleries, and any market that leases photographs to reproduce them. Payment and rights differ when you lease a beautiful scenic of Yosemite to a book publisher, or to a calendar company, or to a client who wants it as wall art. The image is the same, but you charge each client a different amount and may make different agreements about who owns what.

Marketing—finding clients and picture buyers and servicing those markets—is not the focus of this book. What new markets pay or what rights they want is discussed, but this book is not a marketing guide. Use it in conjunction with a list of photo buyers.

Another book that will help you tremendously is *Professional Business Practices in Photography* (ASMP, 4th ed., 1986). Sometimes referred to as the *ASMP Book*, it was originally published in 1973 and is revised regularly. Investing in it will pay dividends. While there is overlapping material in my book and the *ASMP Book*, neither can substitute for the other. I am free to discuss pricing whereas ASMP must take a restricted position because it is a trade association. On the other hand, the *ASMP Book* contains many useful agreement forms that aren't reprinted here, as well as pricing charts that appear here in digested form. I suggest that you consult the *ASMP Book* and other references for material not included in this book. (See the "Suggested Readings" list for these titles as well as for ASMP's address and ordering information.)

THE ELEMENTS OF SUCCESS

You cannot achieve success in media photography by conducting yourself as an "arteest." You can be artistically creative and highly respected for photographic skills and ideas, but you must be aware of the business side of photography so you won't be cheated. Approach the profession in a pragmatic and dignified manner.

Finally, no one claims this book will make you rich. But it can help you avoid disappointment brought on by ignorance or innocence and attempted larceny when you are the victim. Business is always hazardous for those who sell their talents on a freelance basis. Eventually you will discover your obligation to yourself—while clients will quickly point out your obligation to them. When you shoot pictures worth someone else's money, it's imperative that you price them correctly. As ASMP tells its members: Charge what your photos are worth, even when doing so seems a bit risky. At the same time, hold on to the rights to your photos; your images will pay residuals, the kind actors and writers earn. Leasing those pictures can help support you in the years to come, making your future more secure.

There are those who will disagree. Among the most vehement will be your clients. The chapters that follow contain information that you can use as ammunition in the friendly debates that may arise in the future as you pursue your career.

1

Establishing a Business

"Business" means earning your living by selling your photographic skills through shooting assignments, personal projects, book contracts, or the sale of stock photos. Some of you who are already in business might skim this section, but the material here will benefit you: well-thought-out approaches and professional attitudes are essential to obtaining proper rates and retaining your rights.

OPERATING BASES

At the outset there are three locations from which you can operate a photography business: your home, a separate office that may have limited shooting space, or a studio.

An Office at Home. Anywhere you put a desk can be called your office, but current Internal Revenue Service rules require you to work in a separate room or area *used solely for business purposes* if you want to deduct a portion of the residential rent and all office expenses on your tax return. It's not difficult to convert one room of a house or apartment into an office. The space can double as a darkroom if you put light-tight blinds on the windows and install a ventilation fan or air conditioner. Many self-employed media photographers shoot mainly on location, don't need a studio, and use one or two rooms in their homes as office space. Several of my early combination office-darkrooms were adjacent to bathrooms where I washed negatives and prints. If your output is mostly color or you prefer using a custom black-and-white lab, you may still want a darkroom for rush jobs, experimental work, or as an adjunct to fine-art photography.

To create an office at home, you need a large desk, a worktable on which you can spread out pictures, bookshelves, cabinets in which you can store prints and/or slides, and letter files. How much space you settle into depends on your personal taste as well as your

This strong image is a prizewinning photograph taken by an amateur. Pictures with dramatic appeal can help a photographer get started in the business.
© Sherree Brown

13

photographic operation. My present office covers about 300 square feet while a friend whose specialty is annual report photography has a new home with an office twice that size. Other friends work from spaces half as large as mine. Your requirements for a work area and storage facilities will eventually expand beyond the capacity of any first office—unless you happen to set up in a barn.

Besides an adequate space, I like a home office with cheerful light. I want to see the outdoors, not the wall of the house next door. Daylight excites me, and I augment it with fluorescent lights and lamps on extension arms. Of course, you may have to make compromises at home, but try to avoid a spot that may depress you. Remember, an office is a personal space.

Working out of your office at home is also attractive because it is a more economical and convenient arrangement than is renting space. If light and space conditions are pleasant and you can establish firm rules about noise levels and the need for privacy, there may come a time when you wouldn't trade your home office for a luxurious skyscraper suite that is accessible only through agonizing traffic or a lengthy commute.

Keep in mind that restrictions about running a business in a residential zone may affect where you locate; however, if you don't hang up a sign that attracts walk-in business, municipal authorities usually won't bother you. Checking the local regulations is always wise.

A Separate Office with Shooting Space. If you don't need a full-fledged studio but would like some shooting space in a home setting, you can convert a living room or den by moving the furniture out of the way and hanging seamless paper. People and still life can be photographed in spaces so limited they would make a conventional-studio operator cringe. Improvise by shooting small objects on a table near a wall against which you have put a piece of seamless paper or other background. Photograph with electronic flash or quartz lights, direct or reflected, and no one will know that the size of your studio isn't 3,000 square feet.

You can also set up an office and mini-studio in such other spaces as converted stores or regular offices. Be flexible in your thinking, particularly if your budget is small. Since many of your clients may be at some distance, you may only communicate with them by phone or visit their offices. As a result, you may not need posh surroundings to make good business impressions.

A Studio. Many advertising (and commercial) photographers need relatively large shooting spaces with adjacent offices, conference rooms, and darkrooms. These studios can be built in lofts or converted stores, or from the ground up; some are even large enough for you to drive trucks and cars into them for ad shots. When your business volume requires such a layout, you will somehow manage to get it.

Advertising photographers also need office space for staff and assistants, storage room for sets and equipment, an area for building sets, and room to maneuver products and lights. Depending on the rate of inflation and how elaborate and stylish your studio must be, you can spend $10,000 for a basic studio—a price that includes a lot of do-it-yourself labor but no equipment—or $100,000 to restyle a first-class studio that impresses clients. One successful advertising photographer I know has a pool table in the reception area so clients can amuse themselves while they wait. Another hangs a collection of fine-art photographs by famous artists and has bins with portfolios through which clients can browse.

Newcomers can substitute energy and ingenuity for space and dollars. On your way up, consider sharing studio space with another photographer if you don't have enough capital on your own. Sustain yourself in modest surroundings and continue to dream in a practical way. As your business increases, your rates will go up and you will be able to manage your rights more effectively, which means more money from additional leasing of images. When you can afford to, move to a fancier studio and double your working space. Your sense of accomplishment will grow along with your awareness of good business practices.

TAX CONSIDERATIONS

The cost of starting up a business may be amortized over five or more years. These costs comprise the money you spend to furnish an office or open a studio before you actually start a business, including refurbishing a building or room, some equipment, wages, advertising, special training, or professional services. Consulting with a qualified accountant before and during the establishment of a business is like investing in adequate insurance.

EQUIPMENT

Everyone has opinions about favorite brands and types of cameras, lights, films, and accessories. Hardware and materials are improved frequently, and the best way to keep up with changes is to read trade magazines devoted to advanced amateur and professional photographers, and to attend trade shows. If you are not sure what the most appropriate size camera is for your work, talk to other photographers you visit or make inquiries at professional-society meetings. Collect literature about cameras, electronic flash units, and quartz lights; then examine everything you might want to use before you buy, and ask questions until you have enough information to make the best decision for you.

Photojournalists favor 35mm cameras, advertising photographers work with all camera sizes but medium-format may predominate, and lots of studio setups are done with view cameras. Buy only what you are sure you need in stages as money is available, and rent equipment you can't afford or won't use more than once a year. Think portable if you will be working on location, and try to avoid "Rolls Royce" spending if the demands of your business can be met with

Buick equipment. As for darkroom equipment, get advice from photo-supply-shop personnel and other photographers. So much color processing is done expertly by outside professional labs that usually only those photographers who work weekends and enjoy hands-on procedures operate their own darkrooms.

You will need to purchase nonphoto equipment as well. A telephone answering machine or an answering service is invaluable because so many jobs originate or are planned over the telephone. An electronic typewriter can be inexpensive and will make an amateur typist's letters, bills, reports, and captions look polished. Handwritten letters are unacceptable, unless you are a fine-art photographer, for whom they seem de rigueur. A computer for word processing is also wise for writing or duplicating the same letter for many people. Computers save time when you caption slides. Computer programs make studio management and bookkeeping easier and more professional. Talk to friends who have computers to learn which hardware and software will benefit your business.

In addition, you may want to build your own reference library. Such references as the *ASMP Book*, *Assigning Advertising Photography* (Advertising Photographers of America, New York Chapter, 1986), specific books on advertising and other specialties, a good dictionary, marketing guides (which should be renewed yearly), materials supply catalogs, and weekly or monthly newspapers and magazines devoted to both the creative and business sides of photography are all in the successful photographer's library. The bulletins, newsletters, and other information you receive through membership in a professional organization may be helpful in alerting you to client practices, especially in terms of rates and rights.

BEING AN ASSISTANT

This book is meant primarily for self-employed photographers, even if they don't yet have business cards and letterheads. In contrast, employees work for a salary assisting photographers and may only do their own work on weekends. Still, assistants need some guidance until they go into business for themselves.

As an employee or photographic assistant, you do not own rights to the pictures you shoot for your employer. Those negatives and transparencies are "works-made-for-hire" according to the copyright law and belong to your employer who has the option of taking credit for them as well. You don't have to worry about setting prices, but you also don't control where the pictures are sold or how often. You do, however, collect your salary whether pictures you shoot are sold or not. As an employee, you should have enough security and motivation to be creative and energetic. Assisting can be a secure way to get started in the field.

As a photographic employee becomes more experienced and more skilled, arrangements may be negotiated to share ownership of some or all the pictures he or she takes for an employer. Agreements vary, and employees with notable talent and business

acumen benefit most from residual lease or sale of their work. Some magazine staff photographers have negotiated the return of pictures for resale and exhibit, especially after a publication folds. In this way they take control of the use of their images and gain additional income. Such an arrangement would not apply to an employee of an advertising studio.

As an employee, learn as much as you can about how management approaches setting rates and leasing rights. The more you find out about business dealings, the more confidence you'll have when you start shooting for yourself. At that point, you'll have much more control and much more risk, but you will also be able to make a great deal more money.

"GETTING THE BUSINESS"

A few years ago, a young woman named Mona came to show me her excellent portfolio, in which I saw an impressive color print of a rock singer. I asked her how much she had been paid for that assignment. "One hundred dollars and no royalties."

I was irritated but not surprised. Companies large and small are regularly able to buy photographs from talented young professionals for dismal payments. As Mona explained, she had been in an awkward spot. The phone company was about to cut off her service. An hour after she got the check, she cashed it to pay the phone bill.

That poster, Mona went on to say, had sold an estimated 500,000 copies and stayed popular for many months. We speculated that if she had had a royalty of only five cents per copy, Mona would have grossed $25,000. Fortunately, she asked for and received a credit line, which was helpful when she showed her work, and she got her original slide back. However, credit lines can't be cashed at the bank.

When you are new in the media photography business, you don't have bargaining power. You're in a peculiar bind: competitors supply the same kind of pictures you can do or that you have on file. You hear that some of them are asking rates that seem ridiculously low, and that still other photographers speculate by shooting a job merely for expenses. The bind comes when *you* are asked to sell cheaply or to speculate without even expenses paid. You must carefully consider the situation and balance your eagerness to work and need for money against your sense of self-respect. You should maintain reasonable standards; don't join the rat pack.

Luckily, going into business as a media photographer doesn't have to be frustrating. There are many positive, ethical people to work with. Some clients may try to "give you the business," squeeze you, or manipulate you when it comes to rates and rights because they think you're hungry and dumb. You are not dumb. You can take risks and try to act professional. Your confidence and experience grow as your work is accepted on increasingly favorable terms. If you are just entering the photographic community, remember that you are not alone if someone attempts to victimize you. You have plenty of colleagues who have to stand up for their rights in the marketplace.

2

Understanding Copyright

The *Los Angeles Times* included this fascinating note in Charlie Chaplin's obituary on December 26, 1977:

> From his earliest days, he had always stipulated in his contracts that after an agreed rental period, sole ownership of his films would revert to him. It was a stroke of foresight that made him a millionaire in his old age, while some of his contemporaries—such as Buster Keaton, who made no such provision—died in poverty.

The Charlie Chaplin anecdote makes clear that copyright is the basis for ownership and control of your creative work, whether it is a movie, a series of photographs, a piece of music, or an entire book. Copyright is the foundation on which photographers' rates and rights are established.

The copyright law is the primary legal device by which a person proves and maintains ownership of "a literary, musical, or artistic work" that is published. The copyright sign or notice on a photograph warns others that they may not reproduce or exhibit that work without first getting permission—and, customarily, paying for the privilege. If a slide or print has no copyright notice on it, through ignorance or chicanery, someone may not bother to contact the photographer about reproduction rights and might assume the picture is available with or without payment. This can lead to trouble, even if payment is later offered. Having a copyright notice on a picture is a good business practice, just as a patent notice protects an invention and a trademark guards a company name or label.

CHANGES IN THE COPYRIGHT LAW

For almost seventy years photographers and their clients conducted business under the copyright law of 1909. This law stated that in most cases the person or company who hired a freelance photographer

and paid for the pictures, owned them and the copyright to them unless the photographer and client made other arrangements. Under this copyright law, photographers sought to retain copyright to their work through agreements and contracts with magazine editors, book publishers, or private companies. But doing so wasn't always easy: the law favored the party who paid for the pictures.

The current copyright law, which went into effect on January 1, 1978, turned the tables. The new law places ownership of the pictures—the copyright control for reproduction and exhibition—in the hands of the creator from the moment a shutter-release button is depressed. Unless there is an agreement to the contrary affecting ownership of copyright, the buyer must lease or buy rights of usage to a picture from the photographer.

The main exception to the automatic ownership of a work by the photographer under the new law originates in an onerous category of the copyright law called "work-for-hire" or "work-made-for-hire." This section was included primarily to cover photographers on salary, in which case the employers own the pictures and the copyright to them, and pictures shot by a freelancer (who becomes a temporary employee) under a contract with a work-for-hire clause. When the revised copyright law took effect, work-for-hire became the basis for unexpected pressure on photographers to relinquish their rights.

Copyright for Published Work. Photographs taken before January 1, 1978, that were not copyrighted or published previously may be copyrighted today as if they had been taken after January 1, 1978. However, if a photograph was published before January 1, 1978, and was not copyrighted, it is considered in the public domain. You are also vulnerable if slides and prints published are not copyrighted and are in someone else's possession. Get them back if you can. Photographs given away as gifts are not a concern, unless you feel someone might take advantage of you and print them in, for example, a magazine or book without permission.

Photographs created or published first after January 1, 1978, are now covered by copyright for the creator's lifetime plus fifty years. Under the old copyright law, photographs were protected initially if you placed the © symbol or the word "copyright" on them before the copyright was actually registered. This was called "intent to copyright" or "common-law copyright," which covered pictures for a limited time. Neither of these terms is formally part of the new law, but the first one still exists in fact for published work. For a few years after the revised copyright law went into effect, photographers felt secure about the protection of their works. However, there is still reason to be cautious, especially about work-for-hire.

Copyright for Unpublished Work. Various facets of copyright regulation are as important to you as ƒ-stops and depth of field. Knowing the

specifics of the law can help to increase your income and your peace of mind. First, in order to protect photographs so that no one may legally use them without your authorization, mark them as follows: © 19-- Your name. The required notice has three elements: the © symbol, the word "copyright," or the abbreviation "copr."; the year of first publication or, if unpublished, the year you shot the picture or the current year; and your name. The notice can be handwritten, but using a rubber stamp is more efficient and looks more professional. You can get a miniature stamp for slide mounts and a larger copyright stamp for the backs of prints. Include at least your address and phone number. If your film goes directly to a client for developing, have a written agreement with the magazine or business firm covering first rights, return of photographs, and copyright notice. Give the buyer a small rubber stamp with your name, copyright notice, and date on it, and ask that all slides and prints be stamped.

The law says that the copyright notice must appear in a "conspicuous area" of a photograph in order to be valid. Both the front and back of a print or slide mount are considered suitably conspicuous.

It is also important that you understand that placing the copyright notice on prints and slides is the responsibility of the copyright owner and does not require advance permission from the Copyright Office. Once you place the proper copyright notice, with the date to make it valid, a photograph is protected from being reproduced, exhibited, or used in any way without your permission.

Leasing Photographs. Smart practice dictates that you lease pictures rather than sell them. "Leasing" means selling limited rights; it is equivalent to renting your pictures for months, years, or some other prearranged length of time. If you rent a house to someone, you can rent it again when that person moves; similarly, leased photographs can be leased again. As such, holding copyright to pictures is analogous to holding title to a house. Selling pictures, on the other hand, connotes that all rights may be involved, just as you give up all rights to a house when you sell it. In an outright sale of your work, you no longer own the pictures or the rights to use them. You may want to sell outright because the rates are dramatically higher than "leasing" rates (this is discussed in detail later). For the most part, think "leasing," where you can stipulate and limit reproduction rights.

With the exception of ad illustrations, pictures included in a copyrighted publication, such as a newspaper, magazine, book, brochure, or annual report, are protected. While editorial photographs are covered by the publication's copyright, advertisements must be copyrighted individually in a magazine. By law your prints or slides cannot be used without your permission; however, a copyright is not a substitute for an agreement that spells out specific arrangements between buyer and seller. For published work that has no copyright notice, make it clear to the buyer that you are leasing onetime rights

only, or whatever rights you have negotiated and arranged payment for. A majority of clients are scrupulous, but you may not discover the contrary until you're in trouble. Deals must be on paper to ensure your peace of mind and to give you ammunition in a dispute.

In addition, if your work has no copyright notice on it and has not been previously registered, you should copyright the pictures in your own name after publication. You have five years to do so, but you must copyright your work within three months if you want to collect full damages in case of infringement. Another business precaution: get your pictures back as soon as possible after publication.

Assignment of copyright. Clearly, pictures used in a copyrighted publication can be copyrighted in your own name; this includes all the pictures from the same take. When your pictures are printed in a copyrighted publication and neither slides nor prints carry your copyright notice, the publication technically holds the copyright for your benefit. However, the publication is obligated to assign the copyright to you upon your request if you have leased the pictures with limited rights. The *ASMP Book* contains an "Assignment of Copyright" form you can use (this form has been reprinted here in the Appendix). To register the photographs in your own name, have the original "Assignment of Copyright" form recorded in the Copyright Office; this form takes the place of a Form VA copyright registration—"for a work of the visual arts" (see next section). Filing tear sheets is voluntary because the entire publication has already accompanied the original filing by the publisher.

If your pictures will be included in a copyrighted publication unaccompanied by your notice of copyright, arranging for assignment of copyright in written agreements or letters is the most practical approach. In fact, you can have a form filled out and signed before you deliver the photographs.

U.S. Government publications. Unfair as it may be, the new copyright law restricts copyright of photographs in publications "of the United States Government." These are defined as "works prepared by an officer or employee of the U.S. Government as part of that person's official duties." Copyright conditions for freelancers doing government work can be nebulous. In each case a government agency may make its own ruling about whether or not the photographer will be allowed to hold a copyright on work that was prepared through the use of government funds.

The state of Virginia is now in litigation with photographers to whom it has refused copyright protection, which means the state has assumed possession of photographs paid for—including all residual rights.

ADDITIONAL COPYRIGHT DATA

The following facts about copyright will enable you to protect your work from unlawful use.

Omission of Copyright Notice. If your copyright notice is on a picture, whether or not it has been registered, and a publication fails to use the notice when reproducing the picture, you are still protected. Copyright of the publication itself is the main protection. But go ahead and register your copyright within three months. However, "innocent infringers misled by the omission or error will be shielded from liability" if the publication is *not* copyrighted and your notice is omitted. How someone gets possession of your picture to become an "innocent" infringer is not easy to understand.

Make an effort to require use of your copyright notice as a condition of leasing pictures in your contracts with clients; this also protects you if the notice is omitted. Try to avoid clients who don't copyright their printed materials such as direct-mail pieces. If this is impossible, try to persuade them to do so for your mutual protection.

Effective Date of Copyright. The date of copyright registration is the day on which an acceptable application, samples of the work, and the fee are received by the Copyright Office. It may take a while for it to return your file copy to you, but you are protected as soon as the application reaches the office.

Term of Copyright. A photographer retains copyright for his or her lifetime plus fifty years. Works-made-for-hire are copyrighted for seventy-five years from first publication. Pictures copyrighted before January 1, 1978, are protected for twenty-eight years under the old law, and copyright may be renewed for forty-seven years. For works already in their second twenty-eight-year term, copyright is automatically renewed for nineteen years. The law also includes material on ending transfer of rights and terminating rights that have been transferred.

Book Jackets. Photographs on book jackets are not covered by the book's copyright and must be copyrighted separately. Remind publishers to include your copyright on the jacket.

Titles and Ideas. Neither titles nor ideas can be copyrighted. However, if you use the title of an existing book as a model and your book is competitive, you can be sued for damages under the law of "unfair competition." This mainly applies to well-known book titles. Many books are out of print, though, and you may reuse a title unknowingly; don't be concerned.

The Professional Touch. Copyright is the basis for sensible business practice, which in turn is a foundation for self-respect and success. When you find someone who seems to be undercharging for so-called professional work, that person is more likely to ignore who owns what. Such individuals are asking to be exploited, perhaps out of ignorance or desperation.

REGISTERING A COPYRIGHT

You may register your copyright on photographs whether or not they have been published. As noted earlier, you actually have up to five years to register copyright on pictures that have been published but have no copyright notice on them. However, unless you register copyright within three months after publication, the amount you can be awarded for unauthorized use—copyright infringement—is limited. There are two advantages to registering copyright: a potential monetary asset and incontrovertible proof that you own the pictures.

Filing for copyright of pictures requires Form VA, which can be obtained from the Register of Copyrights, Library of Congress, Washington, DC 20559. Make requests to the Information and Publications Section, which can also provide you with explanatory material about the copyright of photographs and about bulk registration (see the next section). For general information, call 202-479-0700. For registration forms, call the twenty-four-hour hot line number, which is 202-287-9100.

Once you have the necessary forms, you can send pictures for copyrighting in various ways. Here are the guidelines:

- For unpublished works, send one copy only. This may be a print, a dupe slide, or a group of pictures for bulk registration.
- For published works, send two copies. Form VA includes instructions for published and unpublished photographs, and while the type is small, the information is clear. You don't have to send a whole magazine; tear sheets are fine. Indicate which pictures are yours if this is not clear. You can also get an "Assignment of Copyright" form from the publication. However, the assignment form has to be registered as if it were an original copyright. If you have sold limited rights and have the slides, negatives, and prints in your possession, you need not have copyright assigned after publication. Simply apply and register the pictures in your own name.
- For each photograph or group of photographs you register, there is a $10 filing fee.
- Each picture or group of pictures you register must be titled so it can be indexed for future identification.
- Form VA can also be used to register the following if they are primarily or exclusively photographic: books, advertising materials and individual ads, periodicals, brochures, posters, postcards, and a series of slides or prints to be used as a set.

Bulk Registration. The $10 filing fee would impoverish photographers quickly if they were to copyright hundreds of individual pictures each year. For greater convenience and at a sensible fee, unpublished slides or prints can be bulk registered. (Published pictures are usually already in groups to be copyrighted.) With bulk registration, a lot of photographs are assembled as one entity for copyright registration, and only one Form VA and one fee are required.

The first step in the process is to place a copyright notice, your name, and the date on each photograph in the collection. Make and keep duplicate slides or prints, and keep a concise list of all pictures sent for registration, so you will know which images are included in a certain group. You can then register the photographs in bulk in one of several ways:

- Photograph a group of slides or prints; shoot in color if all or some of them are color. Arrange a number of slides on a light table or place them in a plastic sheet against a window, and shoot the group on positive or negative color film. Submit a slide or enlarged print of the group to register copyright on all recognizable images. The slides can be projected by copyright personnel to identify separate images; an enlarged print must show images large enough to be seen clearly. You may also submit for registration groups of slides reproduced in the form of distinct, sharp color photocopies (such as those by Xerox).

- Send contact sheets of black-and-white or color negatives for bulk registration. Place a number of contact sheets in one binder, give the whole a title, and copyright all the pictures at once for the $10 fee. If the pictures have a unified theme, use such titles as "A Day at Lincoln Park, 1987." If the themes are a smorgasbord, divide the pictures by subject and title them separately for registration. As an alternative, if the collection is diverse and of reasonable size, give it a title similar to "Collected Work of J. P. Photographer, January–April, 1986." Dates are always required.

- Send dupes for registration. They must not be too far over- or underexposed; it is essential that images be recognized readily.

An important point to remember: It is unacceptable to send a very similar transparency in place of a dupe of the picture you actually want to copyright. The claim that representative outtakes can be substituted for select slides is wrong. The Copyright Office wants to avoid the unexpected complications an "almost-like" shot can lead to.

Keep in mind, also, that the collection you send has to be organized so that it can be examined without difficulty or confusion. Because procedures can change, some bulk registration alternatives may not be acceptable on a permanent basis. Check on current practice by calling the Copyright Office. If you write, a reply may take weeks.

FAIR USE

Under the revised copyright law of 1978, fair use allows reproduction or use of pictures without permission or notice, within such categories as criticism and book reviews, news reporting, teaching, scholarship, and research. There are four standards for evaluating fair use:

- If the use of the work is not for profit, such as use for noncommercial educational purposes, fair use is granted.

- The nature of the work itself influences fair-use application.
- If using the work or a portion of it can harm its future sales as a copyrighted work, fair use can be limited or denied.
- The amount of the work used in relation to the whole copyrighted work, such as a book, is also considered.

Interpretation of fair use is somewhat complex. For instance, under certain conditions a public library may duplicate and distribute one copy of a work without infringing copyright. Monitoring such cases is impossible. However, the new copyright law established a five-member commission, the Copyright Royalty Tribunal, to oversee royalty distribution for fair use of photographs on public television. The Tribunal determines royalty rates and how they are to be divided among those entitled to share them. Royalty rates are very low, and a coalition of visual artists' organizations has consistently tried to have the rates raised to a more realistic level. This effort may have to be continued for some years to come.

COPYRIGHT INFRINGEMENT

The most frequent problem photographers encounter is unauthorized use of their pictures by clients who happen to have slides or prints on hand. I call it the print-in-hand syndrome. If the pictures have your copyright on them, you can claim infringement. Consider, for example, this scenario: you lease pictures to a company for a brochure and limit the usage in your invoice; however, before the images are returned to you, an eager beaver hands some of your photographs to a colleague who wants them for a poster or for a spot in an annual report. The colleague doesn't bother to contact you for permission, believing it to be unnecessary. After all, the pictures were in the company's possession at the time, weren't they? Some buyers do not readily consider photographers' rights. And, as for the original company contact, he or she may think that doing you this "favor" will result in added income for you.

Had you been contacted, you might have been happy to arrange to lease rights and additional payment for a poster or annual report, but you first become aware of the infringement when you see your pictures reproduced without your agreement or consent. The company had no right to use the pictures again, whether or not they are marked with a copyright notice, if it had agreed in writing to limited rights. You now may negotiate for more money than you would have been able to had you discussed payment before the shots were used again. If the client is honorable, you will come to a mutual agreement. If not, the company may expect to use your pictures again without any payment. Having marked a copyright notice on your pictures will certainly strengthen your case. Here are some guidelines:

- Clients who have knowledge of the publication field will avoid using copyrighted photographs without permission. Even if they

are handed off from one office to another, someone should be wise enough to check for agreements that apply to them.

- Copyright also protects you from unauthorized copying of your pictures, either photographically or by drawing or painting. A slick rendering of a cat made from a friend's photograph, with every hair in place, was foolishly used in a cat food ad. My friend sued and collected handsomely.
- Copyright infringement also includes intentional imitation of a picture. Even when the imitator tries to disguise the similarity by using a different model or changing minor details, infringement may be proven.
- You may file for copyright registration after a violation has taken place, providing you have marked a copyright notice on the pictures involved. An infringement is an infringement, whether or not you have filed for registration and paid the fee before the violation took place.
- You may sue for statutory damages in a federal court only. If you win, the court may award you between $250 and $10,000 per infringement. This amount can be increased to $50,000 for "willful" infringement, or reduced to as little as $100 for "innocent" infringement. To be entitled to statutory damages and attorney's fees, you must register pictures before the infringement, or within a three-month period following first publication.
- Alternatively, you can sue for actual damages. This requires determining how much profit an infringer made at your expense, and it is worthwhile when the stakes are high enough. However, it is often more practical to accept statutory damages. An attorney can help you decide a logical course.
- As noted, you may also sue to cover your legal fees. This makes your case more attractive to an attorney who may then work on a contingency-fee basis.

Be aware, however, that a lot of state-court suits for unauthorized use of photographs are not based on copyright infringement, but on breach of contract and other legal technicalities. If you have a problem about pictures used without permission, get an attorney's advice as to whether or not copyright infringement should be the basis of a suit. Gather all the facts you can and keep good records of your transactions; doing so will help prevent a judge from deciding that the infringer was unaware of an offense and from awarding you a small amount—or nothing.

SUMMARY

Protecting your rights through copyright goes hand in hand with wanting to improve the quality of your photographs. Clients are better satisfied; quality clients want to respect your rights; and true professionalism helps foster self-worth, which leads to greater income for you.

3

Determining Rates

How to charge for media photography is a confusing subject. Pricing, however, is based on two relatively simple concepts:

1. The type of media affects potential fees, depending on how the client will use the pictures and how valuable they are to the client
2. How broad or limited the rights the client wants to lease or buy are

Let's begin with an example. Marty is an advertising photographer with a medium-sized studio. He specializes in pictures of products and people; his clients run from mid-size to large. Marty has been in business for four years, and he has enough volume to employ a full-time assistant and to enlist part-time help from his wife, Cindy. Marty has never charged more than $1,500 for one shot (as of 1988), and his work has been used regionally as well as in national publications.

One client asks Marty to estimate an advertising job that is larger than any he has ever tackled. "It'll mean shooting in the studio for three days and on location for two more," he explains to Cindy. "They want to know if I charge by the day, the shot, or the ad. What should I tell them?" Cindy suggests they refer to the latest edition of the *ASMP Book*, in which average professional advertising fees have been compiled from a national survey. Marty reads several pages and tells her, "For a photo for a single-page, national consumer magazine ad, 42 percent of ASMP members who responded charged $1,500 or less, 41 percent charged between $1,500 and $3,000, and the rest charged more than $3,000. Now, how does this affect us?"

Is this photograph fine art or historical record? Charging for this archival picture taken in Los Angeles during the 1950s depends on its use.

They talk, analyze, and agonize. They know the client wants to use the pictures in both local and national magazines. The purchase order calls for two insertions of three different photographs over a six-month period. Marty summarizes, "The account exec mentioned four magazines and said there could be two more, but he wanted a

fee that allowed additional usage, like converting to black and white for newspapers. We have to cover ourselves, but not be too high."

As a result of their research, Marty asks for and receives more than $3,000 per shot, which will cover the variety of usage. Marty and Cindy feel they have been paid fairly, but sometimes wonder if Marty could have charged more. Marty's worries about estimating fees are justifiable because he must think about many factors, such as:

- Preparation time—two days in the studio creating sets for two of the photographs and another day finding an exterior location for the third
- Actual shooting time—one day for each of the three ads
- Post-production time—three days to dismantle the sets, edit the film, and meet with the client

Total time for preparation, shooting, and post-production was about nine days. A magazine-ad picture rate of $3,000 multiplied by three (pictures) is $9,000; dividing this figure by nine (days) is $1,000 per day. This sum has to cover all overhead, which may not be billed directly to the client, such as rent, several kinds of insurance, amortization of equipment, and telephone. It must also take into account other items that cannot be billed separately as expenses, including association memberships or seminars. Marty and Cindy's profit, or taxable income, is perhaps $500 a day. Since Marty may shoot only six or eight days a month, at his stage of business advancement, Marty and Cindy are not getting rich by charging $3,000 a shot, especially when they must continue to make capital investments in their business.

Marty took into consideration the rights the client wants, which include six months in specific magazines. But his fee does not adequately cover additional usage. He later negotiates extra payment of $1,000 per shot for newspaper use, after talking to a more experienced colleague who told him, "Magazine rights are one thing, but newspapers, brochures, or whatever are another. Charge separately for each category of rights."

Clearly, establishing professional fees can be complex and rewarding. Keep in mind that charging for media photography is always predicated on these questions:

- What does the client want the pictures for?
- For what length of time does the client want to lease the pictures, and what combination of rights is requested?
- How important is the photographer's reputation, and how well does he or she negotiate?

TERMS OF THE TRADE

In order to understand your rights, you need to understand the terms that underlie them. These terms will help you negotiate with a client and enable you to feel more secure in accepting an advertising,

editorial, or corporate assignment. These terms apply to photography for publication only; pricing for pictures sold for individual use, such as portrait and wedding photography, is not included in this discussion.

Style. Certain intangibles, such as a photographer's talent, reputation, experience, personality, and marketing skills, all influence business success. These qualities contribute to what we know as "style." Famous photographers who command unusually high fees have personal style—taste and talent that are marketable, even though such categories do not appear on a photographer's invoice.

Assignment. An assignment is a business deal: an order or request for a photographic job, backed by commitment to pay for the work plus expenses. As part of an assignment, the client states what is expected photographically, and the photographer estimates how much time the job will take and ascertains the rights the client wants. They then negotiate rights and fees. The client agrees to make payment in reasonable time for work delivered. In turn, the photographer agrees to be conscientious, imaginative, efficient, ethical, and sensitive to the visual and practical requirements of the job.

To be valid, an assignment should be in written form. A purchase order or an assignment confirmation form, like that in the *ASMP Book*, is a standard form for validating media or advertising assignments (sample forms are reprinted in the Appendix). A letter from an editor or other photo buyer can also serve as an assignment contract, particularly when all the conditions involved are included.

If an editorial assignment is given to you over the phone, ask the client to summarize the arrangements in a letter to you, or do so yourself immediately after the call and send your summary to the client. If you receive no complaint within a reasonable amount of time—about ten days—you are protected. Preferably, ask the client to sign a copy of your letter and return it to you. You can also choose to use the ASMP assignment confirmation form instead of a letter.

If an assignment is offered to you orally and in loosely defined terms, you are taking a business risk. Put the agreement in writing so both parties understand the same specifications. Even if you work frequently with a client, never rely on oral arrangements alone. There are too many potential pitfalls between a friendly oral contract and the successful execution of a job and payment. Be especially wary of unwritten job arrangements with your relatives.

Speculation. Speculation is a dirty word among creative people. Speculation means that you will work without a guarantee of payment unless the potential client finds your photography acceptable and agrees to buy it. Such an arrangement may indicate your inability to negotiate rates or rights because both are dictated to you. This is unfairly weighted in the buyer's favor.

Sometimes the prospective buyer puts a carrot on a stick and offers limited expenses. Credit lines are magnets that attract creative people, and here the client's risk is minimal: with little or nothing at stake, he or she can seem excited about the prospects but be indifferent about buying your finished pictures. Your risk is potentially serious. It's easy for someone to tell you later, "Too bad it didn't work out."

Photographers speculate for the same reasons they enter contests: the possibility of a sale, an award, exposure in print, and money. Obviously, speculation is a gamble that turns what should be a legitimate business arrangement into a crap game. No one should be allowed to give specifications for a shoot without also being obligated to pay for your time and expenses.

Speculation is rarely expected in advertising photography because specific products and services are involved. If you are foolish enough to work for free and the pictures are rejected, you probably won't be able to do anything with them. If you speculate on a magazine story or a book, there are other potential markets if the first one falls through.

Independent Production. Photographing a story or shooting for a book when, where, and how you please is called independent production. If you have an idea or a photo project in mind and undertake it without contacting prospective buyers, you are taking a risk on your own, but you're not speculating in an unbusinesslike manner. You may undertake an independent production for experience, or because you have strong convictions about a subject, or because you want no interference. Independent productions are often started without informing any buyer, but a sales effort may be made before the project is completed. Many fine photographs are made as part of independent productions.

Minimum Guarantee. A buyer may also offer a minimum guarantee to cover limited shooting time and expenses to induce a photographer to work on a story or book project. This often happens on potentially long projects in editorial photography so both photographer and buyer can sample the possibilities.

Payment may take the form of a flat fee or an amount for a specified time at a day rate plus expenses. For this money, the client gets first refusal rights. This means that you shoot all or part of a story or project, submit the pictures, and if the client will not buy, the minimum guarantee and the pictures are yours. If the client does buy, the minimum guarantee is a down payment against a day rate or page rate. In the case of a book, you may decide to negotiate a contract, based on the shooting. Whether or not your nonreturnable fee is included in the contract is a subject for negotiation.

A minimum guarantee is an investment in you and your ideas. It's a subsidy that shows mutual good faith. *National Geographic* once

guaranteed me a great deal of film and processing to pursue a story idea that never came off. If I had been able to shoot the birth of a walrus in captivity, the magazine would have had first refusal rights on the chromes. I would have had the motivation to take the time necessary to shoot the pictures, and the oceanarium would have been encouraged to cooperate with me fully.

MOTIVATIONS

At some point, every photographer is motivated to invest time and money in shooting, whether someone is waiting to buy the pictures or not. A friend of mine, for example, is on her second trip to a remote section of Central America because she and an archaeologist think his discoveries will be worthy of a magazine story, perhaps even a book. She anticipates six good magazine markets; she will have some wonderful stock shots to sell, as well as excellent portfolio samples to show to clients. My friend's sense of adventure enables her to invest in herself.

Some photographers prefer independent production to satisfy inner urges and to avoid client supervision until they are ready for it. Conversely, magazine and book editors like seeing picture projects partially completed: they get an impression of what the photographer can do and can determine the potential of the material. In some cases, you can charge a higher fee for the final series or story because its value is readily apparent.

Just be certain to remain independent, and do not promise pictures for a pittance or on speculation.

PHOTOGRAPHIC FEE METHODS

Payment for media photography is usually determined by the amount of time involved, the space given to the photographs, or the type of job. The exception is payment for photography for books (see Chapter 9).

The chart on page 34, courtesy of photographer Steve Murry of Raleigh, North Carolina, shows the correlation between usage rights and photographic fees.

Suggestions About Fees. If a buyer wants extended usage at a reasonable fee, the best arrangement is to lease *unlimited, nonexclusive* rights. This gives the client full usage while preventing the photographer from having to do any monitoring; it also gives the photographer stock and portfolio use.

Photographers who sell stock photos from assignments should discuss holding time with the client and should agree, in writing if the client prefers, not to sell to the client's competitors or to a specific market that poses a conflict of interest. Photographers must protect the interests of the original client during and after the job.

Photographer Charles Gupton of Wake Forest, North Carolina, suggests: "Individual photographers vary their fee increases according to the job, the client, and their own approach to business. It's important to know the parameters, and not vacillate about how much

to charge. Of course, we all must negotiate rights and rates. We have to accept certain practicalities, like the determination of a client to maintain a budget, and our own desire to work, especially at challenging assignments. There are usually personal elements in most business arrangements."

FEES RELATED TO USAGE RIGHTS FOR EDITORIAL AND ADVERTISING PHOTOGRAPHY

Limited use: one use, nonexclusive **Normal fee**
This method is the type normally bought by most clients. How the pictures are to be used is spelled out on an estimate form or invoice.

Exclusive limited use: one use, no stock **50%–100% more***
This method prevents the images from being resold without the client having to buy more usage rights than needed. The photographer cannot resell the photographs as stock.

Multi-use: two or three uses **50%–100% more***
This method is applicable when two or three specific uses are known in advance. The number of images included should be specified on an estimate form or invoice.

Unlimited use: nonexclusive **100%–300% more***
This method is a good way for a client to buy usage without paying too much for unneeded ownership rights. "Unlimited" usually applies only to the photographs used, not the whole shoot. The photographer agrees not to sell to a competitive client.

Exclusive unlimited: no stock or resale **200%–400% more***
With this method, the buyer gets everything but the copyright; the photographer is allowed portfolio use of pictures including the image(s) used in ads or otherwise.

Buyout: client buys copyright and all rights **300%–500% more***
With this method, the buyer obtains all rights to the work. The photographer cannot use any of the images for any purpose. The photographer must sign a contract. Work-for-hire need not be involved.

Note: Suggested percentage increase above normal fee.

Day Rates. As noted earlier, a photographer's reputation and ability to negotiate are just as much part of deal-making as the circulation and the type of publication are. Whenever you contemplate what to charge, your eagerness to work, future opportunities with the client, and the advantages of seeing your pictures in certain publications are all factors. Discussing day rates with your colleagues helps you know what's current.

Mini-max. Minimum day-rate figures need not be allowed to become maximum charges. In addition, you should be alert to raising your rates when the climate seems right. Some accounts may fade away, but as your reputation improves, you will make more money per job and your volume will eventually increase if your work is good.

Advertising day rates. Though photographers charge on a day-rate basis, they commonly equate a day's work to the price of advertising shots. Day rates should be balanced against the ad rates listed in Chapter 7. The main objection to day rates in advertising is that because you might be able to shoot several advertising pictures in a single day, you may not be adequately paid, even at day rates of $1,500 or $2,000 plus expenses. An advertising day rate is valid only when you are sure that the time spent will be equivalent to the value of the advertising pictures you have been assigned to shoot.

Ad Rates. Estimating fees for advertising photography involves the following often-overlooked factors.

Preparation time. It could take you a few hours to arrange a small set for a still life or several days to build a larger set. If you're going on location, you might spend a day or two looking for the right garden in which to photograph two lovers walking.

Complexity of the job. Imagine a picture that requires five models, clothing that has to look perfect, props, front-screen projection for the background, a dozen lights, an assistant, a stylist, and a trained dog. Compare that with a simple still life of a potted plant, a few books, a homey background, two lights, and a reflector. These extremes illustrate the importance of careful estimation of ad rates.

Post-production time. The film has to be edited and readied for presentation to the client, who may want to see it quickly. A set may have to be dissembled, the studio cleaned, rental items returned, and vehicles washed. You shouldn't do any of this for free.

Overhead. Studio rent, insurance, equipment purchased, employees, on-site lab, telephones, electricity, messengers—the list goes on. Some of these are recurrent bills that have to be paid whether or not you are shooting.

Space and Story Rates. Many magazines pay a space rate, which is based on the amount of space taken up and is also known as a page rate, or pay a story rate. This translates into a certain number of dollars per page or per series of pictures, on several pages, usually with captions, sometimes with a short text. It is necessary to compare these rates to your day rate to determine if you will be paid fairly for an assignment.

Publications may pay a day rate or space rate, whichever is higher. For example, a magazine assigns you to an event that will take at least two days to shoot. You do the job and submit a bill for $700 ($350 per day) plus expenses before the story runs. Suppose this publication has a $400 page rate and your story gets 2½ pages. Since you've been paid just $700, you submit a bill for another $300 because the space rate is higher than your day rate. Sometimes the accounting department of a magazine is set up to pay additional fees automatically, but don't expect new clients to do so. Send another bill and reiterate the rights granted. Had the story been printed on 1½ pages, the $700 you had been paid would have prevailed. Thus the axiom: Charge day rate or space rate, whichever is higher.

Story rates are often used by medium-sized and smaller magazines that expect a package of pictures and words from the photographer. Some story rates are often unrealistic in comparison to day rates, but evaluate each potential market or assignment separately. Although you might work 1½ or 2 days plus preparation time and receive a story rate less than your day rate would be, some publications are good training grounds and provide income for part-time contributors not yet ready to compete in the higher-paying markets.

Postponement and Cancellation Rates. Some clients will agree to pay a photographer if an assignment is postponed on the basis that you may have turned down other work for the period of time you expected to be shooting. But a postponement with reasonable notice, such as a week or more, may not require a charge if the job is rescheduled.

A cancellation fee may also be charged for time spent preparing for a job that is called off because a client's needs change. This can be included in a written agreement, especially if the starting date of the job is several weeks away.

Reshooting Arrangements. Being asked to reshoot pictures declared unacceptable by a client can prove to be a touchy situation. If you're largely responsible for the problems, you should offer to reshoot for no charge. If the responsibility is shared, the client might pay half your shooting fee and provide models, props, and other necessities. Such a situation may occur when instructions to the photographer are wrong or muddled. If a client changes his or her mind and asks for a reshoot, the photographer has not been negligent and should charge again on the same basis as the original job. This is more likely to occur in the advertising field because product changes and creative revisions are more prevalent. The ASMP assignment confirmation form includes provisions about reshoots.

CHARGING FOR EXPENSES

All worthwhile clients pay a photographer's normal expenses, which are charged in addition to photography fees. However, among smaller magazines and companies, you may come across picture buyers who

ask, "How in good conscience can you charge for film, processing, and other items when you are being paid $----- a day (or for a shot)?" This unenlightened view stems from the belief that you earn a day rate every day of the week and are pocketing most of the money, especially if you have no staff and work out of your home.

You may have to explain to such clients that you shoot a limited number of days a month and that your continuing overhead includes your rent or mortgage, various types of insurance, equipment, repairs, a telephone, an answering machine or service, a secretary, an accounting service, and a messenger service, among other items. Even if you work out of your home, many such expenses apply and all contribute to the daily cost of running your business—whether or not you are shooting. Clients must understand that your day rate, shot rate, or job rate covers not only your skills and experience but also your overhead. Charging for expenses on a job helps keep you in business.

Unlike the legendary "swindle sheet" in sales, your expense account will not provide you with a great deal of additional profit. Many clients require expense receipts submitted with your bill. Be sure to collect these diligently to substantiate all expenses. Expenses you forget to charge for reduce your income noticeably.

EXPENSE CATEGORIES

The billable expense categories that follow apply to most types of photographic jobs. Not all of these occur on any one assignment, and some are flexible. Your intention to be fair to the client as well as to yourself should be obvious when you bill properly. When in doubt, discuss expenses before doing the work. Recently, I estimated air fares, car rental rates, and motel charges on a potential job for a magazine that I had done local assignments for. The magazine agreed to cover about $400 worth of expenses on an assignment that would pay $800 to $1,000, depending on space. Enlightened self-interest led me to discuss expenses ahead of time, and the magazine considered this a courteous business practice.

Film and Processing. When possible, charge the retail price of film and processing, even though you may pay a discounted rate. Such a markup is common and generally accepted because it helps to cover some of the unpaid-for time it takes to obtain supplies or to pay for an assistant who makes trips to processing labs. Some ad agencies stipulate in purchase orders that you include a detailed receipt for every expenditure. In such a case, do not list the number of rolls of film shot or processed, even if the unit cost is on the receipt. Color film is usually edited before delivery, and getting fifty worthwhile slides from ten rolls of film is within normal limits. List the charge on the bill as follows:

Color film and processing: $-----.

Remember to charge the list price per roll and if questioned, say that this is standard practice among professional media photographers.

Finally, because the copyright to your pictures belongs to you, charging for film and processing does not constitute transfer of ownership of slides or negatives—unless you make other rights arrangements for an additional fee. You may negotiate sale or lease of these materials when it's in your best interest to increase your profits. Don't, however, be conned into believing that payment for raw materials is tantamount to ownership.

Transportation. Air fares, car and helicopter rental rates, and other transportation charges should be billed at the rates you pay, plus tips. Your own car should be charged on mileage basis. While the Internal Revenue Service allows you to deduct a certain amount per mile for use of a business vehicle, its allowance does not cover your costs. If you are not sure about mileage charges, ask more experienced colleagues who have formulas of their own for advice. Keep all receipts to document these expenses.

When billing mileage, unless specifically requested, do not state the number of miles driven on a job. Simply state: "Mileage: $----." Give the rate per mile if you wish, and keep your own record of miles driven. If you provide too much detail, you may be questioned about why you drove so many miles. You may know all the driving was necessary, but justifying it can become annoying. Furthermore, many clients accept mileage charges without cross-examination.

Food and Lodging. These expenses are easy to keep track of when you use a credit card for meals, motels, and hotels. Receipts are given routinely, and you don't have to carry as much cash. When in doubt about what a client may consider reasonable restaurant and hotel rates, discuss the subject with an editor, art director, or account executive. Clients are not always predictable, and some may have informal limits. A client may object to paying for a double room (for a friend or spouse) when you're supposed to be alone.

In large studios, these and similar expenses are handled on a routine basis by the studio manager because expenses for crew, models, and other personnel can mount.

Rentals and Props. On an editorial or advertising job, when you need a stuffed alligator, a motor scooter, or a bass drum in a photograph, renting such props is usually your best option. You can also charge for renting special electronic flash units, special-purpose lenses and cameras, furniture, clothing, or such offbeat props as a cowboy saddle. Depending on the budget within which you're working, a rental might prove to be a problem; check with the client first.

Models. Advertising and fashion photographs in particular and various other kinds of editorial work may require models. You may hire people directly or use a model agency. Get releases from the models no matter what type of pictures you take. Be certain the client

realizes that professional models may be expensive. In the advertising field, it is customary to have the model agency bill the ad agency directly. This relieves you of having to make decisions about fees, reduces cash outlay, and simplifies bookkeeping. If the model isn't being paid directly by the agency, make it clear to the model how long it may take for him or her to be paid. However, if the fee is minimal, pay the model, make note of the fee on the release, and bill the fee in your expenses.

If you hire minors, be certain their parents know what the children will be doing: you need legitimate signatures on the releases.

Assistants. Any temporary help you hire for a job becomes an expense-account item. Such assistants may include a carpenter, painter, camera carrier, home economist, stylist, hairdresser, or driver. On jobs for which estimates are submitted before the assignment is made, the client knows what special help you need and approximately how much it will cost.

Communications. The most important billable charge in the communications category is that for telephone calls. The myriad arrangements made over the phone before, during, and after a shoot are essential to successful media photography. Keep a record of calls and attribute them to each job, unless you can separate them easily on the telephone bill.

Messengers and shipping costs are also billable charges.

Special Expenses. Some of the following may be needed occasionally for a photography job, and they are billed to the client:

- Liability and other types of insurance specifically required for a job
- Vehicles, such as trucks or forklifts
- Location scouts and location fees, such as rental of a yard or home
- Building of special sets
- Gifts to helpful people not otherwise paid
- Overtime lab fees
- Entertainment for clients, models, and crew essential to the job

GOOD BUSINESS PRACTICES

Good business practices usually involve consideration both for your client and for yourself.

Collections. Photographers in business for themselves are often unsure when bills for services and expenses will be paid. Ad agencies, magazines, and corporations may take thirty to forty-five days, or even longer, to pay, depending on their routines and attitudes. Expect both inconsistencies and delays. Discuss with colleagues the practice of noting on a bill that an interest charge of 1½ percent per month will be added after thirty days. This charge is familiar to everyone because credit card companies use it.

Advances. Many advertising photographers ask for and receive an advance to help pay expenses because they cannot afford to become bankers, lending money to their clients for a month or more. Photographers doing extensive magazine stories or annual reports that require a great deal of time and travel also request and receive advances on their expenses. When hundreds or thousands of dollars are involved, clients realize the equity of such arrangements.

Persistence. Keep track of the dates you bill for jobs, and be prepared to send second bills and to call and remind editors or art buyers when payments are very late. The people you work with don't pay the bills, but they can contact the accounting department and make waves on your behalf. (More information about dealing with remiss clients can be found in Chapter 12).

THE COST OF A PHOTOGRAPH

Richard Weisgrau, a photographer and business consultant working in the Philadelphia area and a friend of mine, did a tabulation for several ASMP chapter newsletters.

While visiting an art director, he heard an agency client ask why photography costs were so high. The client could not understand how a single photograph could cost $1,750—and this was in 1986.

Wondering how he would answer that question, Weisgrau analyzed some work records in his studio in terms of his overall operations. A $1,750 job, he discovered, would account for .48 percent of the total billing of the studio that year. Allowing 1.2 days for the $1,750 photograph, he divided that fee in terms of overall studio operating costs. The resulting breakdown is shown in the table on page 41.

Trying to determine how he could juggle the figures to make a better profit, Weisgrau decided to "create a Utopia on paper" and do the same job for half the price. This meant working out of his apartment with no staff and hiring outside help for all required services. The job might take five or six days depending on the reliability of assistants and suppliers. He stopped dreaming when he determined he would first have to find a place with enough floor space.

How much does a photograph cost to make? Think about your own rent, insurance, salaries (including your own), film, supplies, models, car, outside services—the list goes on—plus your experience and talent. Your list may be shorter than that of Weisgrau, but the principles are the same.

A CHECKLIST FOR CHARGING

Keep the following points in mind when charging for photographs:

- Think about how much the job is worth to the client.
- Use industry guidelines as a reference for pricing. These are suggestions, not set prices, but they may help persuade a client that you're not improvising. The *ASMP Book* is the best one to use, but *Assigning Advertising Photography*, by the Advertising Photographers of America (APA) is also helpful.

A $1,750 PHOTOGRAPH: A BREAKDOWN OF COSTS

Description	Amount	Percentage of job cost
Production salaries	$ 287.00	16.44%
Models	183.75	10.5
Corporation officer's salary	183.75	10.5
Sales commission	175.00	10.0
Supplies and props	152.25	8.7
Film and processing	145.25	8.3
Office salaries	122.50	7.0
Outside services (retouching, stylist, freelance help)	91.00	5.2
Rent	56.00	3.2
Auto and travel	52.50	3.0
Promotion	52.50	3.0
Payroll taxes	49.00	2.8
Insurance	26.25	1.4
Delivery fees (messengers, express service, regular mail)	14.00	0.8
Office overhead	14.00	0.8
Utilities	12.25	0.7
Telephone	10.50	0.6
License and permit	10.50	0.6
Depreciation of equipment	8.75	0.5
Interest on loan for line of credit	8.75	0.5
Legal and audit	8.75	0.5
Camera repair	5.25	0.3
Bank charges	3.50	0.2
Professional dues	3.50	0.2
Benefits	1.75	0.1
Total costs	**$1,678.25**	**95.8%**
Before-tax profit	**78.75**	**4.2%**

- Be careful about using day rates when pricing advertising photography. Unless you know how many days will be involved, you won't know how much you're charging for each shot. You must guard against the risk of making multiple shots in one day for a single day rate, which clients should understand is unrealistic.
- Don't emphasize price when discussing potential jobs with a client. Emphasize instead your ability to work with people, to handle complex lighting, to improvise on location, or to work to exacting layouts. Promote your skills and show your understanding of the client's needs (see Chapter 14).
- Present your pricing quotes in a professional manner, using an estimating form, an assignment confirmation form, a form of your

own, or a carefully written letter. Try to give yourself enough time to consider the job carefully. Quick quotes are fine for smaller jobs, but your proposals will be received better when clients know you gave them proper attention. You'll also make fewer mistakes.

- Contact the client occasionally after you have submitted an estimate. Ask about the status of the job in question, and show your continuing interest.
- Remember that rates for photography vary from one part of the country to another; be especially up-to-date in your area.
- Practices discussed in this book should remain the same but prices will change. ASMP issues its book every two to three years, and its pricing and practices surveys of members are excellent guidelines for most professionals.
- In the magazine field, page rates and space rates tend to stay constant too long. This is caused partly by supply and demand: too many photographers in competition for too few jobs. When photographers need the work and want the exposure in print, their objections to low prices are minimal. There's a parallel in advertising. The fees magazines charge advertisers for space have escalated enormously in comparison to publication page rates or to the fees photographers charge to shoot ad pictures.
- Business conditions operate in cycles. It's important to stay in touch with your professional colleagues and to join at least one professional organization so you are aware of pricing and business trends. When professionals compare notes, they can learn a great deal from one another.
- "Cheap" practitioners exist in every field. Some photographers specialize in undercutting, but few of them go very far. As the old saying goes, you get what you pay for, and the undercutter must eventually raise rates or settle for inferior status.

SUMMARY

When photographer Charles Gupton spoke of the "personal elements in most business arrangements," I think he was referring to various psychological factors and personality traits. Photography schools don't teach a course called "Personality 101," although legal curricula are starting to include "Trial Communications." Law students learn to use their acting skills to more effectively project facts and influence juries. Photographers would benefit from a similar class: they would learn to better use their personal assets to persuade clients.

Knowing all the proper fee categories and writing thorough agreements and invoices are not enough. Photographers must have the courage, conviction, and self-esteem needed to pull off client meetings successfully. First you have to know the pertinent background information. Next you have to gain experience by actually negotiating with clients, starting with small ones usually. At the same time you should exchange views with colleagues, attend programs given by professional organizations, and take courses on salesmanship, business negotiation, or basic psychology.

During this often lengthy learning period, your mistakes are as important as your achievements. Luckily, I remember my embarrassing, costly business mistakes much longer than jobs where all went well. Years ago I did an assignment for a large picture magazine that is no longer published. I was paid a minimum day rate because I was new in the business and didn't have the clout to ask for more. The picture story came off well and was published on four pages—a stroke for my ego. A week after publication my editor called and asked me to send him the negatives; the magazine wanted to make more prints for distribution through its syndicate. I was so flattered by the continuing interest that I didn't ask about further payment or additional rights. As a result I simply gave away my negatives and residual income out of sheer naiveté. My loss in dollars paid for a gain in awareness. This mistake increased my business acumen. Years afterward, I would recall how dumb I had been, and I would try to build safeguards into agreements that I might not have otherwise been aware of.

Your feelings and experiences guide the way you relate to clients, the way you handle yourself in negotiations, and the results you get from being sure of yourself. Each of us has a somewhat different outward personality, but we all want to establish a harmonious relationship with those we work for. And, in order to be successful, you have to be informed.

4

Understanding Your Rights

Rates and rights are interdependent. You can't determine proper charges for photographs and assignments until you know what rights are included. Conversely, as you discuss rights with a client, the cost of the job or the pictures is always involved. Having established the framework of photographic rates, let's discuss photographers' rights, an equally important part of your business.

GUARDING YOUR RIGHTS

Since the custom of media photographers is to lease, not sell, rights to pictures, the legal use of your photographs is limited by the rights you lease. A client is charged for the opportunity to reproduce images in magazines, books, brochures, advertisements, annual reports, and other media.

Setting limits on the purchase of rights to using photographs is much like the method that writers, composers, playwrights, and actors have long used to lease (sell) their creative work. Publication, performing, or recording rights are leased for specific purposes and times. Media photographers may earn less money per job, but the rights principles by which they operate are the same. Ideally, you and the client agree on the rights to be leased, you set fees accordingly, and you retain control and ownership of your work. The photographs are returned to you after use. Similarly, a play may be leased for a year on Broadway and rights retained by its creator, who can then make other deals.

Because self-employed media photographers have no company-provided pension fund, health insurance, or sick leave, it is essential that their photographs be available for continued leasing to provide residual income, especially in stock photography. Clearly, you owe it to your present and future to arrange business agreements that maintain your ownership of pictures. Chromes and negatives in your files can be income insurance for you in later years.

This shot of the Brooklyn Bridge, a double exposure, was taken for a promotional release, but the photographer presumably retained the rights to his theme.
© Bryan Peterson

In case a client expects you to sell complete ownership of your work, remind the client that freelance photographers are independent contractors and get none of the fringe benefits an employee enjoys. Leasing or licensing rights to your photographs made on assignment or from stock files helps to provide your fringe benefits.

TYPES OF RIGHTS

The discussions that follow are based on definitions developed over the years by ASMP and through my own experience.

Exclusive Rights. With exclusive rights, the photographer leases to the client the right to reproduce work, usually for a specific time period, geographic area, or type of use. During this time, the photographer agrees not to grant rights to the same or similar pictures to another client. For example, you may lease exclusive rights to a series of pictures in a magazine article for six months or a year, and arrange payment for use in more than one magazine owned by the same client. You may allow a greeting card publisher exclusive use of some of your images for a specific time period. Other variations include exclusive use of pictures in a specific country or continent, or exclusive use for posters and billboards. There are many possibilities for exclusivity in advertising or editorial photography.

Connected to the type and time limit of exclusivity you negotiate are reproduction fees that are higher than average for onetime rights. Exclusivity may be worth twice the price of nonexclusive rights, depending on the type of pictures and buyers involved. The client pays more because you are restricted from licensing the pictures elsewhere for a while. Remember, you can set sensible limits. For example, you can arrange exclusive rights to a farm scene for an ad that also allow you to lease the same picture to an encyclopedia, which is hardly competitive and won't be published for a year.

An unusual exclusive rights deal was made some years ago when two separate photographers happened to photograph actress Marilyn Monroe doing a semi-nude movie scene in a swimming pool. They formed a monopoly by combining their pictures and systematically leasing them to publications around the world. One magazine in each country was offered exclusive rights, and the rates charged were high for that era. Had the photographers not teamed up, the exclusivity they proposed would have been impossible and they would have made far less money.

First Rights. With first rights, pictures are leased or sold in one edition of a publication only, though the photographer may permit use of work in specified related publications in an agreed-upon area. At the same time, the photographer agrees not to allow any prior publication of the same or similar images, perhaps within a specific country. First rights are customary for many types of editorial assignments and are often granted with a time limit, such as ninety days or six months. After that, the buyer may still have onetime rights (see the

next section) if the photographs have not been used yet, but the photographer is free to lease them again. A first-rights agreement may also limit the leasing of pictures for a period of time after their original publication, an added benefit for the client. The first-rights principle is applied to assignments, independently produced work, and stock photographs as well.

In the advertising field, first rights may be granted to cover the same pictures reproduced in more than one publication or medium over a specified time. Fees increase in accordance with exposure of the photographs. Photographers agree not to lease the same pictures to any competitive type of client.

Onetime Rights. With onetime rights, pictures are leased for one reproduction in one language in one edition of one publication in a specific area. For instance, you might sell the same scenic shot to a postcard publisher for onetime use, and lease it at the same time to a noncompetitive market, such as an encyclopedia publisher or a bank check manufacturer. First rights are more restrictive than onetime rights, which are most often used for stock pictures.

Distribution Rights. Distribution rights define where the publications in which your pictures appear may be distributed. These rights often concern language or geography. For example, a book may be licensed for sale in English-speaking countries, or a poster may be licensed for distribution in Canada only.

Promotion Rights. Promotion rights allow a publisher to promote your magazine story or book by giving the pictures to reviewers or inserting them in ads. When the book is your own, you usually don't charge for promotion rights. However, it is customary to charge for use of your pictures in ads for a specific issue of a magazine.

Electronic Reproduction Rights. Electronic reproduction rights, covering such electronic use as still photographs sold or leased for television use, can also be limited. Specifics may evolve according to the medium and rates may vary, but the practice of retaining ownership of your images is precisely the same as for printed materials.

Buyouts or All Rights. Buyouts usually mean a complete transfer of all rights to photographs from the photographer to the client, including copyright. Buyouts can also mean a transfer of specific rights, rather than all rights, or of all rights for a limited time or area.

An all-rights agreement to sell all rights to a client means a transfer of limited rights, but not a transfer of copyright. The terms "all rights" and "buyout" are sometimes used interchangeably. Be sure that if your agreement, invoice, or purchase order specifies all rights, it stipulates that some rights and/or copyright are reserved for the photographer.

Disclaimers. It is poor business practice to sell all the rights to pictures unless they seem to have little or no residual value or unless payment will be especially high. (See the discussion of work-for-hire.) Keep in mind that in the advertising field a buyout may be designated as a "flat payment," and may require you to turn over all slides and negatives to the buyer. It may also mean selling extensive but limited rights: the original pictures will eventually be returned to you. Some advertisers claim to want all rights so pictures commissioned for them will never be used in other ads, especially those of competitors. However, your assurances about that eventuality can be covered by a proper agreement drawn up for the assignment.

Sneaky deals. Photographers new to editorial, advertising, or book publishing may be asked for all-rights, buyout, or work-for-hire deals, and may agree to them out of ignorance or in an effort to please the client. Photographs for a magazine may then end up as posters or in ads without additional payment. Buying all rights for the price of limited rights may be good practice for clients, but for the photographer, selling all rights for the price of limited rights is, of course, dubious charity.

Clients asking for all rights or a buyout may ask you to sign a work-for-hire agreement. This is closely related to a buyout. When negotiating any of these cases, point out that all rights and the higher fees involved are unnecessary; offer to protect the client from unauthorized usage in more acceptable ways. Try to explain that as a self-employed person, you must make sure that your creative work is available for display, books, and sales to noncompetitive markets.

Check legends. Occasionally, an all-rights arrangement sneaks up on you via the legend on the back of a check, which is a surreptitious place to write a contract. You may find a rubber-stamped message, such as: "The undersigned warrants that the work paid for by this check is original, and that the buyer is hereby assigned all rights to the material described on the reverse of this check. Signature to this agreement is a condition of payment." I have received such checks even when the publisher was happy with first rights and had already returned my pictures. Had I signed the check with the legend intact, I'm not sure whether my rights to my photographs would have been taken or not. I crossed out the offending words.

Before endorsing such a check, send it back to the company with a request for another one without the legend or cross out the entire legend and cash it. Complain to the editor or art buyer if you wish, though this is not necessary. You are simply refusing conditions you didn't agree to in the first place. If you are in doubt about the legalities, consult an attorney. Explain that limited rights were agreed upon and stipulated on your invoice, and that the check legend represents a one-sided contradiction. If you have not sent a bill, do so and date it at the time the pictures were delivered. It may state: "First

rights. All prints/slides are leased for _____ months and must be returned to the photographer as a condition of this sale." There is no reason to be victimized, especially when a check legend may undermine arrangements you negotiated in earnest.

WORK-FOR-HIRE

"What if you woke up one morning and found that all your work was stolen? And then discovered that you had no right to recover it? Well, it's happening! It's *work-for-hire* and it's spreading."

So read the copy on a Graphic Artists Guild (New York) poster announcing hearings in the United States Congress about work-for-hire contracts. Work-for-hire, a shorter version of work-made-for-hire, is a provision in the copyright law through which ownership of photographs, including copyright, is purchased or assumed by an employer, by a buyer who commissions a freelance photographer to do a job, or by one who buys all rights to a stock photograph.

Work made by an employee. The copyright law states that if you are hired as an employee to take pictures, are paid a salary, and receive such benefits as insurance or sick leave, your employer owns the pictures you take and the copyright thereto. Your employer doesn't even have to give you credit when the pictures are published. The work-for-hire clause was conceived mainly to cover the employee-employer relationship.

A collective work. The copyright law also states that pictures commissioned or leased "as a contribution to a collective work," if both parties agree to this in writing, are considered work-made-for-hire. The term "collective" was meant to cover use of photographs that are part of a movie, an audiovisual display, or an instructional text. You may find that magazine or book publishers try to take advantage of photographers by misinterpreting this section of the law.

Work-for-hire abuses. In place of an all-rights or buyout agreement that may cover a limited time and exclude transfer of copyright to the buyer, clients in advertising and editorial media may press photographers to sign work-for-hire agreements. If you do so, you will lose copyright and ownership of your pictures. You will also run the risk of receiving no credit line and will have no chance to resell rights to pictures for additional income. The only consolation is that you should receive a great deal more money than you would if you leased limited rights.

Work-for-Hire in Advertising. For years photographers have been advised by knowledgeable legal counselors that advertisements are neither collective works nor compilations as defined by the copyright law, so they do not fall into the category of works-made-for-hire. Nevertheless, if you sign a work-for-hire arrangement covering an advertising photograph, you are signing away your rights.

In the mid-1980s, photographers and graphic artists united to try to influence the United States Congress to modify the work-for-hire section of the copyright law, to prevent it from being misused to pressure creative people to give up rights without gaining worthwhile benefits. Unfortunately, advertising agencies have been advised by their own trade associations that the copyright law gives possession of the copyright to photographs to the advertiser or agency that commissioned the work. A few preliminary court cases have caused a deterioration of photographers' rights, which are slowly being restored by the courts. It is clear that improvements in the copyright law are necessary.

A different type of attempt to help combat the dangerous inroads of work-for-hire has been made in California. There, if a photographer signs a work-for-hire agreement, he or she is temporarily an employee, and all benefits, such as workers' compensation, health insurance, and vacation pay, accrue to the photographer. The red tape and paperwork involved in covering a photographer as an employee for a short period help discourage work-for-hire requests.

As of this writing, ASMP and a coalition of other organizations received an interesting notice from a legislative specialist working on ways to refine the copyright law. In essence, media photographers were told that the types of commissioned work that can be considered work-for-hire, if the parties agree in writing, actually fall into the editorial photography category. None of the categories defined in the law states or implies anything about images created for advertising. But the ad agencies continue to present photographers with work-for-hire agreements. As ASMP's legislative specialist states:

> The advertising industry's reliance on work-for-hire agreements is wholly unauthorized under present law, because advertisements are not one of the categories enumerated. . . . Yet the advertising industry increasingly forces these *illegal* [italics added] work-for-hire agreements on independent artists.

Clearly, the law that was supposed to protect photographers has been misinterpreted by the courts, where work-for-hire decisions are not based on the actual law, and independent photographers have been victimized.

To preserve your own rates and rights, as well as your sense of well-being, remember that a majority of people in the media world do understand the true intent of the copyright law. You own the copyright to your work unless you are a salaried employee or you sign your rights away.

RIGHTS QUESTIONS AND ANSWERS

Question. What is the main reason ad agencies and other clients say they want work-for-hire agreements?

Answer. They do this to prevent photographs taken for one company from being used by a competitor. However, these agreements are often a smokescreen for clients trying to obtain all rights so photographs can be used in multiple applications with-

out additional payments. Most photographers are happy to restrict resale of pictures so those shot for one client are never sold to a second user whose business may be considered competitive. Such provisions can be written into contracts and agreements.

Q. Where can you get a contract for selling photos?

A. ASMP has an assignment confirmation form (this can be found in the Appendix). It serves as a suitable contract. APA also provides photographers with a confirmation form. There is space on these forms to type a description of the job, intended uses to be leased, fees and estimated expenses, date and time of the job, and other applicable terms. Standard terms and conditions are on the back. Both the photographer and the client sign the agreement.

Q. Is an oral agreement with a client binding?

A. In some states no oral agreement is binding. (Check with an attorney in your area.) In those states in which oral agreements are binding, they are difficult to enforce. Even if time is short, it is imperative that you confirm the essentials of an oral agreement in writing before shooting a job. If your summary of terms and conditions is not fully acceptable, find the time to negotiate an agreement. This helps reduce pressure on yourself and the client, and increases the goodwill between you.

Q. What should you do if you have to shoot on short notice and have no time for all the paperwork?

A. If a client representative, art director, or editor is at the shoot, have an agreement signed there before shooting. If no client rep will be on hand or the assignment was given to you over the phone, send the confirmation agreement that states your fee and the rights previously agreed to via messenger or overnight delivery to your client contact. Ask the client to call you with a confirmation as soon as the agreement is received. Explain that you cannot start to shoot until you have a mutually acceptable deal, and ask that the signed agreement be returned to your office immediately, either by messenger or overnight delivery.

Q. What is the best answer to give a client who wants a work-for-hire arrangement?

A. If the client says, "I'm paying for the work, and I feel I'm entitled to use the pictures where and when I wish," state that your fee has to be much higher under such circumstances. You must charge three or four times more than you do for onetime rights in order to cover unknown, additional usage of the pictures. Explain that this makes work-for-hire costly and that it is unnecessary. Extended rights can be arranged and licensed when they are needed, and if they're not needed, the client saves a great deal of money.

Q. What should you do about a purchase order that includes a work-made-for-hire clause?

A. First, talk to the client as suggested above and discuss, in a friendly fashion, all the rights being negotiated. If you have already made an agreement about rights and the purchase order includes

work-for-hire to which you didn't agree, call the client or write a note explaining that you have deleted objectionable terms, and then sign the order. The client should not complain if work-for-hire was not intended.

Q. What if a client can't or won't tell you where or how the pictures will be used? How can you determine a price?

A. It is difficult to agree to an arrangement if you don't know what media usage you are granting; fees are based in part on extent of usage. Offer an estimate based on the limited data you can discover. Base your fee on onetime use and make a note that when the client decides on its full needs, you will negotiate additional payment.

Q. What do you tell a client who claims the concept for a photograph came from the company's art director, so his or her creativity is on the film as much as yours is?

A. Tell the client that you made the actual photograph, that the picture is what you're charging for, and that it is covered by your copyright. The idea or layout for the photograph is not the photograph itself. A photograph is an idea interpreted by you through a camera. It is a creative expression that you own, while the client may take credit for describing what was wanted.

Q. How do you answer this question: "If the photographer doesn't have to do any more work, why should he or she be paid more money when pictures are reproduced in more than one medium?"

A. Reply that the more ways a photograph can be used to profit the client, the more valuable it becomes and the more a photographer has the option to charge for it. Draw a parallel between a photographer and a novelist whose royalties increase with the sales volume of a book; mention that the writer receives additional money if the book is also put out in paperback, even though it didn't have to be written again.

CASE HISTORIES

Photographers' rights are eroded in various ways. The following case histories reveal two of them.

Case History Number One. This is an uncomplicated story that combines certain problems we all may face when trying to define and protect our photographic rights.

Tim, a photographer who has been in business for five or six years, is doing well. One day a friend who has written her first book calls. "Anne Author" wants Tim to take her picture in an outdoor setting for use on the book jacket. The situation would be the same had the author been a stranger. It's a relatively easy editorial portrait, and Tim and his friend agree on a price for jacket usage plus expenses.

The author loves Tim's pictures and asks for two prints each of four different enlarged negatives. She pays Tim soon after receiving his bill, which states the following:

Photography of Anne Author for book jacket only $ ____

Film and processing ____

8 prints at $____each ____

Mileage ____

Note: Credit line and copyright symbol with date must accompany photograph on jacket. Additional use of photographs may be negotiated.

Tim insists on the copyright notice because a book copyright itself doesn't protect jacket photographs. When Anne's book is published, Tim receives an autographed copy. The jacket photo is nicely displayed, with credit, copyright, and date.

A week or so later, however, Tim notices a newspaper ad for Anne's book, and in it is another of his portraits of her, also carefully credited and copyrighted. He telephones Anne and explains his surprise in seeing the ad photo: no such use of his work was included in the fee he had charged. "I'm sorry," she says. "When the publisher asked for another picture of me, I just sent it along. The publisher said you would be contacted about further payment. In fact, I think the publisher copied another one of the photos to send out to reviewers."

Luckily, Tim noted on his bill that use of his photographs was restricted to the jacket, and that additional rights could be negotiated. He sold Anne four variations of her portrait theme so she could have a choice, not for multiple usage. In truth, Anne is responsible for payment because she made the arrangement with Tim and gave the publisher the prints now being used on her behalf.

Tim explains to Anne that he will contact the publisher to complain that his photographs were reproduced without authorization in ads and that he never gave permission for any of his pictures to accompany review copies of the book. Tim tells Anne that she is responsible, but that he will try to get the additional payment from the publisher, who benefited. He tells the publisher's business office that Anne didn't understand photographers' rights; the representative admits that the company never asked about Anne's deal with Tim. Tim then negotiates a fee for additional rights that is higher than the amount he charged Anne for jacket usage. He asks to be notified if the publisher wants to use more of his pictures later.

The people Tim worked with were enlightened and realized that additional use of photographs requires additional payment. Tim's friend Anne was naive, but Tim was smart enough to give her a precise bill. Some authors might have asked Tim not to make waves with a publisher about more money. Others may have elected to pay for additional rights themselves. Some publishers might have brusquely asked Anne to pay Tim, knowing that many first-time authors are willing to do almost anything to please.

Within three months of the book's publication, Tim registers the copyrights of all his photographs to Anne. He sends proof sheets as well as the jacket, and copyrights the whole take.

This story illustrates the precise attention you must give to specifying rights. Accidental or intentional misunderstandings will occur, but you can resolve them in your favor if you have prepared thorough agreements and invoices. Even if Tim sold the pictures directly to the publisher and stipulated rights carefully, he would have been wise to monitor the pictures. He would not have been looking for problems or dealing with large amounts of money: he knows that an unethical client might overuse his pictures and offer him nothing—unless he finds out. This is a main reason to copyright your pictures before delivery. Once they are registered, you can collect monetary damages for unauthorized use.

Photographers can be victimized through their own ignorance or negligence. As you get smarter and more experienced, you should continually try to educate clients tactfully. Those who pay for your services are usually very definite about what they expect from you. Your expectations of them should be equally clear.

Case History Number Two. Elaine is an advertising photographer. An agency asks her to photograph an experimental farm, an ultramodern setup that is the pride of its client, a bank that lent money to a group of farmer-businessmen to develop the farm. The bank wants to show potential clients how progressive and wise its lending policies are. Elaine agrees to shoot a minimum of six horizontal pictures for use in bank ads in *Time, Newsweek, U.S. News and World Report*, and *Forbes* over a six-month period.

"We may want to convert a shot or two to black and white for a couple of trade magazines," the art buyer tells Elaine, "but we'll discuss any additional usage fees later." Elaine's color fee for six ads in four magazines is quite satisfactory, and she's delighted that the client seems enlightened about rights. She will certainly make the pictures available later for trade ads, and after nine months she will be able to offer the color as stock to agricultural markets, which offer no conflict with the bank.

Before Elaine photographs the farm, the agency's standard purchase order arrives by messenger. It includes a preprinted clause that states that the job is "a work-made-for-hire." Following the advice of the American Association of Advertising Agencies (AAAA), this agency incorporates a work-for-hire clause in all its purchase orders, whether or not that is the deal that has been arranged.

Elaine calls the art buyer and points out that the purchase order is clearly inconsistent with the agreement she made with him. He apologizes and tells her to strike the work-for-hire stipulations. She does so and gets on with the job. The pictures are beautiful. The client is happy with the magazine ads, and later Elaine has a few black-and-white pictures made for trade magazines. Even with the extra fee, the agency paid much less than it would have in a work-for-hire arrangement. Eventually, Elaine sends out stock shots of the farm for additional income.

Remember: Read all the fine print. Stand up for your rights, and you'll be respected.

SUMMARY Creative people in all fields face the same types of problems about ownership rights. They expect to be compensated for each use of their work, while some clients feel that one average payment covers all usage. When the revised copyright law went into effect in 1978, photographers thought that their dreams had come true at last: they owned their work unless they chose to sell all rights rather than lease them in a limited way.

Then, in the early 1980s, business took a dive. Buyers of advertising photography in particular, but some editorial clients as well, decided that work-for-hire was the answer to their dreams. They were quite willing to ignore the residual rights photographers were entitled to. "Give us all rights or we'll find someone who will," photographers were told. Members of ASMP and APA were briefed about how to deal with all-rights or work-for-hire arrangements. Much of the advice they received is included here.

The battle has now been taken into the United States Congress, where it is hoped bills will pass that will confine work-for-hire to salaried employees and certain collective works only. Legislation is the only positive, longlasting solution to the work-for-hire problem. Photographers should not be automatically pressured by a few courts' decisions about a copyright law that was revised to help them. Clearly, clients should not have an unfair advantage. Photographers should be considered either employees with all the benefits thereof, or independent contractors who own their work and have the right to make business arrangements to protect themselves.

Learn about the latest legislation through photographers' associations and their newsletters. Your rights may have been undermined since 1978, but you can only protect your rights if you are informed.

5

Editorial Photography

An editorial photographer works mainly for magazines, newspapers (in this context as a freelancer, not a staffer), books (covered separately in Chapter 9), and similar print media. Editorial photographs are published primarily to inform, while advertising pictures are used in purchased space to sell products and services. The editorial category includes photojournalism, photographic illustration, and feature photography. Additional media for editorial pictures are informative brochures (rather than advertising brochures), theater programs, personal portraits for publicity, and other types of visual reporting.

Most editorial photography is intended to be reproduced in print. Related photography with a separate pricing structure is produced for the electronic media, which is the nonadvertising portion of television. These markets are targeted for educational television, for titles in commercial television, and for allied documentary and decorative uses. Production of educational television filmstrips and other editorial photography continues to be small, but data about shooting for television can be found in the *ASMP Book*. (Rates and rights concerning television are covered in Chapter 8.)

MAGAZINE PHOTOGRAPHY FEES

Because magazine photography techniques have long been applied to periodical and newspaper reporting and illustrations, and similar forms of visual communication, magazine fees have become a pricing standard for related media. Variations of the fee structure are applicable to photography for news events, feature stories, sports stories, editorial portraits, food illustrations, and other informative photography. Whether your client is a magazine or a symphony association, fees for these assignments are based on day rates or space rates, according to a publication's policy or, in the case of a business client,

day rates or job rates. Fees for photography for public relations purposes and for brochures tend to be higher than other editorial photography fees.

In the editorial field, charging per picture is rare. Even if a client indicates only two pictures are wanted, such as one portrait of a company president and another of the executive committee around a table, a photographer is likely to quote a job rate or day rate. Charging by the picture is more practical and more common in advertising and commercial photography.

Editorial Day Rates. Since the early 1950s, when ASMP adopted its first Code of Minimum Standards with a suggested day rate of $100 for magazines with minimum circulations of 250,000, ASMP's day-rate figures have been influential in the media photography business. ASMP surveys show that over the decades, the basic day rate offered for editorial photography has steadily increased, but not in pace with inflation.

As a basis for editorial fees, magazine day rates are always compared to space rates, and the photographer is paid whichever is higher. For example, if you charge $400 a day and work two days, you may bill $800 on delivery of the pictures. If, however, those images are used on three pages of a magazine that pays $300 a page, you bill another $100 upon publication because the fee due you on a space basis is higher. This is a common practice well understood by magazine editors.

This advice is based on selling first or limited rights only, for a specific period. Magazines often want a year in which to publish the photos. Your opportunity to resell photographs may begin soon after publication, depending on the nature of the pictures. Should a client want exclusive rights after publication for six months, a year, or even longer, the guide to usage rights and fees suggests charging an additional 50 percent to 100 percent. When photographers negotiate such fees, they usually base their business practices on their own experience and research. (You may wish to review the material on day rates in Chapter 3.)

Average editorial day rates. In 1985 ASMP surveyed its general members, those with three or more years of experience in the field, using a careful scientific method designed by a professional research firm. Besides inquiring about photographic fee structures, the survey solicited information about various business practices; the pertinent data is incorporated into the fourth edition of the *ASMP Book*. "The prices charged, according to the survey, vary substantially in different regions of the country," notes ASMP, adding that survey prices should not be rigidly used "as a guide to pricing." ASMP gathers information but does not establish minimum or maximum fees: it is a trade association and cannot do so legally. Thus, from ASMP surveys comes a wide range of fees.

By averaging these survey figures and those found through other research, you will be able to make your own determinations about approximately what to charge for any given job. Check the pricing survey, talk to colleagues, read business magazines, and rely on your own experiences. Also, consider the specific details of each job and combine various recommendations for a good foundation for pricing. Since professional fees have not changed rapidly during the 1980s, the 1985 survey results are generally still valid.

THE 1985 ASMP SURVEY: EDITORIAL DAY RATES

For news and general feature magazines:
34% charged less than $350 per day
55% charged between $350 and $750 per day
11% charged more than $750 per day

**For news and general feature magazines,
with less than two hours of shooting:**
77% charged less than $350 per day
18% charged between $350 and $750 per day
 5% charged more than $750 per day

**For specialty magazines, such as fashion,
architectural, and women's:**
14% charged less than $350 per day
60% charged between $350 and $750 per day
26% charged more than $750 per day

For corporate publications and certain house organs:
 8% charged less than $350 per day
58% charged between $350 and $750 per day
34% charged more than $750 per day

For trade books and textbooks:
21% charged less than $350 per day
56% charged between $350 and $750 per day
23% charged more than $750 per day

Note: Percentages were based on the number of members responding in each category, which in some cases included more than 900 respondents, and have been rounded off.

Sometimes establishing fees is easy, based on what a magazine or business client is known to pay; other times you have to suggest a fee and be prepared to negotiate. Photography is like any other business in which you learn and grow through success as well as through error. The photography fees in the chart above may seem excruciatingly general, even vague. If you are relatively new to the business and you

receive an assignment within any of the categories listed, look first at the fee charged by the greatest number of respondents. Ask the editor or client representative if the publication or company offers a specific day rate; compare the fee the publication offers to the rate you might charge based on the survey. Consider these factors also:

- The size and type of client and its ability to pay should be consistent with the day rate it offers. For instance, a regional magazine with a circulation of 75,000 is unlikely to pay as much as a national magazine with a circulation of 2,000,000. However, a corporate publication may pay a higher day rate than some magazines with smaller circulations do because the promotional value of the photography is more important to it. (The advertising page rate of the average magazine is usually not a valid indicator of what editorial page rates should be. A magazine that charges $30,000 a page for a color ad may pay the same editorial page rate to photographers as one that charges $25,000 or less.)
- If a day rate quoted to you by a prospective client seems too low, suggest, "My usual day rate for that type of work is ____," and state what you feel is fair. If the increase is relatively modest, you'll probably get what you asked for. However, if a client is looking for bids and wants to shave the budget under the recognized minimum fees, you may have to gamble. Ask more, and be refused. Ask less, and be accepted, exploited, and resentful. Ask more, and get it. It is well known that many people feel the more they pay for something, within reason, the better the quality of the product or service. There's a psychological sense of well-being when you can afford more expensive things, but they must be of top-notch quality as well. Keep in mind that confidence in yourself stemming from success is also an excellent bargaining chip.
- The fee you charge should reflect your experience and reputation. Obviously, a well-known photographer can command a higher rate than someone who has only a few years in the business. At the other end of the spectrum, it is unprofessional to charge a fee much lower than you believe is average just to undercut the competition. Such a practice will come back to haunt you. Reasonable clients learn that a photographer who charges at the low end of the scale, when a higher rate is expected, may be worth less, or worthless.
- Sensibly, a photographer's day should be no more than eight hours long, with time for food and rest breaks. However, editorial assignments often call for irregular divisions of time. A day may be split to take advantage of the light, beginning at dawn and ending at night with an idle gap in the middle. A day may be stretched when you have to travel to shoot parts of a job on separate locations or when a job includes lots of waiting time. Learn to interpret the length of a photographic day for purposes of payment according to good sense and your own convenience. If you start a job at 8 A.M.,

change sites, wait for people or for light, and wrap up the shooting at 8 P.M., charging for 1½ days is legitimate. Try to anticipate and discuss these conditions before doing a job, especially with new clients. In that way you can operate in good conscience about adding to your fee for delays caused by others.

- An assignment that takes no more than two hours, including travel time, and from which only one picture will be used, should be charged as a half day—though the space-rate payment may be higher. The practice is to charge roughly two-thirds your day rate. For example, if your day rate is $400, you might charge $250 or $275 for a half day. However, if you shoot a job in a few hours and the client uses a number of pictures, charge the full day rate. Explain to any reluctant clients—especially business clients unfamiliar with day-rate practices—that if circumstances allow covering a number of situations in a short period, the value to the client is the same as it would be had the job taken all day.

Editorial Job Rates. Editorial assignments for magazines, among other clients, may be paid for on a per-job basis. To arrive at a fair fee, you have to estimate the time involved as well as the complexity of the work and, based on your day rate, quote a figure for the whole job that can be spread over a period of time. Since underestimating a fee is risky and estimating too high a fee will annoy the client, try to build some flexibility into the arrangement.

A job rate may also be predicated on the number of pictures the client wants. If you work two days at a rate of $500 a day and are expected to deliver one usable picture from each of sixteen separate situations, you will receive only $62.50 per shot. Such a fee might be suitable for uncomplicated photography, but is much too low for photography for some clients. You may decide that $100 or more per shot is more equitable, and charge accordingly. A great deal depends on the client, the amount of circulation the pictures will get, and the difficulty of the photography.

Editorial Story Rates. Some magazines pay for photographs, captions, and a written story on a package basis or story rate. Usually, they pay a certain amount per page or per photograph for the pictures and another sum for the words. By adding the two and coming up with a total based on selling a minimum number of pictures, you can decide if the story rate will be equivalent to your day rate for the time spent. If more pictures are used, your fee for the job rises. If writing isn't a strength, suggest having a writer assigned to the story.

AGENTS AND AGENCIES

There are three categories of agencies and agents:

- Assignment agents for editorial photographers
- Advertising photographers' representatives (reps)
- Stock-picture agencies

To some photographers, trying to sell themselves and their work is anathema. Their talents and personalities are more adapted to dreaming up ideas, shooting, and post-production activities. They don't enjoy trying to convince potential clients. These individuals may be better off working through an agent or an assignment agency; both sell ideas, get assignments, may help package the pictures, send the bills, collect fees, go after deadbeats, and may make advances on the photographer's expenses.

The oldest assignment agency is Black Star. Others include Contact Press, Sygma, Gamma-Liaison, and Camera 5. Some agencies, such as Magnum, are owned by the photographer members they represent, and some have a limited roster of photographers in the United States and abroad. Today, the best assignment agencies represent well-known and less-well-known photojournalists. In most cases, the photographer and agency have a contract. The agency sells ideas, completed pictures, or stories, and seeks assignments. Agencies may not choose to represent newcomers, but by all means approach any that interest you and try to show your work.

There are also some individuals who represent a limited number of photographers. They operate the way a picture agency does, but on a smaller scale. Such individuals work in ways similar to photographers' representatives in the advertising field, but their product and clients are different. They may offer more personalized services than a picture agency may, but an agency may have broader contacts. For more information about picture agents and agencies, refer to ASMP's *Stock Photography Handbook* (see the "Suggested Readings" list). Study the listings and read the background material: more than just stock-picture agencies are covered.

Needing an agency. The question of whether or not you need an agency is probably academic in the first few years of your editorial photographic career. Most established agencies and agents don't have the time or resources to guide beginners through their early years. This is not necessarily negative. Through your own preliminary training period in the business and craft of photography, the skills you learn on your own will be the most valuable. In time, your style and experience can make you attractive to an agency and in turn, you will be able to evaluate more accurately whether an agency is right for you. Then, once you are connected with an agency, past experience will make it easier for you to tell if it is doing an adequate job representing you.

On the positive side, you can expect these advantages from agents or agencies:

- They certainly will negotiate with clients, which you may find awkward.

- They can sometimes ask for more money than an individual photographer might ask.
- They maintain a rapport with most prominent clients.
- They are familiar with markets you may never hear about.
- They may help you develop ideas and make arrangements to shoot jobs.
- They may advance you expense funds, do your billing, and free up the time you might otherwise spend on clerical details.
- They resell pictures for you.
- They may do film processing, picture editing, and caption writing for you, giving you more opportunities to do research and to make new contacts.
- They "recommend" your photography through their affiliation.

While an agent or agency may generate jobs you might not have found yourself, keep in mind that the usual agency commission is between 40 percent and 50 percent. If that figure seems high, remember that at first you need direct contact with clients to gain experience shooting and to understand business variations. Later, you may be happy to pay the price for an agency affiliation, which helps you protect your rights and maintain acceptable fees.

PUBLIC RELATIONS PHOTOGRAPHY FEES

Various types of businesses and charitable and educational organizations have their own public relations departments or hire public relations firms to publicize and promote their products and services. The public relations department or firm hires freelance photographers to shoot pictures; the subjects of and the techniques used for the photography are usually similar to those of a general magazine job. I have done stories or shot pictures about computer price-code readers and chemical toilets on yachts, and have covered manufacturers' conventions. The material was included in various business and specialty publications, as well as employee newsletters. I have also created stories featuring budding television stars using certain products and sold them to magazines; I was usually paid by both the manufacturer's public relations department and the publication.

The more places that public relations pictures are printed, the greater the value to the client. Because your work is likely to have multiple usage, you can charge about twice your usual day rate for a public relations job.

THE 1985 ASMP SURVEY: PUBLIC RELATIONS DAY RATES

66% charged between $400 and $800 per day
32% charged between $801 and $1,600 per day
2% charged more than $1,600 per day

Note: Percentages were based on the number of members responding in each category and have been rounded off.

Since the average editorial day rate was between $350 and $400 at the time the ASMP survey was taken, a fee of $700 to $800 per day for public relations photography is consistent with the suggestion to double your magazine rate when you work on a national public relations job. There are local and regional public relations campaigns for which charges will be less than double your day rate but more than the day rate itself.

Usage rights. A photographer's basic fee should cover use of pictures in press kits, brochures, newspaper editorial space, trade publications, television, and local poster display. The client may use pictures "normally for the life of the event." Such events include a regular ballet season, a book promotion tour, or a publicity campaign with a time limit. Excluded usually are advertisements, album covers, or other paid-for space.

Credits. Photographers should arrange that all public relations pictures offered to whatever sources be credited to them, and that their name and copyright notice should be on each slide or print. This is good advice; however, even though you stamp every print or slide, there's no guarantee that the publishing source will include your credit. Most public relations clients will question your request for credit and copyright because they can't enforce the requirement on publications. Talk to your client but expect anonymity.

Return of negatives and slides. If you must lend negatives to a public relations client, be sure to arrange for their return after use. Preferably, have prints made yourself, and keep the negatives in your control. As for color slides, if dupes are made for public relations distribution, arrange to oversee their production to be certain of quality and to know how many dupes will be circulated.

BROCHURE PHOTOGRAPHY FEES

Pictures for brochures and other published materials are done either on an editorial basis or for advertising. An example of editorial photography: hospitals hire photographers to take pictures of their activities, personnel, and facilities. In part, the images are used to illustrate attractive brochures, which are given to patients to promote the hospital. Brochures fall under the corporate/industrial photography category in the *ASMP Book.*

THE 1985 ASMP SURVEY: BROCHURE DAY RATES

40% charged less than $800 per day
54% charged between $800 and $1,600 per day
 6% charged more than $1,600 per day

Note: Percentages were based on the number of respondents in each category and have been rounded off.

Higher day rates for brochure photography can be justified because brochures are a cross between editorial and advertising material. An example: a sales brochure for a vitamin and food supplement company showing its farms, crop processing, manufacturing, packaging products, and closeups of the products themselves. This kind of brochure is given to customers and sent to prospective customers. Photography fees are based on those for advertising (see Chapter 7). A day rate of $1,250 to $3,000 is the average range for an advertising brochure; the fee is determined in part by regional or national distribution. A job rate based on the time estimated to shoot all the pictures is also feasible. Advertising photographs for a brochure may be the same as those made for ads, or they may result from additional shooting at the same time or after the advertising job is done.

FLUCTUATING FEES

To many photographers and clients alike, the fluctuations and vicissitudes of conditions and pricing in the marketplace may seem like variations on *Alice in Wonderland*. Fees mentioned here (and in the *ASMP Book*) can seem valid or unreal, according to the city or section of the country in which you live. Commercial photography prices vary in the same way, as surveys by many professional organizations show. In Portland, Maine, and San Francisco, the cost of living differs and the amount of competition varies; as a result, more new photographers gravitate to the West Coast. Other local factors account for fee differentials. For example, smaller towns cost less to live and work in, so photographic fees may be proportionally lower. Fees also reflect the quality of a photographer's work, but not always. Good reputations can be built on clever promotion, skilled advertising, and solid but uninspired photography.

You may also notice that, in the editorial field, page rates, space rates, and day rates tend to remain constant for too long. One reason for this is economic conditions: too many photographers compete for too few jobs, so those who work are less inclined to complain about static rates when they need the income and want the exposure in print. It's sad but true that many magazines boost their advertising rates considerably and neglect their page or day rates because they can get the photography they want without having to pay more.

When ASMP made its last survey of members, asking about rates, rights, and business practices, it found that more than half the respondents made a major part of their income from editorial and related photography. Slightly less than half the respondents made most of their living from advertising photography. Twenty-five years ago, advertising was a much less important area of photography, but it came on strongly in the 1960s. However, editorial photography and its ramifications are still the backbone of media work. Increases in editorial fees have not paralleled increases in the cost of living, but editorial rights seem easier to hold onto than advertising rights. If you intend to pursue editorial photography, the various markets available to you can inspire you indefinitely.

6

Annual Report Photography

A company's most important publication, an annual report necessitates striking, innovative images that represent the firm at its best.

Photography for annual reports offers a special challenge that pays very well and is sought after by top professionals. Most companies consider annual reports so significant that it is unrealistic for newcomers to media photography to expect to reach this level in their first few years of work. If annual reports appeal to you as a means of expression and opportunity for travel, study all the annual reports you can find and talk to colleagues. Be aware of the requirements more than the money. This holds true for both newcomers with limited professional experience and photographers whose skills are fairly well developed. It is important, then, that you charge appropriate fees and retain your photographic rights.

The Securities and Exchange Commission (SEC) requires companies issuing stock for sale to the public to publish an annual report stating their assets and liabilities. Small companies may compile pages of statistics and a few facts. Large companies use their annual reports as an extension of their public relations program. They satisfy SEC requirements with facts and data, and at the same time they promote the company and its investment potential to brokers and to the public through masterly photography and superior design. The annual report, therefore, is a primary promotion of the company image, as well as a way to inform readers about products, services, modernization, and other assets that help elicit investment response.

ANNUAL REPORT PHOTOGRAPHERS

Year after year, many companies produce elaborate, four-color annual reports on high-quality paper; this results in a significant need for visual variety, especially since the photographs often have to cover almost the same ground every year. Some companies use staff photographers, or local freelance, journalistic photographers to shoot annual report pictures. One school of corporate thought con-

tends, "We prefer our own people because they understand the company and its policies and production methods. They don't get in the way, nor make excessive demands, and they're on salary, so costs are reduced."

Company photographers often do distinguished work, particularly when they use initiative diplomatically. Their main struggles are with the status quo and with managerial types who are not motivated to help a mere staff photographer. Making arrangements to interrupt production in order to shoot specific pictures is a chore for both staff and freelance photographers alike.

To better deal with the very familiar scene a staff photographer faces, many companies hire annual report specialists. These may be top-notch editorial photographers and photojournalists whose forte is corporate/industrial photography. These specialists may also be advertising photographers, who do well shooting on locations because they can adapt to widespread manufacturing plants, high-tech electronic equipment, mixed lighting sources, and foreign countries in which the customs seem strange. Such flexibility is a key to successful annual report work. This type of photography also necessitates extensive, portable lighting equipment, electronic flash usually, and special lenses that the average photographer may not have.

Companies expect that the outside photographer—the freelancer with a fresh eye—will often be able to make very exciting pictures in mundane situations. Through the use of colored filters, wide-angle or long lenses, dramatic camera angles, multiple exposures, planned blurs, and other devices, a dingy place or routine process can be made to look almost glamorous. The pictures often have to symbolize the quality of a company's products and services to make the company more appealing to current and prospective stockholders. Annual report photographers must have a talent for improvisation and must make the obvious seem unusual.

Travel requirements. Since major company plants, divisions, and subsidiaries are often spread across America and abroad, annual report photography involves extensive travel. I know of two annual report specialists whose work has taken them to Belgium, Korea, Canada, Italy, Alaska, and Japan—among other places—during the past year. They have to select their equipment for versatility and pack it for safe passage by plane, to arrive when they do. "I try to keep all my cameras, lenses, and film with me and my assistant," says expert Ken Whitmore. "These are the irreplaceable items."

ANNUAL REPORT THEMES AND DESIGNS

While some annual reports are designed by a company's advertising or public relations department, major reports are ordinarily designed by firms that specialize in such work. The designer usually chooses a visual theme to distinguish this year's report from preceding ones. For instance, in a report I photographed a few years ago, seven full-page pictures were tied together because the foreground of each was

out of focus. In another report done by Ken Whitmore, the lead picture for each plant or department featured foreground details to dramatize such themes as computers, production machinery, and activity within a division. Whitmore used a 21mm lens to achieve the designer's visual theme of pictorial distortion.

Just as an advertising photograph or magazine illustration may be designed and photographed to fit a theme or to offer a strong visual message, annual report images are almost always shot to appeal to the eye. The facts and statistics in such a publication are often dry, but are laid out attractively. The photographs are meant to beautify an annual report and make it distinctive, year after year. To this end, annual report designers are an integral part of the final product and often work side by side with photographers.

The repetitive need for annual reports is a principal reason why experienced photographers are chosen by design firms, which consult with their corporate clients on photographer selection. Photography subjects, which vary, include executive portraiture, individuals and groups, interior and exterior shots of plants and offices, production activities, and slick still-life setups in makeshift on-site studios.

ANNUAL REPORT PHOTOGRAPHY FEES

Corporate annual report work is usually done on a day-rate basis. The photographer, designer, and company representative estimate the number of days it should take to shoot the required pictures, most of which are planned in a layout by the designer. Also estimated is the number of travel days, which are charged for "from a full day rate to 50 percent of the usual day rate, depending on the circumstances," according to the *ASMP Book*.

The book also offers this practical advice: "Travel to an unusual place where the photographer may be able to obtain good stock material should be considered when pricing travel time." If you can negotiate such a schedule, whereby you stay an extra day or two in a location to shoot stock photos that could have future value, you could offer a travel-time rate that is less than your usual day rate.

When considering the fees below, keep in mind that working in many plants and facilities is often difficult, and considerable preparation is involved. Furthermore, there could be resistance to your presence; the company will probably help neutralize this. Many annual report photographers hire an assistant whose fees and expenses are reimbursed by agreement with the client.

THE 1985 ASMP SURVEY: ANNUAL REPORT DAY RATES

27% charged up to and including $800 per day
67% charged between $801 and $1,600 per day
 6% charged more than $1,600 per day

Note: Percentages were based on the number of members responding in each category and have been rounded off.

As noted, annual report work often includes a lot of travel; scouting and evaluating locations for the best shooting spots; delays for production and preparation; long hours to shoot dawn and sunset pictures; and meticulous placement of camera and lights, which may take more time than related editorial jobs might. When you consider charging $1,200 or $1,500 a day, remember that the annual report is a company's very important, best-foot-forward publication. As such, its budget is usually high to ensure hiring talented photographers and designers, as well as getting the best color separation, paper, and printing. Although annual reports are the cream of editorial photography because they pay well and offer potential stock opportunities, rarely is a photographer credited in an annual report.

ANNUAL REPORT PHOTOGRAPHY AND YOUR RIGHTS

Good practice indicates that the fee charged cover the use of your photographs in an annual report only, and that additional payment be negotiated for use in brochures, advertisements, and elsewhere. You may want to allow the use of a few pictures in an employee newspaper, for example, because minor corollary publication is a small concession. Specific restrictions on publication should be included in the agreement, along with provisions for negotiating additional fees to cover further uses of annual report pictures. Your agreement should prevent any uncompensated use of photographs taken for one year's annual report in future reports. By all means, make available pictures taken for earlier reports, but arrange payment for them separately.

To help ensure that your photographs are only used in ways agreed upon, it is important to have all transparencies and negatives returned to you within thirty days of publication of the annual report. Your contract or agreement can specify the methods you arranged to make the pictures available in the future to the client.

In addition, you should make a commitment to the client, probably through the design firm with which you're working, to govern further use of pictures shot on the annual report assignment. Use the following terms as guidelines:

- No pictures of a plant, or anything that could be identified as part of a company's operations, will be offered for sale for a given period, such as six months after the report appears.
- You may agree that some pictures, specifically of the company's products, services, or facilities, may not be offered for sale at all, or offered only in ways that no competing company would have use of them. Your use might be restricted to editorial space in books and magazines.
- You should not have to restrict your sale of any stock pictures taken on location on your own time, unless they pertain to the company. General shots of cities, the countryside, etc., in the vicinity of a client's plant or business would be yours for whatever use you wished.

SUMMARY

Study annual reports, which are offered routinely by many companies. In the financial pages of large city newspapers you may find offers for obtaining numerous reports because wide distribution of reports benefits sales of shares in the company.

Find out if there are design firms doing annual reports in your vicinity, and show your portfolio when you think you're ready. Ask plenty of questions when you are interviewed. In time, you'll discover when you're prepared for the specialized requirements and high day rates that accompany annual report assignments.

Finally, it is crucial that rights to the pictures be spelled out in writing before the job begins so you can avoid any misunderstandings. Restrictions on your resale of pictures should also be in writing.

7

Advertising Photography

This promotional shot for Kodak T-Max 100 film could be a successful advertising photograph for a musical instrument company. Such illustrations require creativity and a clear understanding of the client's needs.

If annual report photography seems to be a financially appealing way to earn a comfortable living, you will find advertising photography to be equally rewarding materially, though the average overhead is higher. Fees for advertising photography are relatively high because space in magazines, newspapers, and other media is expensive. However, if a magazine page costs $40,000 and the photographer gets $3,000 for an ad photo on the page, that charge is hardly exorbitant. Along with the potential for making large sums of money, advertising photography also includes certain tensions and insecurities unique to working with ad agencies and clients. Of course, it's a law of photographic creativity that high fees are accompanied by an elevated potential for ulcers.

While it's possible to conduct business from a home office when doing photography for magazines, books, or annual reports, the active advertising photographer usually needs a studio. The size of the studio and the amount of lighting and camera equipment in use depend on the photographer and how much business he or she generates. At first, unless you're wealthy, the studio and equipment are modest. Luxury comes later. I have read about individuals in business six years who are doing so well they spend $200,000 to build and equip sensational studios that will certainly impress clients and colleagues. I have also been in a few plush studios whose owners bill $750,000 a year or more to keep up their standard of operations. I admire these talented people, but don't envy them.

HOW AN AD PHOTO BEGINS

Although sales of stock photographs for advertising have increased dramatically in the 1980s, ad pictures are usually created to order. The advertiser has a product or service to sell and hires an ad agency to develop an advertising campaign that may continue for weeks,

months, or years. Many people are often involved. Some write the ad copy; some, such as the account executive, deal with the client directly; and an art director designs the ad. The art director, or an art buyer, then interviews and assigns photographers to specific jobs.

The art director usually envisions the kind of photographs needed for the ad using layouts called comps (short for comprehensives) and sketches. The layout is given to the photographer, who may be included in planning the ad illustration when the agency or art buyer realizes the contribution the photographer can make. How closely the photographer is expected to work within the framework determined by an art director depends on the type of account and the personalities involved. Occasionally, an exact transfer from sketch to photograph is required, but more often the agency encourages the photographer to interpret a layout according to his or her own style.

PHOTOGRAPHERS' CONTRIBUTIONS

Whether or not the requisites are strict, the photographer must be creative to translate the concept of a sketch into an effective photograph of actual people and objects within a setting. The skilled photographer is sensitive to nuances in a model's expression; in the interaction of models; in the placement of people and props; in backgrounds; and especially in the practical, subtle, and aesthetic handling of lighting. The photographer's taste and visual ingenuity are always among the important elements a client pays for. When a great deal of money is spent on ad space, the preparation for and shooting of ad pictures are also expensive; as a result, ad agencies and clients are, understandably, very particular about which photographers they hire.

BUDGETS, ESTIMATES, AND BIDS

Many years ago, an ad agency decided how much it could spend on photography, and when choosing a photographer, told him or her what the budget was. If the amount wasn't agreeable, the photographer negotiated to improve the fee. The need to come to agreement about money and other terms before shooting started was recognized early. Conflict was often avoided when photographer and client knew from experience to compromise in order to protect their mutual interest.

Predetermined budgets for advertising still exist, but in the spirit of competitive business, it has become customary on many jobs for ad agencies to ask photographers for written estimates, or bids, based on an art director's layout and full job specifications before an assignment is given. An estimate or bid puts the photographer on record about money, so there should be no misunderstanding later. But estimates and bids are not the same.

Estimates. An estimate, as noted in APA's *Assigning Advertising Photography*, is a photographer's projection of the approximate cost of an assignment based on initial information provided by the buyer. An estimate is expected to be a reasonably accurate, "careful calcula-

tion of costs, subject to change with approval from the art buyer," says one agency representative. According to APA, by industry practice an estimate may be subject to plus or minus 10 percent, though photographer and client may agree to other limits.

Bids. A bid, on the other hand, as defined in *Assigning Advertising Photography*, is a firm offer to shoot a specific assignment for a specific fee, and is usually binding on the photographer unless the client makes changes that are not included or described in the written specs. An art buyer describes a bid as "a fixed cost for a project, with no flexibility." This makes it very important for the buyer to give you precise requirements for a job and, if bidding is competitive, it is usually helpful for the assignment to be explained with all bidders present so everyone hears the same requirements at the same time.

At the average ad agency, however, only a portion of photography jobs are assigned competitively. "The rest are given to a unique talent that the art director feels can do the job," an art buyer explains. Furthermore, at some agencies, bids foster a tendency for agents to pit photographers against each other in an uncomfortable and sometimes degrading manner.

Comparative vs. competitive bids. There are two kinds of bids. In a comparative bid, the specifications for the photographs are submitted to perhaps three photographers, and the lowest bidder may or may not get the job. In a competitive bid, the lowest bidder always gets the job. This art buyer also notes, "One reason we ask for bids is to analyze how the photographer would approach the job. The art buyer and art director discuss costs listed in the bid and, while they are important, we choose the person we feel can best shoot the job we need done." Ordinarily, photographers are given specs for a job individually, but for some ad campaigns, the agency may invite a number of photographers to a roundtable session during which the job is described and questions are answered.

CALCULATING AN ESTIMATE

In order to put together a reasonable estimate, photographers need to understand the basics of advertising usage. The following information is from APA's *Assigning Advertising Photography*. Before drawing up an estimate, make sure you have the answers to these questions:

- What is the distribution: national, regional, or local?
- What's the specific or primary use of the photographs and what kind of ad or ads are involved: consumer advertisements, freestanding inserts, trade ads, billboards, transit posters, point-of-sale ads, direct-mail pieces, catalogs, packaging, television stills, photomatics (storyboards), research materials, test-market use, and artists' references?

- How long does the client want to use the pictures? This is often easy to resolve because the client usually buys usage for a specific period until the images are no longer needed or are supplanted.
- Are multiple usages intended, such as for magazines and posters? According to APA, "From the standpoint of the client, it is rarely efficient to buy out all of the rights to a photograph, or the underlying copyright itself." This is because the categories of usage "lend themselves to so many combinations" to fit so many advertising situations. Nevertheless, there are three major types of buyouts: a complete buyout (most expensive), a rights buyout (not as expensive), and a limited buyout (least expensive, but costs more than buying just specific rights).

ASSIGNMENT AND ESTIMATE FORMS

To make thorough and systematic estimates, many photographers use preprinted job confirmation forms designed by ASMP or APA (a sample ASMP form is reprinted in the Appendix). These forms are very complete, so you may have to ignore the spaces that don't apply to a particular job. Understand the terms and conditions you're asking for; these are printed on the back of the advertising form. If you have little or no experience with such forms, read about them in the *ASMP Book* or *Assigning Advertising Photography*, or read the explanation that accompanies the APA forms.

Following the estimate form is a production summary form that serves as a checklist of fees and charges and provides detailed notes about them (this form is also reprinted in the Appendix). The production summary form is optional and can be customized to suit your needs. Ordinarily, the ad agency sends the photographer a purchase order confirming the fees, expenses, terms, and arrangements agreed upon in negotiations. Whether or not you receive this purchase order, you should still send the job confirmation form to the client to protect yourself.

Billable expenses. In both the *ASMP Book* and *Assigning Advertising Photography*, you'll find lists of billable expenses and production charges for casting, talent (models), film and processing, assistants, stylists, rented equipment, props, wardrobe, set construction, studio materials, insurance, location fees, travel, lodging, meals, telephone, and messengers.

ADVANCE PAYMENTS

When an ad job is going to be expensive, and especially when the estimated production charges and other expenses exceed 50 percent of the creative fee, the client usually pays the photographer an advance to cover expenses. Normally, this payment is made before production begins, before you go on location, or before you start spending expense money. The theory is simple: if you put hundreds or thousands of dollars out of your pocket to pay expenses, or even charge some of them for a limited time, you are acting as a banker for the client. It is logical, therefore, that the ad agency (or other type of

client if a large job is an editorial assignment or an annual report) pay an advance against expenses to prevent your money from being tied up and your credit from being overextended.

ADVERTISING PHOTOGRAPHY DAY RATES

Based on the 1985 survey of ASMP's general members, many of whom have been professionals for a decade or longer, there is quite a spread in what clients are charged for advertising photography. Several factors are involved.

THE 1985 ASMP SURVEY: NATIONAL ADVERTISING AD RATES

For a spread in a consumer magazine:
42% charged less than $1,500 per ad
41% charged between $1,500 and $3,000 per ad
17% charged more than $3,000 per ad

For a single page in a consumer magazine:
49% charged less than $1,500 per ad
45% charged between $1,500 and $3,000 per ad
 6% charged more than $3,000 per ad

For newspaper advertising:
58% charged less than $1,500 per ad
37% charged between $1,500 and $3,000 per ad
 5% charged more than $3,000 per ad

For billboard photography:
44% charged less than $1,500 per ad
44% charged between $1,500 and $3,000 per ad
12% charged more than $3,000 per ad

For stills for television commercials:
56% charged less than $1,500 per ad
36% charged between $1,500 and $3,000 per ad
 7% charged more than $3,000 per ad

For point-of-purchase advertising:
52% charged less than $1,500 per ad
43% charged between $1,500 and $3,000 per ad
 5% charged more than $3,000 per ad

For publicity stills for television and film:
72% charged less than $1,500 per ad
26% charged between $1,500 and $3,000 per ad
 2% charged more than $3,000 per ad

Note: Percentages were based on the number of members responding in each category, and have been rounded off.

THE 1985 ASMP SURVEY: LOCAL ADVERTISING AD RATES

For a spread in a consumer magazine:
57% charged less than $1,250 per ad
38% charged between $1,250 and $3,000 per ad
 5% charged more than $3,000 per ad

For a single page in a consumer magazine:
61% charged less than $1,250 per ad
36% charged between $1,250 and $3,000 per ad
 3% charged more than $3,000 per ad

For newspaper advertising:
70% charged less than $1,250 per ad
28% charged between $1,250 and $3,000 per ad
 2% charged more than $3,000 per ad

For billboard photography:
54% charged less than $1,250 per ad
40% charged between $1,250 and $3,000 per ad
 6% charged more than $3,000 per ad

For stills for television commercials:
67% charged less than $1,250 per ad
30% charged between $1,250 and $3,000 per ad
 3% charged more than $3,000 per ad

For point-of-purchase advertising:
61% charged less than $1,250 per ad
37% charged between $1,250 and $3,000 per ad
 2% charged more than $3,000 per ad

Note: Percentages were based on the number of members responding in each category, and have been rounded off.

Shooting Time. Besides the number of days you estimate it will take to shoot a job, you must consider the cost of preparation time for an advertising job when calculating your fee. Some job preparations may take as much time as shooting, and you have to structure your fee accordingly. If you spend a full day preparing, you must charge for this along with the shooting time because preparation is basic to the finished ad.

Media Use. Fees are generally highest for ads in publications circulated nationally, and the higher the circulation, the larger the potential fee. General-interest magazines and large-circulation, special-interest magazines command the highest advertising photography fees. As an example, photography for an ad in *Time* or *Newsweek*

should be paid for at a higher rate than for an ad in *Personal Computing* or *Field and Stream* because the latter two magazines have smaller circulations.

Photography fees are often predicated on usage in several publications, such as three womens' magazines or a group of photography magazines. The fee is higher for multiple use. For instance, if the range you're considering is between $1,251 and $3,000, a figure of more than $3,000 may be appropriate when the ad is running in multiple publications.

Photography rates for regional and trade magazines are lower than those for national magazines because their circulation is usually smaller and advertising space sells for less. There are exceptions, such as medical and pharmaceutical publications for which photography requirements may include difficult technical shooting and for which ad space rates may be elevated as well.

Overhead. Advertising photographers find it necessary to outfit and maintain studios because their work often requires extensive space, elaborate lighting, and special equipment. As a result, the overhead advertising photographers must pay is higher than that of editorial or annual report photographers. These circumstances, along with the special value of the photographs to a client's business, contribute to the size of photography fees.

THE 1985 ASMP SURVEY: TRADE ADVERTISING AD RATES

For a two-page spread in a magazine:
45% charged less than $1,250 per ad
51% charged between $1,250 and $3,000 per ad
4% charged more than $3,000 per ad

For a single page in a magazine:
61% charged less than $1,250 per ad
38% charged between $1,250 and $3,000 per ad
1% charged more than $3,000 per ad

For newspaper advertising:
66% charged less than $1,250 per ad
32% charged between $1,250 and $3,000 per ad
2% charged more than $3,000 per ad

For billboard photography (regional):
52% charged less than $1,250 per ad
44% charged between $1,250 and $3,000 per ad
4% charged more than $3,000 per ad

Note: Percentages were based on the number of members responding in each category, and have been rounded off.

APA Book Fees. In *Assigning Advertising Photography*, a chart of fees charged by APA (New York) members shows that their low, medium, and high fees are higher than those indicated in the preceding charts. For example, the fees for a consumer ad in a nationally distributed publication as listed in an APA survey taken in June 1986 are as follows:

- The "low" fee for a "simple" photograph ranges from $1,500 to $6,000.
- The "medium" fee for a more complex photograph ranges from $2,000 to $8,000.
- The "high" fee for a very complex or specialized photograph, which is part of a campaign with a large budget, ranges from $2,500 to $16,000.

Keep in mind, however, that overhead in the New York area is higher than that in many other places, and that people with a top reputation, "heavy shooters" in trade parlance, are concentrated in and around New York. These facts account for some of the differences between the ASMP national survey and the APA New York City survey.

EXPECT THE UNEXPECTED

Photographers learn to expect irregularities and realize that they must charge accordingly.

Postponements. When a photography job is postponed, it is rescheduled by the client to a date mutually agreeable to both parties, which is usually within thirty days of the original date. At the time of postponement, the client usually reimburses the photographer for all expenses already incurred in preparation for the job. In addition, if a job is postponed with two business days notice or less, the client should pay the full creative fee. When a job is postponed with more than two working days notice, it is common professional practice to charge 25 percent of the creative fee to cover time that might be lost because other assignments could not be scheduled.

Cancellations. If an assignment is terminated before the shooting starts, the client customarily pays the photographer a cancellation fee for time and effort already spent, and for the loss of other jobs that he or she might have accepted. The photographer should also be reimbursed for production costs and other expenses quickly. If a job is canceled with two business days notice or less, the full creative fee is customarily paid. If a job is canceled with more than two working days notice, 50 percent of the fee agreed upon is usually paid.

Reshoots. How a reshoot is paid for depends on the reasons it is necessary. *Assigning Advertising Photography* lists three common situations, which follow:

- If there are flaws in the final pictures that are the result of circumstances beyond the control of the photographer, it is customary for the client to pay 50 percent of the original fee for the reshoot, along with all reshoot expenses. Such flaws may be caused by defective film, processing failures, or undetected equipment malfunctions. The client or the photographer may cover such instances with insurance.
- If a reshoot is needed because of the photographer's negligence—because something is overlooked or forgotten, for instance—the photographer should reshoot without charging an additional fee.
- Sometimes a photographer chooses to reshoot pictures that seem unsatisfactory for whatever reasons; in such cases no additional fee is charged. The client's deadline is a factor here.

If a client requests changes in the photographs after a shoot is completed, new pictures are not usually considered a "reshoot," but a new assignment with its own fees and expenses. Industry practice and good business ethics suggest that a new shoot should be discussed first with the photographer who did the original work.

Nonuse of Photographs. If a client decides not to use your pictures even though they have been done satisfactorily, the client is still responsible for payment under the terms originally negotiated.

PRECAUTIONS

Portfolio and Sample Shots. Any portfolio or sample pictures you leave with a client at the client's request may not be released or reproduced unless you agree. This prohibition includes photocopying for use in comps or in-house displays. You may charge for use of your pictures for research, reference, or developmental purposes.

Releases. Since model and property releases are required by law for all advertising photographs, it is normally the client's responsibility to obtain them. The photographer might agree to get such releases, if doing so seems more expedient or reliable.

Copyright. Remember to place a copyright notice on your chromes and prints because the copyright on a magazine or book pertains only to the editorial material, not to the ads. If the photographs will be copyrighted as part of the ad, even though you have leased only limited rights, remind the client that for its own protection the ad should have a copyright notice in all media. Copyright can be assigned back to you after publication.

ADVERTISING PHOTOGRAPHY AND WORK-FOR-HIRE

In spring 1986 the influential monthly *Photo District News* reported that the American Association of Advertising Agencies (AAAA) sent all of its members, including its branch offices, bulletin number 4203. This bulletin states, in effect, "Photographers should not assume they own rights to a photograph unless they have paperwork to prove

it." This message was expanded in a booklet issued by the AAAA in 1986, titled "Guide to Advertising Art Buying."

In the "Guide to Advertising Art Buying," AAAA advises its members that their best protection remains an explicit written contract stipulating that all copyrights in the work (the copyrights to the photographs) belong to the advertiser or agency. The booklet also recommends that ad agencies require photographers to sign work-for-hire agreements, whether or not they want to. Bulletin number 4203 goes even further to counter the copyright law, advising AAAA members that photographs assigned to independent contractors (not employees) should be considered "work-made-for-hire" even in the absence of a written contract.

Clearly, AAAA has unilaterally decided that photographers have no rights to their work because all commissioned or assigned work is "work-made-for-hire," which by AAAA's definition means rights are owned by the assigning or "supervising" party. If photographers were to agree to follow AAAA's illegal policy, they would be selling all rights to their pictures without an attempt to resist or negotiate.

In reality, the new copyright law specifically states that photography done by a freelancer is work-for-hire only "if the parties expressly agree in a written instrument signed by them." Even more important, the categories of commissioned work that can be work-for-hire if the parties agree in writing all fall under editorial photography. Nowhere does the copyright law state or imply anything about photographs created for advertising.

Charles Ossola, an attorney for a coalition of creative organizations including ASMP, maintains:

> The advertising industry reliance on work-for-hire agreements is wholly unauthorized under the present law because advertisements are not one of the categories enumerated in the law. Yet the advertising industry increasingly forces these illegal work-for-hire agreements on independent artists.

As of this writing, photographers are not acquiescing to AAAA's view. The United States Congress has not changed the 1978 copyright law, photographers are still the legal creators of their work, and neither ad agency personnel nor clients who claim to supervise a shooting can legally claim ownership of the work. Of the few court cases in which a judge had ruled that the supervising party owned the pictures, many authorities said that the decisions were ridiculous as well as contrary to the law. These few cases are the basis for AAAA's directives.

Photographers and their trade organizations, such as ASMP and APA, consider these judicial rulings as clear contradictions of the content of the copyright law. They do not concede that the party that hires and supervises a shoot is the "author" and owns the copyright. It is the photographer who owns the rights, as the law states and as knowledgeable people understand.

Refusing Work-for-Hire. As a photographer, you may hear clients say, "I paid for the photographs, and I am entitled to own them." An agency representative may quietly require you to sign a work-for-hire agreement before doing business. It may be called a buyout or an all-rights agreement but the result is the same as that of a work-for-hire agreement in most cases. You will have to transfer all rights to the client and cannot lease or sell your pictures in the future.

If you are chosen to shoot an advertising job, chances are you have certain qualities and merits the agency and client want. Your previous work is impressive. Also, your studio, personality, and fees are acceptable or even outstanding. If you have been called and offered a job on a work-for-hire basis and you refuse, the agency has to call other photographers in order to meet its deadline. If enough of these photographers refuse work-for-hire terms, it takes the agency a while to find someone it can trust who will also give away his or her rights, unknowingly or not. When enough photographers say no to work-for-hire and buyout arrangements, the agency faces frustration. It may have to go back to the client and say, "Let's look at this situation again. We can't get quality photographers, people whose work and talent we can trust, because they won't do work-for-hire. Let's explain this to those company lawyers who insist on work-for-hire, to help them understand our problems." The agency is likely to make concessions.

Many photographers in the know contend that agencies and their personnel are really not out to get photographers. At the root of the dilemma are company or agency lawyers who decide, "Let's see if we can get all rights without much struggle." After all, lawyers are supposed to work for the benefit of their clients, and work-for-hire arrangements usually mean the client gets something for nothing. This, in turn, makes lawyers look good.

Despite AAAA's cavalier attempt to exploit the rights of photographers, most advertising agency personnel realize how much photographers contribute to ads. They know we are creative people, not just technicians. They understand how much experience, patience, equipment, and talent goes into the average advertising photograph. With these facts in mind, when you say no to work-for-hire, you are demonstrating your sense of self-worth. If you don't stand up for your rights, you will not get the respect of clients.

Negotiating Work-for-Hire. The *ASMP Book* contains some excellent advice about dealing with work-for-hire, such as, "more often than not, the user simply does not need to own all rights." Both parties should analyze what rights the client actually needs, and the photography fee should be set accordingly. In the agreement, arrangements can be made for the photographer to license all further rights that the client might want—in terms of the media, time limits, and geographic distribution, among other factors. In this way, the client

pays less for the photography job and can buy additional rights only if needed. Consider the following discussion between a photographer and a client:

Photographer (P). You'll keep your budget down by paying for only what you need.

Client (C). How do I know I can extend the time or use the pictures in additional ways? Can we agree to that now?

P. Yes, we can write all such contingencies into the agreement. Then we'll both know that the promises in the contract will be honored. Besides, I intend to stay in this business and hope to work for you again. And even if we don't work together again, I have a reputation to think about.

C. What about restricting your use of pictures so that none are ever made available to my competitors? That would be embarrassing—and unfair.

P. We can arrange that.

C. But my attorney says the only safe way to ensure all residual rights and exclusivity is to own the pictures outright, and not have to trust anyone to fulfill his or her part of a bargain.

P. I understand the basis for that point of view, but I don't agree with it. I hope you understand that all rights or a buyout will cost you more than twice the fee we've been discussing for limited rights, which are all you really need.

C. Really? That's a problem. The deal for limited rights is already stretching my budget. Why do you charge a double fee for all rights when I have agreed to pay you well for this assignment?

P. Additional rights cost more because they increase the value of the photographs. If I lease pictures for a longer time period as well as for additional usage in magazines, billboards, brochures, and other options on an individual rights basis, the aggregate fee would at least triple. Even if you paid $10,000 for a buyout, I could be underestimating the value and life expectancy of my photographs. I would much rather accept $5,000 now with an agreement about where and how the pictures will be used. There may be no markets for me to sell the pictures to in the future, but I'd rather retain ownership and arrange to lease whatever specific rights you need later on. This costs you less, and I maintain a principle that is important to me.

C. You're probably familiar with the Peregrine vs. Lauren Corp. case in which a court ruled that even though Peregrine owned the copyright to his pictures, the ad agency owned the pictures because Peregrine was an employee for purposes of the work-made-for-hire copyright law provisions. Based on this and other cases, AAAA advises us that the client owns "specially commissioned works made by independent contractors even without a written agreement." What about that?

P. It's illegal, and besides, only a few courts have agreed that photographers are employees unless they contract to be one temporarily. In

the Peregrine case, the court noted that the work was done at the agency's request and that Peregrine was supervised during the shoot. Although the court recognized that Peregrine's many suggestions made during the shooting were usually followed, it decided that because the agency could veto such suggestions, it was the employer and he the employee. The court based its decision on a discarded precept that "the copyright is owned by the person at whose insistence and expense the work was done." The law says, you know, that without paperwork, there can be no work-for-hire.

As of this writing, efforts are being made in Congress to clarify the distinction between being an employee and being an independent contractor. If these succeed and the 1978 copyright law is revised and refined, the photographer's lot will be more fair.

WORK-FOR-HIRE: POINT AND COUNTERPOINT

A veteran advertising photographer made the following comments on rights protection:

I have another explanation for clients about why it's better if I don't do work-for-hire or accept a buyout.

If the job's on a work-for-hire basis, don't expect me to shoot ten different situations. If the layout calls for one situation, I may opt to do a second one, but forget the other eight I might have done.

If I were an art director or art buyer, I would never ask a photographer to shoot on a work-for-hire basis because it stifles initiative. Creative people aren't nearly as motivated when they have to give up all rights, and sometimes getting the additional fee becomes a big struggle.

Another photographer may counter this view with:

Look, I take pictures of products like machine tools in home workshops, and I can't imagine how I could find a market for those pictures later. My largest client, whose ad campaigns are limited, only uses my shots in a couple of magazines and maybe a couple of brochures. So why make a fuss about a buyout or work-for-hire? I get good money for shooting, and I don't feel exploited.

The latter could be a short-range viewpoint. In many cases, when you sell all rights or agree to work-for-hire without specifically increasing your photographic fees, you are setting a precedent for yourself that may be hard to overcome. You are apt to be categorized as a good photographer who sells his or her work without asking too many questions or negotiating carefully. Even if you do raise your fees eventually, you may not reach the level of income that your increased competency and experience dictate. By pleasing the client and not defining your rights, you are undermining yourself and the profession of media photography.

Risks taken today may help build your reputation and pay off handsomely tomorrow.

INTERPRETING CLIENTS' VIEWPOINTS

Richard Weisgrau, who chaired the ASMP committee that planned negotiating seminars with clients, has found that many ad agency clients have little understanding of photographers' rights. Some clients regard photography as a service like printing, and they expect to own everything. They view the photographer merely as a vendor, although talented and well paid.

An advertising agency has the obligation to represent its clients, and will try not to lose clients by telling them that their perceptions are wrong about photographers' rights. The agency earns a commission for advancing the best interests of the client, and the photographer may become the unwitting victim or target.

Legal department influence. Often the unfair terms photographers face in agency purchase orders are the product of agency legal departments.

The legal department is operating to protect the agency (or the publisher of books or magazines), not the advertiser. It wants the agency clear of liability from any cause, and it applies stringent terms to photography. In addition, the legal department may well feel that owning all rights to photographs precludes future negotiation or conflict. The department may also assume that limited rights or all rights should cost the same amount. Experience shows that business representatives and creative people will overrule a legal recommendation when they have to, in order to get the photographs they want from the photographers they feel are essential to them. However, the legal department prevails in some situations because the photographer has little or no clout and is replaceable.

It is essential that photographers and their organizations try to reach ad agency legal departments, to open lines of communication with them, because it serves all our interests. In some cases, photographers' reps can make such contacts. Agency personnel and legal departments in particular need to be assured that photographs shot for their clients will not be used afterwards in any way that would jeopardize the agency's position with the client. Perhaps you or your rep may have to educate picture buyers, who in turn may be able to influence the legal department. The main goal is an agreement without excesses.

An Advertising Photography Case History. Sam received a terrific assignment from the XYZ Corp. a firm that makes skis. The art buyer told Sam that the job was a risk because Colorado was covered with new snow, and that the pictures were to be shot "four days from now." Sam had not worked for the XYZ before, but its reputation was well known, and Sam came highly recommended. Sam and the art director worked out an acceptable fee plus expenses for three ad photographs, to be run three times within a year's limit. Sam requested that the purchase order be immediately sent by overnight delivery. He then started preparing for the shoot. The job sounded challenging.

Sam arrived in Colorado with an assistant before the purchase order reached his office. The art director didn't have a copy, but said not to worry. Sam saw the layouts, contributed quite a few ideas during the four-day shoot, and got great chromes. Back home he found the purchase order on his desk and read it too quickly to realize it was vague about usage. He edited and delivered the pictures. He also sent a bill for his fee and expenses.

The exploitation did not begin until after Sam was paid. XYZ ran its three ads in magazines three times, but afterward Sam found the same ads in newspapers, converted to black and white, as well as in other magazines. Then a contact at XYZ sent him a brochure that included his main shots and some outtakes. Another ad using his pictures showed up in a trade magazine. Sam complained to the agency immediately, but the original art director was gone, and her substitute was evasive: "Why are you making such a big deal? You got paid, didn't you?"

Sam's attorney then wrote to XYZ Corp, and Sam sent bills for all additional usage. The "renowned" company ignored both attempts to resolve the problem. Its ad agency blamed the company president for being obstinate. Sam's attorney filed a suit. The trial date was set for a year later, which was discouraging since Sam had still not received his pictures back from the agency.

Two days before the trial date, the company's attorneys offered to settle for about half the amount Sam was asking for additional usage. Frequently, the client stretches the time and at the last minute offers a settlement in an effort to save itself more legal expense. It hopes that because the photographer has waited so long, he or she may be eager to accept less money and to end the aggravation.

Sam and his attorney knew about such tactics, so they reduced Sam's added-usage fee a mere 10 percent, demanded to have all the chromes back within forty-eight hours, and agreed to settle. The chromes, being held hostage, arrived the next day, but the company countered with an offer that was 20 percent less than the added-usage fee Sam sued for. Sam was advised to accept, to avoid incurring more legal fees and to avoid any further time delay.

A client may be intentionally unethical from the start or circumstances may simply develop. The XYZ Corp. hoped that Sam would not notice his pictures in additional media and would be satisfied with merely getting his chromes back if he complained. Of course, the company's judgment was faulty.

If you don't have a purchase order, a signed assignment-confirmation form, or a letter of agreement before the job begins, don't start the job. Sam never had a chance to negotiate terms because he immediately tried to accommodate the client. (He should also have received an advance on his expenses.) If Sam had waited for the purchase order before leaving his office, or at least insisted on getting the purchase order on location, XYZ might have felt he was a more formidable individual.

TIPS FROM A SUCCESSFUL PHOTOGRAPHER

The following discussion was digested from an excellent article written by Royce Bair for the fall 1986 *Utah/Mountain West ASMP Newsletter*. Bair began his piece by contemplating the fact that photographers may fear competition because there are so many more of us working today than there were a decade ago. "We know that for every job we turn down because of price," he says, "there are at least a dozen other photographers waiting to do it cheaper. So why shouldn't we take what's offered and at least get *something*?" Bair suggests that the fear of not being able to pay the rent may seem to lead to such a viewpoint, but the reason is "generally ignorance."

Photographers must know what to charge in order to pay their overhead and make a profit, Bair feels, just as printers or color separators do. It requires business sense, says Bair. He quotes photographer Ron Scott, "A photographer can be *good* and *cheap* in the beginning in order to get known, but if he continues to be cheap, he won't remain good." In addition, Bair states:

You must know what it takes to turn a profit on each job. If you're taking jobs only to justify your overhead, maybe you should remove some of the pressure so you'll have the courage to say NO to unprofitable "offerings." . . . Unfortunately, most "offerings" do not allow for much negotiation—they're more of a take-it-or-leave-it situation. The Utah Travel Council called and "offered" to purchase one of our photos for a map brochure. The brochure was using twice as many photos as previously, so the extra separation costs had eaten up most of the budget. . . . [By a tricky formula] the ad agency suggested $34 a photo. I was told that most of the photographers responded with comments like, "Well, if that's all there is, then I'll take what I can get." I responded with the one option I had left: "No thanks."

I don't think there were very many PROFESSIONAL photographers in that group of photo suppliers. . . . Just selling an occasional picture does not earn one the title of "professional photographer."

Bair also believes that professionals should make a point of educating clients as to their own uniqueness, and one way is to "make yourself valuable and irreplaceable in the client's eyes by offering something he can't get easily elsewhere." Finally, Bair suggests, "When negotiating fees, try to follow the 'I win, you win' philosophy. For example, if they ask you to come down in your price, ask them for speedier payment."

SUMMARY

One question advertising photographers especially may not like is, "What do you charge?" The answer must combine their need to cover expenses, make a profit, and maintain a professional stance at the same time. Maria Piscopo, a Southern California marketing consul-

tant to photographers, suggests that you turn the question around and ask, "What is the job worth?" To put it another way, ask the client what the budget for the job is, which, as Piscopo points out, "places the pricing where it belongs." Piscopo also recommends that you use an industry guideline, such as the books published by ASMP and APA, because as she believes, "No client wants to feel photographers are pulling prices out of thin air." At the same time, she warns, you must be very careful quoting day rates beacuse they "do not tell the client what the photography will cost." Ask for job specifications in order to make a realistic quote that "shows concern for the client's needs."

In addition, Piscopo suggests that you stress the advantages of working with you rather than with other photographers. For instance, if you are good with people or are experienced in lighting difficult locations, mention these special abilities to help the client focus on more than just budget figures. You can tactfully blow your own horn without seeming egotistical. Here are some additional pointers about pricing an advertising job:

- Make suggestions to show your creative side, without being too aggressive.
- Discuss price orally, but submit written proposals "attractively," advises Piscopo. Take the time needed to fill out estimate forms accurately.
- Show samples of your work that relate to the job in order to reinforce your professional stance.

As Piscopo says, successful photographers must believe they deserve to get the job. You can project this subtly to clients. When your self-confidence is evident, clients are apt to respect you as a business professional as well as a photographer.

8

Stock Photography

A stock picture is one that has already been taken and filed, ready to be licensed to a client. The files may be your own or those of a stock-picture agency. As is the custom in most media photography, photographs from stock are not sold. They are licensed, which means the original transparency or print must be returned by the user to the photographer or to the stock agency. Many stock photographs have an indefinite life, depending on how timely they are and how well they are cared for while passing through various hands.

More and more photographers are concentrating on stock photography as a primary livelihood because so many clients are now licensing pictures for editorial, advertising, book, and corporate uses. However, a majority of photographers still shoot stock as an adjunct to or as the result of other jobs, especially when traveling. In my stock files I have slides from three European trips; from jaunts across America; and from many one-day visits to art museums, coastal areas, and trips to the zoo.

A typical stock file usually includes photographs that originate as assignments. Suppose you get a job in a city 700 miles away and decide to drive rather than fly. On the way there and back, you can shoot a national park or other scenic spots. While on the job, which might be photographing a baseball team's spring training or a new tycoon on his way to fame and fortune, you shoot liberally. Later, when the client has chosen and reproduced its pictures, you are free to lease similar shots, or even the same ones, if there is no conflict. Your first obligation is to shoot the assignment well, but at the same time, think of future stock sales.

It is easy for people new to the field of media photography to fantasize about all the salable pictures they can shoot on a trip or during a job. Success depends on being able to take strong pictures

The rights to stock photographs can be leased repeatedly to various markets, such as magazines, calendars, postcards, and posters.

that synthesize a place or include action, drama, or timeliness—all of which many clients want. As you come to better understand the techniques of leasing stock photographs, you will also learn about producing pictures that provide continuing income.

STOCK-PICTURE MARKETS

To distinguish between the ways various media seek and lease stock photographs, some pertinent information on these and other markets is necessary.

Magazines. A variety of stock material is used by general-interest and specialized magazines. When assigning photography seems too costly, or when only a few pictures are needed and time is a factor, editors look for stock images to fill their needs. In most magazines you'll find stock pictures, which should be credited to both photographer and agency. For example, *Modern Maturity* prints color scenics inside its covers, *Time* and *Newsweek* buy news and feature pictures of people and events, and many other magazines illustrate travel stories through stock sources. A magazine may not employ any staff photographers and still have access to excellent pictures. In addition, by leasing stock, it may look at more variations on a theme in less time and save paying expenses to a freelance photographer.

Advertising Agencies. Advertising agencies use stock photography a great deal for reasons of availability and economy. The smaller the advertiser's budget and the more limited the campaign, the more advantageous it may be to look at stock images from several sources and choose the ones that can immediately fill a need. When an ad requires a specific photograph of a product, place, or person, the pictures are usually assigned. More general material comes from stock files.

In order to sell pictures for advertising, you need signed releases for recognizable people. When it's possible to obtain a release from a person, get the release—whether you expect to lease pictures for advertising or not. Offer to pay the subject a percentage (perhaps 10 percent) of the fee you receive if the photo is leased for an ad. You may also offer duplicate or similar slides or prints as compensation, which many people prefer to the promise of money since a sale is not certain. Be sure the individuals are of legal age (eighteen in most states, twenty-one in some); if in doubt, ask for a parent's signature.

You also need a release for homes, pets, and some other types of property used in advertising pictures (see Chapter 12).

Corporate and Business Users. Some stock photographs are purchased for annual reports, brochures, house organs, company publications, and record album covers; many pictures are leased for calendars. Requests for all types of subjects come from business clients, including: people at work; building and construction; professional services, such as computers in use; scientists with equipment; agricultural

subjects; and other topics, such as sports and leisure. Many such pictures are more desirable when no location or company is identifiable. Images for business use are often valued because they are symbolic rather than specific. The trick is to make the connection between yourself and clients, such as through a stock agency, so they know what you have available.

Book Publishers. Book publishers consistently use stock photography for factual books; school books; and textbooks on such subjects as science, geography, and social studies. Encyclopedias are full of stock pictures, and new editions of them and of textbooks are continually being prepared. The unknown photographer will get a welcome reception from these areas of the book publishing field.

Television and Multimedia Users. Stock images are used in television and other media for illustrations, as background for titles, for filmstrips, and for promotional publications. In the audiovisual field, slide shows are created in which stock shots and assignment pictures are intermingled. If you are in a place remote from stock agencies, the work in your files might be more in demand; you will, however, need to promote it.

Miscellaneous Users. Other markets for stock pictures include publishers of postcards, greeting cards, decorative posters, and wall art.

USAGE CATEGORIES

As ASMP's *Stock Picture Handbook* says, "The market for stock photographs is indeed diverse, and at times delightfully unpredictable, but experienced photographers and stock agents, who receive thousands of requests annually, find that certain picture categories are requested more often than others." This, of course, affects the value of images. The *Stock Picture Handbook*—first published in 1984 and scheduled for revision in 1988, it is the only such specialized reference available—provides two principles and five usage factors on which stock pricing is based.

The first principle: The larger the total budget of the project, the more the buyer may be able and willing to pay for stock photographs. In advertising, therefore, payments may range from $500 for a single trade ad to $10,000 for a multiple-insertion campaign in magazines, on billboards, and for other uses. A payment of $2,500 for a single color photograph in a full-page ad, onetime use, in *Time* or *Newsweek*, is typical. For corporate and industrial purposes, the range may be $300 for each picture in a twelve-page corporate desk calendar of limited press run, to $2,000 for the cover of a glossy annual report of a circulation of one million. For magazines and books, the range may be from $135 for a quarter-page in an elementary science book to $1,000 for the cover of a newsstand magazine.

The second principle: Any use that increases the visibility of the photograph increases its value to the client.

The five usage factors are:

- Size (full-page, half-page, etc.)
- Circulation and print run (doubling the print run of a sales brochure from 500,000 to 1,000,000, for example, increases the average fee for a full-page ad by 40 percent, not 100 percent)
- Distribution (local, regional, national, etc.)
- Number of formats or versions, such as hardcover and softcover books
- Length of time the picture will be used

STOCK PHOTOGRAPHY FEES

According to ASMP's *Stock Picture Handbook,*

> To those unfamiliar with the markets for stock photography, the pricing of stock photographs can be very confusing. In many instances, the same picture will yield different prices. Why? When? How much?
>
> Agreeing with a buyer on price can be as simple as a ten-second phone call, or it can require visits to the buyer's office, the viewing of layouts, consultations with other photographers and referring to price guides.

Pricing is easier when you know the buyer and you have a relationship, and mutually agreeable, fair prices are originally set. Pricing can be complex, especially when the photograph is one-of-kind, or at least hard to find. Ordinarily, you expect the buyer to offer a suitable price, unless the use of the picture is so unusual that you name a firm figure. Pricing often results from research and negotiation. If pricing and the business side of stock photography don't appeal to you, consider selling through a stock agency. For a 40 percent to 50 percent commission, you should get the reliable sales practices you may lack.

Black-and-White and Color Parity. "The ASMP recommends that black & white photographs be priced on a parity with color," says the *Stock Picture Handbook.* The effort expended and the creativity needed vary little, whether you're shooting black and white or color. The time, talent, and taste involved are approximately the same.

Remarkably, production costs are at least three times more to add a black-and-white print to your file than they are to add a 35mm Kodachrome. Because of this and because so many more publications are now in color, some major stock agencies offer color only. When black-and-white pictures are needed, a slide is converted to a black-and-white negative and a print is made, at the buyer's expense. I shoot only 35mm color slides for my files, and they are all I send to the several agencies through which I sell. (Some illustrations in this book have been converted from color slides.)

Some editorial and advertising markets still do not recognize parity pricing between black-and-white and color film, but the effort

continues to close the gap and equalize prices. One reluctant market is book publishing, especially college-level textbooks. Budgets and print runs are often modest, and the author often has to supply the pictures. Some photographers and agencies are advising textbook publishers that they are closing the color/black-and-white price gap about 15 percent a year.

Average Stock Photography Rates. The pricing tables that follow are from the *Stock Photography Handbook* and contain the results in condensed form of a survey of ASMP members and stock-picture agencies throughout the United States in fall 1983. Prices have risen only slightly in some areas since then. (Check ASMP's 1988 *Stock Picture Handbook* for later data.) Because ASMP does not set rates and because many photographers and agencies charge differently, the prices shown are averages based on the survey.

THE ASMP SURVEY:
AVERAGE ADVERTISING STOCK PHOTOGRAPHY RATES

CONSUMER MAGAZINE RATES	Quarter page	Half page	Full page
National circulation			
Over 3,000,000	$1,250	$1,625	$2,500
1,000,000–3,000,000	750	975	1,500
500,000–1,000,000	600	775	1,200
Under 500,000	425	550	850
Regional circulation			
Over 3,000,000	$ 750	$1,000	$1,500
500,000–1,000,000	600	775	1,200
250,000–500,000	500	650	1,000
Under 250,000	400	525	850
Local circulation			
Over 500,000	$ 500	$ 650	$1,000
100,000–500,000	425	550	850
Under 100,000	350	450	700

Note: There are variations for number of insertions and for extended rights. The Stock Picture Handbook *includes three-quarter-page, double-page, and back cover prices.*

TRADE MAGAZINE RATES Circulation	Quarter page	Half page	Full page
Over 500,000	$ 675	$ 875	$1,350
250,000–500,000	500	650	1,000
100,000–250,000	450	575	875
50,000–100,000	400	525	800
20,000–50,000	350	450	700
Under 20,000	300	350	500

ADVERTISING STOCK PHOTOGRAPHY RATES (*continued*)

NEWSPAPER RATES

Circulation	Quarter page	Half page	Full page
450,000 and over, first insertion	$ 450	$ 650	$1,150

Note: Additional insertions up to 20 are charged at $100 to $2,650 depending on number (refer to the Stock Picture Handbook*).*

200,000–450,000, first insertion	$ 350	$ 500	$ 825

Note: Additional insertions up to 20 are charged at $85 to $2,000, depending on number (refer to the Stock Picture Handbook*).*

50,000–200,000, first insertion	$ 225	$ 275	$ 375

Note: Additional insertions up to 20 are charged at $65 to $1,125 (refer to the Stock Picture Handbook*).*

BROCHURE AND CATALOG RATES

Press run	Quarter page	Half page	Full page
1,000,000 and over	$ 450	$ 575	$ 875
500,000–1,000,000	375	500	750
250,000–500,000	325	425	625
100,00–250,000	275	350	525
50,000–100,000	225	300	450
20,000–50,000	200	275	400
Under 20,000	175	225	350

Note: The above prices are for a one-edition, nonexclusive, one-year limit. The Stock Picture Handbook *includes three-quarter-page, double-page, and cover prices.*

TELEVISION COMMERCIAL RATES

Circulation	One 13-week cycle	Two 13-week cycles
National	$600–$1,200	$900–$1,600
Regional	$375–$600	$575–$900
Local	$200–$500	$325–$750
Test (in-house only)	$225–$375	

Note: Variations covered in the Stock Picture Handbook*.*

POSTER RATES

Stock photograph fees for posters run from $260 for a small poster, under 10,000 press run, to $1,325 for a promotional poster, world circulation. Some poster publishers pay a royalty of 10 percent of the wholesale price of the poster; some give the photographer a quantity of posters each time the poster is printed. Initial press runs average about 3,000. For detailed figures, refer to the *Stock Picture Handbook.*

Note: Also included in the Stock Picture Handbook *are tables of prices for packaging, billboards, point-of-purchase advertising, presentation and layout, artist references, and house organs.*

ADVERTISING STOCK PHOTOGRAPHY RATES (*continued*)

CORPORATE ANNUAL REPORT RATES

Circulation	Quarter page	Half page	Full page
1,000,000 and over	$ 600	$ 700	$1,000
500,000–1,000,000	550	600	900
250,000–500,000	475	550	775
100,000–250,000	425	475	675
50,000–100,000	375	450	600
20,000–50,000	350	425	575
10,000–20,000	325	400	550
5,000–10,000	275	325	450
Under 5,000	250	300	400

Note: Variations plus three-quarter-page, double-page, and cover prices are included in the Stock Picture Handbook.

BOOK RATES

Press run	Quarter page	Half page	Full page
Textbooks			
Over 40,000	$ 160	$ 185	$ 250
Under 40,000	135	160	210
Trade books			
Over 40,000	$ 160	$ 185	$ 250
Under 40,000	135	160	210

Note: There are many variations related to chapter-opening pictures, revisions, and rights discussed in the Stock Picture Handbook. *There is also great variation of prices in the field of educational and encyclopedia publishing. Black-and-white prices have not reached the level of color. (Check the notes in the* Stock Picture Handbook.*)*

RECORD ALBUM AND TAPE RATES*

Front cover	$450–$1,250
Back cover	$325–$900
Wraparound cover	$850–$1,500
Enclosures (booklets)	$200–$450
Test only	$275–$425

Note: If a stock photograph is used on both an album and a tape or compact disc, add 50 percent to the fee.

**It is difficult to price record album and tape or compact disc covers only on the basis of press run because it is not known how successful each item may be. The* Stock Picture Handbook *suggests a yearly residual fee to protect your rights.*

CALENDAR RATES

Press run	
100,000 and over	$900–$1,700
10,000–100,000	$350–$900

Note: The greater the exposure, the larger the fee.

Following the charts of prices in ASMP's *Stock Picture Handbook* are three pages of circulation figures and ad rates charged by magazines and newspapers. These include general and specialized national consumer magazines, city and regional magazines, in-flight magazines, and a list of large newspapers. Refer to these figures when considering fees for stock photography in specific markets.

THE ASMP SURVEY:
AVERAGE EDITORIAL STOCK PHOTOGRAPHY RATES

MAGAZINE RATES

Circulation	Quarter page	Half page	Full page
3,000,000 and over	$ 405	$ 475	$ 675
1,000,000–3,000,000	330	385	550
50,000–1,000,000	255	300	425
250,000–500,000	210	245	350
100,000–250,000	180	210	300
Under 100,000	150	175	250

NEWSPAPER RATES

Circulation	Quarter page	Half page	Full page
Sunday Supplements			
3,000,000 and over	$ 360	$ 420	$ 600
1,000,000–3,000,000	300	350	500
Under 1,000,000	225	265	375
Daily Newspapers			
Over 250,000	$ 255	$ 300	$ 425
Under 250,000	165	195	275

TELEVISION RATES
Television Editorial Use

National use	$250
Regional use	$150
Local use	$140

Note: Additional figures are included in the Stock Picture Handbook.

GREETING CARD RATES

For United States rights, two-year limit, retail	$250–$425
For advertising or promotion	$300–$625

PUZZLE RATES
For average press run, three-to five-year limit (negotiable):

United States rights	$325–$525
World rights	$500–$700

FRAMED REPRODUCTION RATES
For United States rights, nonexclusive, 15,000 press run: $375 or 10 percent of retail price on royalty basis.

THE ASMP SURVEY: SPECIALIZED USE FEES

Dependable industry standards are still being established regarding new or unusual applications. When you are faced with an unfamiliar or unusual stock photography pricing problem, consult with other photographers or a stock picture agency. Free exchange of information helps sellers and buyers to reach fair and competitive fees.

Bank checks: Regional		$550–$850
	Local	$375–$575
Place mats		$300–$600
Shirts, tote bags		$300–$450
Plates, mugs, etc.		$325–$600
Stamps, first-day covers		$375–$500
Playing cards		$325–$550
Stationery (business)		$325–$475
Novelty tags, key chains		$275–$450

BUILDING A SUCCESSFUL STOCK FILE

Success in stock photography sales requires a substantial file of images—in the thousands. If you only have 100 or 200 slides you feel are top-notch, you cannot expect to interest many publications or advertisers unless the style or subject matter is very special. You may make a few sales while your file is small, but your income will be skimpy until you have a relatively large quantity of pictures from which to choose. I have several thousand slides in the files of three separate agencies at present, and while my sales are steady, they wouldn't buy groceries for more than a couple of months each year.

The only way to build a stock file is to go out and shoot, or to produce pictures in your studio or wherever you work. When you travel, plan ahead so you will be ready for scenic highlights at the best time of day. Every photographer I know who has built an impressive stock file did so by concentrating on specific subjects, and was prepared when serendipity offered a hand.

To learn more about creating pictures that sell, about the categories of photographs clients want, and about stock-picture markets, refer to the "Suggested Readings" list. You may also wish to attend seminars given by successful stock photographers or agents around the country. Photographic organizations, such as PSA and ASMP, and colleagues can help keep you informed.

Duping. Duplicate slides—dupes—can be made so skillfully today that some buyers will accept them as they do originals. Investigate duping offered by local labs or Eastman Kodak, and consider whether you will be able to dupe your own slides by talking to photographers who do this successfully. Original color transparencies are fragile and vulnerable. Dupes are good insurance for your stock business. And since the best dupes are made in the camera at the time you shoot a subject, shoot two or three, or even more, shots of every salable situation.

Slides can be made from color negatives, but the color may not be quite as saturated as slides made on Kodachrome, the favorite film of most stock photographers. Avoid color-negative, motion picture stock films from which slides are made by various companies. The color may fade, and craftsmanship may not be up to professional standards.

Filing. Number every slide and print when they come from the processor, and keep an index of each roll with descriptions of the shots on it. You may also want to keep a list, by file category, of photographs in your file, to make finding pictures faster. Be sure to keep detailed lists by file number of all photographs that you send to buyers or to agencies.

Filing by number, by symbol, by symbolic letters, or by color coding is a systematic business. Some photographers use computer programs for filing and labeling slides to save time and make retrieval faster. However, unless you anticipate a slide file of 1,000 or more, computer filing may not improve efficiency. You can learn more about filing by working with an agency or by referring to some of the books on stock photography in the "Suggested Readings" list.

MARKETING YOUR STOCK PHOTOGRAPHS

In the beginning of your career, you will probably market your own stock pictures until you have a large enough quantity from which an agency can choose. Leasing your own work offers worthwhile experience. You will gain a better understanding of the types of images that sell, and you will develop more polished techniques while shooting. Don't expect immediate success. Steady stock sales and repeat business take time and effort. Eventually, you may decide that selling on your own will be more lucrative than through an agency, but your concentration and effort must be intense. Edit and file your stock, and begin sending lists of what you have to potential clients. You won't make much money if selling your stock is not a priority.

Keep in mind the following points from ASMP's *Stock Picture Handbook* when considering selling your own photographs:

- You may work a lot harder conducting your own stock business— keeping records, soliciting sales, and collecting money—but you keep the full amount of a sale rather than splitting it fifty-fifty with an agency.
- You will know where your pictures are sold and for exactly how much, though picture agencies often supply this information now, especially those that are computerized.
- You will be in contact with clients and can conduct a more personalized business. Also, feedback from sales and rejections can lead you to more effective shooting.
- If you are a specialist and shoot uncommon pictures, such as scientific or sports subjects, you can build a reputation more directly by selling your own work.

- You won't have to fear that your work will be almost insignificant in vast files, as do many photographers who sell through a stock agency.
- You may not wish to sign a three- to five-year contract with an agency because commitment to an unfamiliar outfit creates uncertainty. However, numerous agencies require no contract or merely simple agreements without specific time periods.
- You may enjoy the shooting, editing, filing, and selling operations, and don't want to enlist others to do them for you.

A STOCK SALE STEP-BY-STEP

Selling a stock photograph usually takes place step-by-step, according to ASMP's *Stock Picture Handbook*:

1. The request. The initial request has to be handled skillfully in order to make a precise selection of photographs.

2. The "pull." Pictures are pulled and edited, and the rejected photos are returned to your files.

3. The delivery memo. Each photo in the submission is listed on a consignment or delivery memo with a copy for your files.

4. The invoice for the research fee. Established photographers may charge a $50 research fee, which is deductible if a sale higher than $200 to $250 results. A bill is prepared and is usually sent with the submission.

5. Packing. The pictures have to be protected well for shipping.

6. Delivery. How the pictures are sent depends on where they are going and how soon they must be there. Safety is the primary concern.

7. Paper files. All records are filed. You may keep a log book or do your filing by computer.

8. Returns. Rejected pictures must be checked off the delivery list and returned to your files. This process is repeated until all pictures are returned.

9. Negotiation. If your price has not been determined, fees and reproduction rights have to be negotiated and agreed upon.

10. The purchase order and/or invoice. You may get a purchase order to validate agreed price and terms. Send an invoice if one hasn't been sent. Request tear sheets of published images.

11. The payment. Examine payment checks for legends on the back that may contradict rights agreed upon previously. Be sure any research fee is paid.

12. The final return. When reproduced images come back, inspect them for damage and check them into the files.

13. Cleaning, remounting, and refiling. The slides are usually removed from mounts to reproduce them, so you may have to clean the slide, replace the mount, and renumber it. Refile your pictures.

SELLING THROUGH A STOCK AGENCY

Once you have some experience shooting and selling stock photographs, and have enough pictures in your files to interest an agency, you may wish to check agency possibilities. As ASMP's *Stock Picture*

Handbook says, "You want to feel that [your pictures] will be tended carefully, sent out into the right part of the world, [and] nurtured to realize their greatest potential [until they are] finally able to support you in your old age."

It may take a while for you to find an agency that suits you. As the *Stock Picture Handbook* suggests, "You want to discover an agency where there is an atmosphere of shared interests, of free exchange of information, of trust in both financial honesty and marketing judgment and of collaboration." The best way to start your search is to ask other photographers about the agencies with which they work. How effective do they feel the agency has been? Is their work handled with care? Do they get regular sales reports? Are they informed of the agency's current needs? Are the people friendly and helpful? Do they trust the personnel and agency operation in general?

After you have spoken to colleagues, speak to the agencies directly. Here is a list of questions to ask prospective agencies, as suggested in the *Stock Picture Handbook.*

- What commission does the agency work on, and how often are photographers paid? Can the photographer see a typical sales statement? Does it specify rights granted? Is the buyer identified? Are the photographs identified?
- Does the agency have a standard contract and if so, how long does it expect the photographer's commitment to be? Is there an automatic-renewal provision in the contract binding the photographer to additional contract time unless the agency is legally notified within a certain period?
- In which pictorial categories is the agency strongest? Which agencies does it consider its biggest competitors?
- How many people are on staff? How many photographers are represented in the files? Will the agency give out photographers' names to other photographers?
- How are pictures filed? Are archival materials used?
- How many photographs does the agency have on file? How often does the agency edit the files for outdated material?
- How many images do the most successful agency photographers have on file?
- Does the agency publish a catalog? Do photographers have to pay if their work is included?
- Does the agency send out promotional pieces, and does it advertise? Do photographers have to share the cost for any of these?
- Are photo buyers charged a research fee? Is it deductible from the leasing fee later?
- Does the agency charge holding fees when buyers keep pictures beyond a stipulated time limit? Does the photographer get a share of such fees?
- Does the agency try to get assignments for photographers? What is its commission?

- How much are clients charged for lost or damaged chromes?
- If dupes are made of chromes, who pays the costs? What happens to the dupes if the photographer leaves the agency?
- What happens to photographs if the agency changes ownership? In case of bankruptcy? In case the owner dies?
- Does the agency ask the photographer's permission before it agrees to a buyout?
- Does the agency supply photographers with "want lists"?
- Do the agency files include pictures taken by the agency staff or owners?

Pros and Cons. Here are some additional factors to consider before deciding whether or not to use an agency.

- The agency has established markets where your pictures may be salable more quickly and more often. The agency also has a professional reputation that will take you time to build.
- You will have more time to take pictures and contact clients for assignments. After shooting stock pictures, all you need to do is number, caption, and edit them, and send the best to the agency. It will choose those it feels are most salable and return the rest.
- You can be affiliated with more than one agency if the agencies do not overlap competitively. I have photographs for sale at three stock agencies. One is large and has widely extensive files. Another specializes in nature and agriculture. The third is also general but is located abroad. I send pictures to all three, and find their needs differ as well as overlap. Each agency knows I work with the others but their competition in the same markets is minimal.
- An agency should be able to get established prices for your pictures because it is bigger than you are. However, agencies give volume discounts, such as 10 percent or 12 percent to, for example, some textbook clients. In addition, some agencies may not hold the price line firmly because they have so many photographers' work at stake and don't want to lose a client for everyone.
- An agency contract may bind you for three to five years, during which time you might find yourself disillusioned with the agency's sales results and operations.
- Once you are no longer contracted to an agency, it may take a year or longer to get all your photographs returned.
- An agency may sell your work satisfactorily but communicate poorly, sending infrequent statements, lists, or letters.

SUMMARY

Selling stock photographs, whether by yourself or through a agency, is an exacting business that you have to learn through experience and by asking questions. To make a decent income selling your own stock, you have to shoot and sell photos consistently. This applies to working with an agency as well, although you leave the selling to the agency.

9

Book
Photography

Although more than 30,000 books are published annually, only a minority are truly picture books, and relatively few are illustrated with photographs. Nevertheless, photographers try to sell their pictures to book publishers for several reasons. The prestige of having photographs published in a book is always alluring. Also, a book remains in the marketplace much longer than a magazine or brochure does. Photographers find that leasing pictures to illustrate books is gratifying too, and can pay well. But a book project is most exciting and lucrative when it's all yours, and enough copies are sold—so that you earn more than the advance. Ideally, if you can lease pictures from stock, get paid an advance, and share royalties, your chances of doing well financially are also good.

INITIAL APPROACHES

Photographers get involved in book projects in various ways.

- A photographer comes up with the idea and proposes it to a publisher. The photographer may be able to write as well as shoot the pictures.
- A photographer and a writer submit an idea to a publisher and plan to work together, on a fifty-fifty basis. How the income, the expenses, and the work are divided may vary.
- A book is already written and a photographer is asked to take all the pictures for it. The photographer should receive a contract, an advance, and royalties separate from those of the author. If a flat fee is offered, the photographer should be sure it's high enough because an advance and royalties are usually more lucrative on a successful book.

105

- A photographer is assigned to shoot pictures to illustrate part of a book and has a contract with a publisher. The photographer may have to negotiate to be paid royalties and an advance.
- A photographer leases pictures from his or her stock file to illustrate all or part of a book. Russell Munson, who already had a number of pictures of seagulls in his files, shot only a few more days to get additional images for *Jonathan Livingston Seagull*. He asked for and received his own contract, advance, and royalties—and later bought a new airplane with his earnings.
- A photographer leases stock pictures to illustrate a book jacket or a portion of a trade book, textbook, or encyclopedia, and is paid by the picture.

TYPES OF BOOKS

A photographer's involvement and the type of picture sale depend on the nature of the book.

Trade Books. Trade books are fiction and nonfiction books sold in bookstores, by mail order, or through book clubs to the general public. Most of the books on counters and shelves in a bookstore and at your library are trade books. This category includes children's books and most how-to books.

How-to books. How-to books cover such subjects as photography, gardening, home repair, and cooking. You may originate a how-to idea, write the text, and take the pictures; this gives you the most control and best opportunity for income. You may also bring the idea to a writer or publisher and arrange a collaboration, or a writer or publisher may come to you.

Children's books. Children's books offer unique opportunities for photographers. Only a minority of children's books are illustrated with photographs, but the creative urge to write and shoot for young readers can be rewarding. For children of kindergarten age and younger, books are short and words are few. The subjects often involve fantasy, so hand illustration abounds. For children who can read, many factual subjects can be adapted for photographic presentations. Children's books take less time to do than adult books and fewer are published, but they generally stay on the market longer.

Textbooks. Textbooks are published primarily for schools and colleges; the category includes encyclopedias. Such books are often illustrated from stock files, though some textbooks generate specific photographic assignments. You may be asked to shoot or supply chapter-opening pictures as well as other illustrations. Textbook photographs may be paid for on a day-rate or job-rate basis or by the picture. If you can, arrange to be paid an advance and royalties. But most textbook publishers want to pay a flat fee. Try to get additional money for successive printings.

CREATING PICTURE BOOKS

There are a limited number of coffee-table books published because they are expensive and generally do not sell well. The glamor and creativity of these books usually comes from the photographer, although the publisher may originate a project. These books are usually reserved for photographers with established reputations, who serve as inspirations to photographers aspiring to the top of the profession.

Themes. If you have a theme—an idea—for an ambitious project, summarize it in words, take pictures that explain and dramatize it, and think about sequences, but don't worry about a layout. When it comes to negotiating with a publisher, consult other photographers who have done picture books, even if they are strangers. Speak to several photographers whose book(s) you admire and ask questions about advances, royalty percentages, print runs, and the reliability of specific publishers. Many successful picture book creators will give you valuable guidance to help boost your professionalism.

Wouldn't everyone want to have a one-person show of his or her work between the covers of a book? Well-known photographers, including David Douglas Duncan, Ansel Adams, Walker Evans, Ruth Orkin, Elliott Erwitt, Susan Meiselas, and Jerry Uelsmann, have published such books, sometimes in connection with a museum exhibition.

It takes a fine reputation, or outstanding photographs for a publisher or museum to be interested in you as the subject of a picture book. Depending on how skilled a negotiator you are and how well a publisher thinks your book will sell, your advance might range from $5,000 to $10,000—or higher. For 99 percent of us, this type of book is simply a fantasy. And for many famous photographers who have done such books, I suspect the experience has been ego-satisfying but disappointing because their books did not sell well.

If you are still interested in the one-person show, a few of the books you might look at as outstanding examples are *The Creation*, by Ernst Haas; *Virginia: An Aerial Portrait*, by Robert Llewellyn; *Minamata*, by W. Eugene Smith; and *The Photography of Max Yavno*, with text by Ben Maddow. You will find some beautiful photographic picture books greatly discounted in bookstores—because they have not sold very well. Publishers undertake such projects because the books reflect well on their reputations, and because certain collections of photographs and distinguished photographers deserve to be in books.

Don't let me discourage you from dreaming and from persevering with a book idea until it is photographed and published. For example, you might become familiar with the work of David Plowden who has done a number of books, such as *Bridges*. I'm certain he has dedication and conviction along with salable ideas. At some time in the past he was willing to gamble time and energy on his ideas and reputation, and he has many books to show for his efforts.

Collaborating with a Writer. Not every photographer is an accomplished writer, so good photographic ideas and excellent photos may be overlooked. Team up with a professional writer to open the door to doing a book.

Agreements and contracts. When you collaborate with a writer, it usually doesn't matter who comes up with the original idea if the work you do together is relatively comparable. In this case, you should split the royalties and the advance equally, and each of you should have a separate contract with the publisher.

At the start, before a contract is drawn up, the two of you should write and sign an informal agreement covering terms on which you agree. Include such items as money, by-lines, whose agent or attorney will handle negotiations, and all other aspects of the project that need to be clarified. Even if you're working with a friend or relative, put your agreement in writing to help prevent misunderstandings later. Such an agreement will also guide an attorney, agent, or publisher when they make out your contracts.

If a publisher refuses to give you and a writer separate contracts, both of you should review, refine, and once more sign your own agreement about dividing income, work, and credit. Be sure that subsequent printings and the reprinting of excerpts of the work for other books or for magazines are included in your agreement. Take into account that if the part of your book that is reprinted contains more pictures than words (or vice versa), you might want to arrange for a proportionate split of the income.

Dividing responsibilities and expenses. When a writer and photographer collaborate on an equal basis, they often share expenses for research and photography. The writer may assist the photographer: during the shoot the writer may suggest valuable ideas, which may then add to the necessary research. Years ago, my wife Barbara and I collaborated with writer Jon Madian, who already had a commitment from a publisher for a children's story on the Watts Towers, titled *Beautiful Junk.* We teamed up to find locations and models, and Madian was there throughout the shoot. The publisher agreed to my layout for the pictures Madian and I had chosen together, and the sequence was followed closely. Since Madian had written and sold the book idea before my wife and I became involved and had contributed a number of ideas for the photographs, we agreed that 60 percent of the royalties would be Madian's share. This compensated him for his effort and for creating the idea.

To create a book proposal, it is often worth working with a writer without payment to ensure your having preliminary photographs to show. This is called enlightened self-interest. Decide how much work you each need to do on speculation in order to present the book idea adequately.

MAKING A BOOK PROPOSAL

When making a book proposal, keep in mind that many book editors and publishers are "word people." Because they think in verbal rather than pictorial terms, they are usually first interested in the text of a potential book project. They may consider the photographs secondary. The pictures may take up more pages, but the words often get primary attention from editors.

Though photography is sometimes considered less important in publishing, making a book proposal usually includes the following:

The Idea. You need a theme, topic, or subject in which photographs are primary—or at least very important. Research will show you if there are books on the market similar to the one you propose. Look in the library for *Books in Print* (R. R. Bowker Co.), which is published annually in separate volumes and lists book subjects, authors, and titles. Compare potentially competitive themes to help you decide if your idea is valid.

Study the book field and its various categories. Analyze picture books that you like or have sold well. Talk to librarians and knowledgeable bookstore personnel. They can give you valuable and practical information about what books have sold well or are frequently borrowed.

In both the children and adult fields, it's not easy to find ideas that are fresh enough to sell easily, but variations on a theme are common. If you are motivated by something you have experienced or by the potential salability of a subject, your chances of success improve.

The Proposal. Write a description of the book you want to do and if appropriate, make a list of the chapter headings with a short synopsis of each. The length of a book proposal can be three pages or longer, depending on what's necessary. Explain your idea, estimate how many pages the book might be, describe the potential audience, and include anything else you feel will help an editor understand what you want to do. Write a tentative introduction to the book; this is often a sales pitch explaining why the book idea is terrific. You can revise this later. If writing is difficult for you, search for a collaborator through a local writer's group or through a university writing class. Write separate captions for some sample photographs and send both with the proposal. Ten or twelve photographs may be enough. The pictures may come from your files or you may shoot them to suit a theme. Dupe color slides are acceptable, as are $3\frac{1}{2} \times 5$ color prints.

Package the words and pictures of your book proposal in a proper folder and enclose a one-page cover letter. If the idea is rejected, examine it with a fresh eye, and make any revisions needed.

BOOK CONTRACTS

Once your book proposal has been accepted by a publisher, you will negotiate your contract. Book contracts vary from one publisher to another, but they have certain elements in common: they are com-

plex, are often written in "legalese," and tend to protect the publisher more adequately than the writer or the photographer. Take a look at ASMP's sample book contract (reprinted in the Appendix), which includes some ideal provisions that you probably won't find in most publishers' contracts. Nevertheless, familiarize yourself with the ASMP model book agreement as a basis for negotiating. The ASMP sample contract provides for the following:

Rights. There are United States rights, foreign rights, world rights, serial rights, reprint rights, and paperback rights, among others. Understand what each term covers and negotiate the extent of the rights you are granting. In general, publishers want all subsidiary rights (foreign, paperback, reprint) to the book, but these are negotiable. (Don't confuse these rights with ownership rights to the photographs, which should remain yours along with the copyright to the book; see the next section.)

Traditionally, a hardcover publisher has the right to make a paperback deal, but you may have the right to try and improve any offer he or she obtains. Your contract may also allow the publisher to sell foreign rights, though many literary agents try to keep these in the name of the author and/or the photographer.

Copyright. A book should be copyrighted in your name or in the names of the writer and photographer, not in the publisher's name. Even if all your photographs are copyrighted, a book copyrighted by a publisher gives the publisher control over the fate of the book. You should avoid this.

Delivery and Indemnification of Pictures. The contract should indicate approximately how many photographs are expected, and should make the publisher responsible for any loss or damage to the pictures while they are in the publisher's possession. In ASMP's sample book contract, the publisher insures the photographs (including those not selected for the book but delivered by you) through all stages of publication. An estimate of the value of each color photograph may be included in your contract. A $1,500 figure is often used, though this is negotiable.

Return of Pictures. The contract should include a stipulation that all photographs will be returned to you after the plates are made, although thirty to ninety days after publication of the book is less restrictive. You may need to be flexible on this, as well as diligent.

Approvals. Good contracts contain a clause that states that the photographer will be informed when photographs are being cropped or altered, so he or she may discuss the changes, and approve or disapprove.

Some contracts include a clause that says that if the material (words or pictures) is "unsatisfactory" to the publisher, and the revision of this material is not satisfactory, the publisher can decline to publish your book and terminate your contract. The contract may also state that you must return any advance money already paid to you. To avoid any such demise of your project, arrange to submit portions of the book as you complete them. An editor can then make objections or suggestions as you go along, thereby eliminating the risk of rejection when the work is done. Keep in mind that a perceptive editor can make strong contributions to your book.

Warranties. Through the warranty clause, the photographer guarantees that he or she owns the rights to the pictures, that the words are original, and that no plagiarism is involved. The publisher must protect the photographer from any legal action arising from the insertion of material or the alteration of pictures done without the photographer's permission.

Advances. An advance is money paid to the photographer that is charged against the royalties the book will eventually earn. In normal circumstances, the advance is paid in three portions: on signing, on delivery and acceptance, and on publication of the book. Make an attempt to be paid in two installments.

The amount of money you receive in an advance varies greatly. For a first book, expect a modest advance, unless the subject is very timely or you're a persuasive negotiator, or both. Advances increase as you do more books or as your reputation gets brighter. As of this writing, you might be offered as little as a $3,500 advance or as much as a $10,000 advance, depending on the type of book and publisher, and the prospects of healthy sales; an average advance ranges from $5,000 to $7,500. The amounts are not consistent because of the subjects, books, publishers, and photographers involved.

Advances for children's books are usually smaller than for adult trade books because the former sell for less money, but they do sell over a much longer period of time if they are successful. These advances range from $2,500 to $5,000.

Avoid doing a book with a contract but without an advance. You take all the risk, and having made no investment, the publisher may decide to reject your book for trivial reasons. You should also refuse to accept a flat fee for a book, without royalties, unless the amount of money is unusually high. It is frustrating and self-defeating to shoot and write a book that becomes successful without receiving royalties in proportion to the book's sales.

Royalties. If at all possible, royalties should be based on the retail price of a book, also called the cover price, as sold in the United States. However, some publishers of illustrated books now pay royal-

ties on the net price of the book—the wholesale price—which is about 40 percent less than the retail price. If you are offered a net-price arrangement, contact a couple of other photographers or writers whose books the publisher has done, and ask on what basis they are paid. If they had to accept net-price royalties, you may find some consolation in knowing that you are not alone.

Royalties usually increase on a sliding scale. For example, if you have done both the writing and the photography, you might receive 10 percent on the first 5,000 hardcover books sold, 12½ percent on the next 5,000 copies, and 15 percent thereafter. For paperback books, the figures may be 6 percent on the first 10,000 copies and 10 percent thereafter, because profit margins are lower on less expensive books. On mass market paperbacks, which are sold in drugstores and supermarkets, royalties are typically about 6 percent on the first 150,000 copies and about 8 percent thereafter, though a higher percentage can be negotiated. Expect to receive half of these amounts if you have an equal partnership with a writer.

Percentages also vary on the paperback edition of a hardcover picture book. Traditionally, the hardcover publisher and the photographer split the proceeds from the sale of paperback rights equally. In some cases, however, the photographer may get 50 percent of the first $10,000, 60 percent on the next $10,000, and finally 70 percent of any further income.

Royalties are usually paid twice a year, thirty to ninety days after June 30, and thirty to ninety days after December 31. A contract that stipulates payment in sixty days is typical.

Failure to Publish. Every book contract should include a date by which the book must be published. The average time period is twelve to eighteen months after acceptance of the book. Infrequently, editors change or the publisher's goals are revised, and an accepted book is seriously delayed. In such a case, the contract should provide for the publisher to return all photographs and text to you, unless you feel that a later publication date won't harm the potential of the material. If the pictures and manuscript are returned within an agreed-upon time period because the publisher chooses not to publish, the contract should state that none of the advance be returned.

If you realize that you will miss a deadline for delivery of pictures and text for your book, be sure to forewarn the publisher and if possible, get an extension. When photographers have invested a great deal of time and effort, publishers are often understanding, and will try to arrange additional time.

If the photographs for a book require expenses for travel, hotels, and lots of film, try to persuade the publisher to share these expenses or to pay all of them, *separate from the advance on royalties.* Unfortunately, publishers usually expect photographers to pay their own expenses, and if money is advanced for expenses by the pub-

lisher, it usually is charged against royalties. Explain to the publisher that the more financial cooperation you get, the better your opportunities to take outstanding photographs and create a superb book.

For more information about publishing contracts, take a look at Tad Crawford's *Legal Guide for the Visual Artist* (see the "Suggested Readings" list).

BOOK PHOTOGRAPHY FEES

Whenever you sell your photographs to a book publisher, you must carefully determine your rates and submit invoices. Day rates for trade books and textbooks are listed in Chapter 5 under "Editorial Day Rates." Individual picture rates for trade books and textbooks are listed in Chapter 8 under "Books."

In addition, if you lease photographs or shoot them on assignment, and do not have a contract because royalties are not involved, use a photo delivery form to cover rates and rights, or stipulate your rates and rights on the invoice. This is very important. Recently, a friend of mine, Marilyn Sanders, was assigned to photograph an author for a book jacket. She charged $500 and wrote on the invoice, "For jacket use only." When the check arrived, it said, "For jacket and promotional use." Sanders immediately contacted the publisher and explained that an additional $400 would be charged for photographs of the author sent with review copies of the book. When such pictures are printed with reviews, they add to the publicity the book gets. The publisher agreed. Someone in the accounting department was not aware of how photographic rights are categorized and did not pay attention to Sanders' carefully written invoice. Because she had written proof, Sanders was reimbursed.

BOOK PHOTOGRAPHY QUESTIONS AND ANSWERS

Question: Is it necessary to use a literary agent, a picture agent, or an attorney when negotiating a book contract?
Answer: It's not necessary, though it's often advisable. But you must find an agent or attorney who is knowledgeable about the contract ramifications of picture books, which are different from those of a written book. Solicit advice about representation from published photographers. Literary agents who are well informed will usually require only a 10 percent commission, but many are unfamiliar with the ins and outs of picture book publishing because so few picture books are published. Attorneys may have the same limitations, even if they have worked on other photographic legal problems. Picture agency personnel often know the book field well. If you are affiliated with an agency, ask an agent for advice about a book contract or have an experienced agent negotiate for you.

A book contract can be a maze. The more familiar your representative is with the problems a contract may cause a photographer, the better the book deal will be for you. If you must tackle a contract on your own, at least consult with someone who's been through the same maze before.

Q. How do publishers determine their budgets for advertising and promoting a book?

A. Publishers spend money only on the books most likely to sell well. Occasionally, they advertise picture books for the prestige they bring the company, even if a healthy sale isn't anticipated. But only a potential best-seller gets much advertising money as well as a budget for promotion, which can provide for sending the author on a personal appearance tour. Resign yourself to promotion through book reviews in magazines and newspapers, or through magazine excerpts from your book. Publishers send out review copies liberally. See that any influential people you know get copies. With so many books published each year in the United States, competition for review space is keen.

Q. Today's books seem expensive. How is a book's price determined?

A. The figures that follow will probably not help you negotiate a contract, but they are revealing. Publishers try to achieve a 4:1 or 5:1 ratio between manufacturing cost and the cover price of a book. Thus if a book is priced at $20, it should cost between $4 and $5 for paper, printing, and binding. Picture books cost more because color-separation costs boost the price of printing. A $20 book is sold to bookstores for about $10, and less with quantity discounts. From the $10, the author with a net-royalty deal gets $1 on each of the first 5,000 or 10,000 books. Production costs; overhead, including cost of distribution, promotion, and advertising; and profit account for the rest of the net-sales price.

Q. How feasible is it to publish a picture book on your own?

A. Self-publishing sounds satisfying since you theoretically make more money than you would make through royalties, but it's risky and challenging because you must pay all costs. You shoot the pictures, write a text or have it written, hire a printer, supervise production of the book, and hope you don't go broke. Your next problem is distribution—a mountain that few self-publishers climb successfully. It is possible to find book jobbers or distributors to distribute a self-published book, but the book itself has to be very appealing—it must look like it will be popular and will sell well. Without conventional distribution, you'll have to fill your automobile trunk with books and visit hundreds of bookstores that will only take books on consignment, which means that you don't get paid until the books are sold—and they may even be returned. You can also sell your book through mail order, which requires an ad budget plus enormous amounts of faith and energy. But this may be more appealing than endless driving from city to city acting as your own distributor.

Self-publishing is not "vanity" publishing, the term used for subsidized publishing: for a fee, your book is printed and attempts are made to have it distributed. In general, vanity publishing is more an indulgence of writers than photographers. It would be

quite costly to farm out a picture book to a vanity publisher. Read some books on self-publishing before you dream too extensively.

A variation of self-publishing is book packaging. You sell a book idea to an established publisher, who agrees to buy a certain number of copies and to distribute the book. You get an advance, shoot the pictures, write the text or have it written, supervise the printing and binding, and have copies delivered to the publisher/distributor, whose name may also be on the book. You get the rest of your money, and are only needed again when the distributor wants more copies. The higher profit on these additional copies is a bonus. However, you need the highly polished skills of a renaissance individual to package your own books, and few packagers of picture books have been successful.

SUMMARY

Picture books are great for the ego, often a gamble for the publisher, and usually a gamble for the photographer who is paid through an advance and royalties. To cut costs, many publishers print their picture books abroad, where reproduction of color photographs can be superb and less expensive.

No matter how you are connected with a book publishing project, read contracts carefully and ask questions. Keep track of your pictures. Try to get them from publishers in a reasonable amount of time after the book comes out. Don't be afraid to request that your valuable images are protected. Finally, don't allow the glamorous light of being published in a book blind you to the realities of good business practice.

10

Fine-Art Photography

Many media photographers have recently started selling pictures as fine art to individual collectors, museums, and business clients. In general, fine-art images are created with exhibition or sale to individuals in mind. While a large number of fine-art photographs are black and white, color is becoming more commercially viable. Still, relatively few people today can support themselves by selling photographs to hang on the wall.

Fine-art photography rates and rights differ from those of media photography. First, you are not selling reproduction rights, you are selling exhibition rights. In addition, prices are predicated on a mystique based on the artist's reputation and style generated by promotion and publicity—rather than on circulation, ad space rates, or news value of the pictures. Finally, the business aspects of fine-art photography are sometimes rather curious.

FINE-ART PHOTOGRAPHY SUBJECTS

Stark photographs, like this shot of rocks, are popular with collectors and galleries.

Unusual photographs, individual shots, or shots in a series can be sold as fine-art photography. The range of styles and treatments varies greatly, from the ridiculous to the sublime, and is expanding rapidly. Conventional beauty, formal design, and familiar subjects aren't necessary. While Edward Weston's style of purist realism is internationally appreciated, all types of imagery sell today. There are painterly, soft-focus pictures; journalistic, snapshot-type images; bizarre and erotic images; and other unconventional approaches, such as putting scratch patterns on negatives of ordinary subjects, printing them, and then hand-coloring them, or putting an "X" on a negative and showing the print as "cancelled" art. Photographs that combine handwork with ink, spray paint, or darkroom manipulations are sold as fine art as well.

The highest-priced individual fine-art photographs are still those by such masters as Edward Weston, Ansel Adams, Paul Strand, and Alfred Stieglitz. These artists worked almost entirely in black and white and used large-format view cameras. In fact, some of Weston's images recently sold at an auction for more than $2,000.

To discover the broad variety of fine-art photography on the market, go to museum exhibitions and gallery shows. Note the wide spectrum of subjects and styles. Try to create a fine-art image. Photograph a friend at high noon or with flash, sitting in a saddle mounted on top of a cinderblock wall. Then color the picture by hand or print it so darkly that you can barely see any detail. You will find that almost anything you shoot, especially if it's a bit eccentric, has potential sales value.

COLOR VERSUS BLACK AND WHITE

Many fine-art photographs are black and white because the masters of the medium worked in black and white. Furthermore, color prints have less archival quality. Most photographers, curators, and collectors believe strongly that any fine-art photograph should be archivally processed, which means fixing, washing, drying, and preserving prints with the utmost care. If processed this way, black-and-white pictures should last at least fifty to one hundred years—if they are stored away from ultraviolet light and excessive humidity. As a result, black and white remains the favorite of collectors and curators who want guaranteed chemical stability.

Color prints made on Cibachrome or by the dye-transfer process have the greatest longevity. Making Cibachromes from slides is a popular process because it costs less than dye-transfer, is more accessible, and may last fifty years or longer. Gallery prints made on conventional color papers may not fade or change color for twenty years or more. In some cases, the artist arranges to replace faded prints using the original negatives or transparencies. When you set a price on a color print, take its archival quality into account.

Unlike curators and collectors, *decorators* are not very concerned with photographic permanence. Many interior designers feel that photographs used to decorate public places can and will be replaced by other images every five to ten years. A color print that won't fade in ten years is preferable to a black-and-white shot that is less aesthetically appealing. Whether you concentrate on black and white or color depends on the area you live in, the advice of gallery owners, and your own taste.

FINE-ART PHOTOGRAPHY OUTLETS

You can sell fine-art photographs by yourself, showing them at your home or studio, or taking them to prospective buyers. If you have enough images to interest a variety of tastes, you might have an illustrated brochure printed to give to potential clients.

Collectors. A modest number of collectors, concentrated in large cities, buy pictures from living photographers, some of whom are

unknown or are gaining stature. They may discover you through a gallery, through work reproduced in magazines or books, or through your direct solicitation. A collector who finds someone at an early stage in his or her career gets the pleasure of encouraging new talent, and often enjoys lower prices than those the general public pays. Taking on the role of patron, a collector may recommend you to others, and to gallery owners and museum curators as well.

Galleries. Many cities have established galleries specializing in photographs, even though the boom in fine-art photography is over. One of the first and still one of the best is the Witkin Gallery in New York City. The gallery publishes a catalog of its holdings, which includes dozens of examples of work by photographers it represents. Two auction houses also publish catalogs of classic and contemporary photographs: Christie's and Sotheby's, both in New York City. These catalogs, among others, provide a good survey of the types of fine-art images available today, as well as approximate prices.

Most dealers of fine-art photography are particular about the type and style of pictures they offer for sale. Photographic quality, aesthetic and archival, is important. Tastes vary, so the range of subjects is great. Along with your work and that of your contemporaries, galleries exhibit and sell pictures by such masters as Wynn Bullock, Imogen Cunningham, Harry Callahan, Ralph Steiner, Clarence John Laughlin, Emmet Gowin, and Jerry Uelsmann. Gallery owners also like to make their own discoveries, hoping that a newcomer's work will have popular and critical appeal.

Decorators and Processing Labs. There is always a market for photographs of landscapes, other scenics, flowers, nudes, and marine subjects. Interior decorators, department-store decorating services, poster and picture shops (often located in shopping malls), and some processing labs stock and sell these popular images. Some shops and galleries sell photographs along with other kinds of prints and decorative paintings. You may also be able to find a store willing to display your pictures as part of its decor. You and the directors of these outlets determine fees together, and on a regular basis you may add to or change the picture selection of your work to stimulate more sales.

Decorators and processing labs sell to individuals, but concentrate on business offices and other commercial settings where pictures on the wall are important but are not fine art. The prices may be lower than those charged by galleries, but the sales volume is higher. If you have the kind of pictures that are popular, show them to decorators and to labs where they may be displayed for sale.

Additional Outlets. Some cities have regular outdoor art/craft/photography shows on weekends in shopping centers and parks. Renting display space depends on what you have to sell and if you wish to

price work low enough to attract passersby. Check the possibilities at such a spot, and ask other photographers for their opinions and experiences.

Secure your pictures to prevent theft. Consider buying insurance if there is no security. Your pictures are valuable, even if they don't carry high prices. Be certain also that your photographs include a copyright notice and are stamped, "Not for reproduction." The public is usually unaware of a photographer's rights, and unscrupulous people may be looking for unaware exhibitors.

When you leave a selection of your pictures with a curator, collector, or decorator for evaluation, make a delivery list in duplicate and have one copy signed as a receipt. The wording might be:

The undersigned agrees to protect with reasonable care my photographs numbering (number) prints and (number) slides left for review by (your name) on (date), and to be responsible for their loss or damage. The value of each photograph is shown on the delivery list. It is understood and agreed that none of the photographs listed by title and/or file number below may be sold, lent, or used in any way without the permission of the copyright owner. The period of review covered by this agreement is (number) weeks, after which the undersigned will return these images to the photographer.

Protecting images. When making arrangements to drop off photographs at galleries, museums, or interior design or business firms, be flexible, but don't be careless. Try to get information from other photographers about the place you intend to leave pictures before you commit yourself. Don't be overcome with gratitude if someone agrees to sell your work, so you're not inclined to undervalue yourself and your photographs.

A SAMPLE GALLERY AGREEMENT

Agreements or contracts with galleries and other outlets where fine-art photographs are sold may be less standardized than those photographers make with publishers or ad agencies. The following sample agreement can be revised to suit specific needs.

PHOTOGRAPHY DEALER/PHOTOGRAPHER SALES AGREEMENT
1. The photographer (your name) is to furnish the dealer (dealer's name) initially with (number) photographs on consignment. Additional prints are to be furnished according to mutually agreeable arrangements that may be included elsewhere in this agreement. All photographs are to be signed, dated, titled (optional), and matted by the photographer.
2. Any framing of prints will be done at the discretion and expense of the dealer. If the prints are not framed, the dealer is to protect the prints in an effective way, such as a plastic casing or cover.

3. The dealer will be wholly responsible for any loss or damage to any print while in the dealer's possession. This shall include occasions when the prints are in another's possession with the dealer's permission. The dealer will pay the photographer for materials and $50 (or whatever seems appropriate) per hour labor to replace damaged prints. The photographer will be paid his or her share of current market price by the dealer, for any prints lost, and shall replace such prints by mutual agreement.

4. The dealer shall exhibit or have available for viewing all of the photographer's prints on hand, along with sales prices, and shall offer information about the photographer if asked.

5. The photographer shall make no direct sale of photographs in the dealer's inventory, and shall refer prospective buyers to the dealer.

6. The basic selling price for the photographer's 8 × 10 prints shall be $ (amount) each, and for 11 × 14 prints $ (amount) each.*

7. The dealer's commission is to be (amount) percentage of the selling price.** Any discount given by the dealer to a buyer shall be taken from the dealer's portion of the selling price.

8. All sales are to be accompanied by an invoice that includes: the name of the buyer; the price, title, and file number of the photograph; notice that all photographs are copyrighted by the photographer; and a restriction that photographs may not be reproduced or exhibited in any way without the permission of the photographer.

9. The dealer agrees and shall inform buyers that no copies, prints, or slides may be made of any prints for any purpose without the knowledge and consent of the photographer.

10. The dealer agrees that no prints may be sold to any other dealer except for said dealer's personal use.

11. The photographer agrees to provide the dealer with additional prints at times and in quantity agreed upon between them.

12. This agreement shall remain in effect for at least one year from the date of signing. This agreement may be renewed, revised, or cancelled by either party on each yearly anniversary date. The dealer agrees to raise prices of prints after request and sixty days notice by photographer.

13. All prints returned to the photographer shall be carefully packed and insured, and postage or delivery charge shall be paid by the dealer.

Dealer _____

Photographer _____

Witness _____

Date _____

Place _____

*Note: Set a minimum for both black-and-white and color shots.
**Note: Twenty-five percent to 40 percent is fairly standard.

FINE-ART PHOTOGRAPHY FEES

When you start selling your pictures as fine-art photography, talk to other photographers, check the prices on newcomers' work in galleries, and look at prices in catalogs. You may find that the larger the print, the more it costs. Also, the better known a photographer becomes, the more he or she may charge. The following guide, based on my experience and observation, will help you price work sold to collectors or to business firms.

FINE-ART PHOTOGRAPHY RATES

Black-and-white prints, 8 × 10
Charge $100 to $150 when starting out
Increase price in $50-increments to $300 or $350 depending on the locality and market

Black-and-white prints, 11 × 14
Charge $150 to $250 when starting out
Increase price in $50-increments to $400 or more as reputation builds

Black-and-white prints, larger than 11 × 14
Charge $250 to $300 for 16 × 20 when starting out
Increase price in $50-increments to $450 or more as reputation builds
For even larger prints, determine price by reputation and market potential

Color prints, 8 × 10
Charge $150 to $250 when starting out
Increase price in $50-increments to $400 or more as reputation builds

Color prints, 11 × 14
Charge $200 to $300 when starting out
Increase price as reputation builds

Color prints, larger than 11 × 14
Charge up to $500 or $600 depending on the locality and market

Notes:
1. All prices are for mounted, matted photographs, unframed. Price frames separately, with appropriate markup.
2. The cost of having a print made will affect the charge, but don't try to directly relate lab charges to your charge for prints. Prices differ for better custom printing, and masking and other special services add to the cost. If the print prices you charge seem low in comparison to the cost of color printing in your area, adjust accordingly.
3. You may tell buyers that charges are higher for archivally made prints because they have a longer life.
4. Prices for photo murals vary; check on how much you must pay to have prints made and add a suitable fee to match the current market value of murals.

"Artistic" and "commercial" fine-art photography may be considered separately or together. Museum curators and a few top gallery owners set an aesthetic pace that collectors tend to follow, and success is imminent when critics climb on the bandwagon. Then prices rise as well. Trendsetters look for the unconventional, the obscure, and the visually provocative. In *Developing Your Own Photographic Style* (Amphoto, 1986), I suggested that some fine-art photography is the product of "articulate deception." Not surprisingly, your personal style of images will help determine their prices, which may seem illogical and arbitrary.

PRICING RAMIFICATIONS

Selling fine-art photographs is not always subject to rigid practices, so you must protect yourself.

Copyright Notice. Place your copyright on the front edge or the back of each print to inform anyone that usage and reproduction rights are not covered by the print price. Include rights restrictions in the invoice you give a client. Business firms that hang your pictures should understand they may not publish them. The same restriction applies to individuals, especially collectors, who may be asked to lend your picture for reproduction in a magazine, catalog, or book. You can allow a museum or gallery to reproduce pictures in a catalog or promotional brochure, but you should stipulate that your copyright notice be included with the reproduction.

Prints for Friends. When dealing with friends, keep this economic principle in mind: Charge what the traffic will bear. If you cannot charge friends and relatives your usual fee, don't undercut yourself too much. If someone offers to pay only for the printing, be sure that the price includes mounting, matting, and framing. Be realistic, tactful, and self-protective when explaining prices to friends and relatives, even if you are just charging expenses.

Decorators. Most decorators will know how to price your photographs according to the style, subject matter, size, quantity sold, client budget, and your reputation. You may not know exactly how much a decorator's client pays because you may get an advance and agree to a specific price per print. The decorator acts like an agent, placing your work and taking a commission.

Decorators in department stores and other shops may want to buy prints from you at what become wholesale prices, and set their own prices for the public. Negotiate, using the average prices as a reference if a decorator undervalues photographic prints. Offering pictures at too low a price can put you at a great disadvantage. There is a fine line between practical pricing and a frustrated ego.

Museums. Museums are nonprofit institutions, and they help build reputations. As a result, you may want to accept slightly lower prices

from them. Many museums will ask a donor to buy your works at reasonable prices and give them to the museum as a tax write-off. You cannot deduct the selling price of your own prints as a business expense when you give them to a museum to be sold, but you may want to donate a picture or two as a gesture of goodwill. This also allows you to say that your work is in a museum's permanent collection; the prestige that comes from this can enable you to raise your prices.

Collectors. If a collector wants to buy your photographs and no gallery is involved, you may ask a slightly lower price. Make this decision carefully. Selling directly to a collector gives you room to reduce prices and negotiate within limits. Avoid being too generous, especially if you are short of money. "Starving artists" have traditionally been the targets of exploitation.

Additional Outlets. Most likely, galleries, department stores, decorators, fine-art photography dealers, and gift shops already have a pricing system in effect. The photographer may receive between 50 percent and 85 percent of the selling price, depending on the circumstances. A gift shop may take 50 percent because its volume is small, while a gallery may want only between 20 percent and 30 percent and an auction house may take only 15 percent. Dealers will negotiate when you have a good reputation and your work promises to sell more readily. If a dealer includes a frame in the price of the picture, the price should be boosted accordingly.

Show Expenses. If a gallery accepts your work for exhibition, it may ask you to share the cost of the show's opening, for announcements, publicity, and refreshments. Depending on the gallery and its commission, you may ask to split expenses. If possible, try to pay a minimum amount or nothing at all. An opening is one of the costs of doing business; it poses certain financial risks to you and the gallery, because sales are not usually predictable. If you are asked to pay for frames, arrange for the gallery to make the capital investment because this cost is passed on to buyers.

After a show ends, the gallery usually keeps your work on hand, in bins or drawers, making it available to buyers for as long as you both agree. Let the gallery set prices for you based on its experience, but negotiate firmly when you feel prices set are too high or low.

Portfolios. Once a photographer has a reputation, a gallery may suggest putting together a portfolio of work, usually ten to fifteen mounted pictures, in a custom-made case. You may want to do your own black-and-white printing and mounting. The gallery then has promotional material printed and sent out. Prints in a portfolio are priced lower than individual prints are. In 1987, portfolios of ten prints were $1,250 to $1,500 for a relative newcomer; an established

photographer can charge $2,500 to $3,000, or more, for the same number. Portfolio expenses are shared through negotiation.

If you have the time and money, you might also offer a portfolio of your work on your own.

SUMMARY

Self-confidence is essential if you are to benefit from the mystique that surrounds the market and influences buyers and sellers.

Appropriate payments and protection of your fine-art photography rights are a matter of good sense, research, experience, and courage. Ask advice from people who know the business. Compare your work to that of others to help determine what to charge. Be prepared to start low and increase your rates as your market improves. Don't give anything away. Balance your pride against promised publicity and promotion. Furthermore, be certain that dealers and buyers understand that you retain copyright to all photographs you have taken. This means they cannot be copied, reproduced, or exhibited without your consent. Don't assume that everyone you deal with has good intentions. Finally, inform and educate others for your own safety and sanity.

11

The New Technologies

When you first see photographs being combined and manipulated by a computer, you'll find the results hard to believe. Using a huge piece of equipment that costs hundreds of thousands of dollars, an operator can eliminate the background in a photograph of a home on a rocky shore and place the image of the home in another photograph of other homes among green hills and ponds, all under a blue sky. The operator can also put children playing on a green lawn near the home by a combining a third photograph with the first two. The possibilities are endless.

HOW THE TECHNOLOGY WORKS

The process of digital imaging, the computer manipulation of photographs, translates a picture into a pattern of electronic impulses called pixels. These pixels are stored on computer discs and can be rearranged to recolor, reshape, and combine your images. The result can then be produced as a print or transparency, or as color separations ready for the printer. The process is expensive and time-consuming, and requires special skills. But digital imaging, a new technology in the graphic arts, can create images that once were only possible through elaborate preparation or on an artist's drawing board.

Digital imaging is also used to retouch or to correct colors in transparencies before or after their colors are separated. For example, if you shoot a sunset and leave the location before the sun is a deep, rust orange, the color can be enriched by computer. The process can also help to refine an image, tone down bright spots, eliminate shadows, or wash out blemishes. These are electronic manifestations of retouching. Because of their innovative effects, such new technologies are moving into the creative enterprises of ad agencies and stock-picture houses.

An image, like this one of a skier on the slopes in Oregon, can now be united via a computer's digital techniques with other images.

A QUESTION OF RIGHTS

Guarding your rights and setting rates for the field of digital imaging are not sharply defined business practices yet. Dealing with the new technologies requires caution.

Although wide use of computerized images is still in the future, advertising agencies are beginning to test the benefits of producing illustrations with a keyboard and monitor. Rather than send a photographer and crew on a more expensive location shoot, an art director can find a stock image resembling the location needed and have some models photographed picnicking in a studio against a white background. The two shots can be combined electronically, saving money, avoiding weather hazards, and giving the agency better control over elements of the picture. In addition the client can preview the picture. Revisions can be made on the computer monitor instead of with a camera at some remote spot. However, certain issues must now be resolved.

Copyright Ownership. The question has already occurred to you: Who owns the copyright to this combined image? Suppose that the stock image was leased on a onetime basis, and the photographer of the models didn't do the job on a work-for-hire basis. Two separate photographers shot individual images, were paid for them, and own the rights to them. If they both authorize the use of their pictures to make a composite electronically, is the new photograph the property of the ad agency and its client or the photographers jointly?

According to some attorneys, the newly devised photograph is a derivative work, which is defined as one based on one or more preexisting works. A derivative work may be given copyright protection itself without affecting the copyright of the original works since the new work has "additional material" in it. According to the copyright law, the new material must be "substantial." How "additional material" and "substantial" will be interpreted by the courts has not been determined. No cases involving computerized image manipulation have been decided as of this writing.

There will be complications. Suppose an advertiser using a digitized picnic scene is selling a vacuum bottle that is exported to ten different countries. For the ad campaign, a studio picnic shot was combined with ten different scenic backgrounds representing each of these countries. To set a proper fee, the photographer of the picnic scene must know ahead of time that the shot will have multiple usage. Otherwise, the photographer may become the co-holder of a copyright for each combined image if he or she did not shoot on an all-rights basis.

Though the legal ramifications regarding rights to digitized images have yet to be tested, preexisting pictures used to create a derivative work may not be used without the owner's permission. When photographers retain copyright to an image, they retain control of the way that photograph can be used.

Setting Limits. Today and in the future, photographers will have to learn how to license pictures for derivative works. A condition of these agreements will only allow clients to use the images in certain ways. For example, distortion of perspective in a scenic shot may be restricted. Similarly, an image may not be altered with unnatural color, or it may not be cropped beyond a certain point. As with usage rights, you will negotiate limitations to altering your photographs along with rates and rights, based on information given by the client.

Your rights, change, however, when you sell pictures to be combined by computer technology under the doctrine of work-made-for-hire. Here, the photographs are the property of the client, who will also own any digitally altered images created solely from your pictures. As digital imaging becomes more common, you may find that shooting on a work-for-hire basis helps to solve complex image-combination problems—if the fees are high enough to compensate for usage rights. You will not have to monitor the use of your pictures. Also, with a relatively accurate estimate about usage, you can charge accordingly and not feel cheated.

Joint Work. Do digitally composed photographs fall into the "joint work" category as the joint efforts of the photographer(s) and the computer operator, or his or her client? Under the new copyright law, the control of and income from a joint work are to be split equally between or among its creators. Some common applications: writers who collaborate on a book or screenplay, teams of photographers. Attorneys believe that a computer image does *not* fall into this category; to be considered co-creators, all photographers whose work is combined must agree at the outset that their work will be merged into an inseparable whole. This stipulation applies whether the work is done on assignment or stock photographs are involved. It seems, then, that the new copyright law provides the groundwork for protecting photographs combined through computer technology. Of course, you would have to be able to identify your own work if it were to become part of a new visual entity through digital imaging.

An effective way to protect your work is to clearly stipulate limited rights whenever you lease your pictures. Then, once they have been used, try to get the pictures back promptly. Some unscrupulous operators may use pictures they have on hand, revising them to disguise their identities, or combining several into a new image without credit or payment. But the stiff penalties for copyright infringement prevent most companies that do digital manipulation from using pictures without permission. In addition, anyone involved in an infringement can be made a party to a suit, whether or not he or she had prior knowledge of the plagiarism.

PICTURE CREDITS Since digital imaging is a new technique, few precedents exist. Be sure to request that you share the credit on the resulting image when

arrangements are made to lease your photographs for combinations. If, however, you are not pleased with the result, because your original is downgraded in some way by the manipulation, you may want to request no credit be given to you—as a service to yourself.

The question of picture credit is also related to the issue of unauthorized use of photographs. Through simple oversight or intentional deception, when a client has pictures on hand, someone may duplicate an image and save it in a computer file for future combination with other images. If and when the picture is used without permission, you probably won't be given credit. Again, keep track of your pictures, and determine if picture agencies are doing the same for you. Part of a shot you admire may be your own.

NEW-TECHNOLOGY GUIDELINES

Most of what photographers learn about the influences of the new technologies on their business practices comes from articles in magazines and trade newspapers. The following information comes from discussions with colleagues.

- Be sure that any stock agency you work with has close contact with clients and is aware of when your pictures will be combined with other shots. The stock agency should also know how to set fees for multiple combinations of your images that result in new transparencies.
- If your pictures are to be used for digital imaging, consult in the process. You should definitely know how the combined images will be used once they are on film or paper.
- Be aware that digital imaging allows operators to place people where they never were, thereby creating false images. Some subjects may object because they are embarrassed or their privacy was invaded. Also, computer composites may create situations not covered by the terms of a model release, and models may then sue you. Check with other photographers or with an attorney, or both, to revise your model-release form accordingly.
- Never allow news or factual photographs to be distorted or manipulated by a computer. Variations of the truth in news coverage can be disastrous.
- Computer systems are only as good as the people working the controls. The machines offer no substitute for talent, skill, and visual taste. The computer cannot create information; it can only synthesize what it is given.

NEW-TECHNOLOGY PHOTOGRAPHY RATES

Having been involved with ASMP and photographers' rights for many years, I charge—and I suggest that you do the same—approximately the same fee for photographic usage in a computer combination as I do for individual use of a photograph. A client may argue that "the shot isn't as important being used in a combination, so we expect a reduced charge." You'll have to learn to deal with that. If two or more pictures in a combination are yours, you might find discounting the

rate is valid. If your shot is very important in a combination, charging your full fee makes sense. As usual, a lot may depend on how a client tries to prevail on your sense of goodwill in setting a fee.

SUMMARY

The new-technology revolution is here, but computerized imaging is expanding slowly enough to be thought of more as an evolutionary process. Estimates indicate that in the United States printing industry, 80 percent of color platemaking is now done on laser scanners. Digitalization systems, now operated by independent specialists on huge, expensive machines, are expected to move, on a smaller scale, into ad agency and editorial offices. Today, *Time* can transmit an entire issue via computer, including color photographs, and can meet deadlines only hours away. In the future, several of your own photographs may be retouched by computer and/or combined on a computer screen, and transmitted by satellite to a receiving office somewhere in the United States or abroad. The picture(s) would then be reproduced in an ad, a brochure, or a book.

Electronic imaging is generating new issues in the area of the photographer's rights and rates, as well as a new class of legal and moral questions. Rights of privacy as related to model releases have to be reexamined. Manipulated images must be evaluated in relation to the truth. Copyright ownership may get tangled before sensible practices are established. Keeping track of your images is becoming even more important in order to retain proper control over their use—and to be paid accordingly.

Some photographers believe that the new technologies offer opportunities. "It takes taste to create beautiful or attractive images," says one, "and quality photography cannot be replaced by computer tricks done by operators. . . . The computer cannot create mood either." Computers can be used only to manipulate existing images taken and offered for lease or sale by photographers. As such, new markets are in the offing, as are new problems that will have to be confronted and resolved.

12

Photographers and the Law

Photographers should check to see if they need to secure special permission to shoot in certain institutions, such as this museum in Florence. They should also get model releases when possible.

A few years ago I photographed Gaston Lachaise's large sculpture called "Standing Woman" in the UCLA sculpture gardens. Visible in the background between the legs of this twelve-foot work of art was a bearded man sitting on a bench reading. Several months later, the editor of a psychology-oriented magazine bought onetime rights to the photo to illustrate an article on human behavior. The picture was used on a full page in a dignified context.

When the man in the picture saw it, he sued the magazine on the basis that he was "embarrassed" by having been seen through the legs of a voluptuous, nude woman. That she was a bronze Lachaise classic didn't matter. I explained to the editor that I had never spoken to the man, and had no release for his picture because none was necessary for editorial use, especially since the shot was made in a public place.

This was a typical nuisance suit. A person can be a nuisance by claiming an invasion of privacy or embarrassment, expecting to collect a financial settlement from a publisher who wants to avoid a lawsuit. The complaining party is usually exploiting the publisher. The outcome of such an incident, however, depends on individual circumstances.

RELEASES

A release states that the person photographed gives his or her permission to take and use specific photographs of himself or herself, or of a minor, for specific purposes. A release also informs the model of exactly what he or she is agreeing to. A signed release, then, protects photographers from lawsuits involving invasion of privacy when pictures are used for purposes of "trade or advertising," ac-

cording to the *ASMP Book*, and from libel suits involving embarrassment, loss of status and/or income. A signed model release ensures a photographer's solvency and peace of mind.

Stock-picture agencies in particular usually want photographers to get model releases whenever possible: a picture may be leased for advertising and a release is necessary.

Editorial use of photographs in magazines is neither "trade" nor "advertising." You don't need releases for pictures published in most magazines, though editors may ask for them.

When you're traveling, it is neither convenient nor feasible in many cases to ask people in public places to sign model releases. Don't bother unless you have a specific purpose. People in large crowds may not be recognizable, and in public places rights of privacy are quite limited for editorial publication. If you feel a shot has advertising potential and people are recognizable, try to get releases; at the very least, get names and addresses. Ask for releases later when you send courtesy prints. Keep in mind that pictures used to illustrate many magazine articles don't require releases because they come under the heading of "educational material."

You may take pictures almost anywhere without getting permission, except:

• At military installations, courtrooms, or any other place where photography is prohibited for legal or privacy reasons. Signs are usually posted.
• Inside museums or other institutions, at concerts, at the theater, or at other privately owned places that make their own rules. Museums often restrict photography because lenders of art require them to. Theaters and concerts must protect copyrighted material. Some places may allow you to shoot but prohibit flash and tripods. When in doubt, ask under what conditions photography is permitted.
• In private homes, on estates, on docks, or at other places that request no pictures be taken for reasons involving privacy or security. Property owners or proprietors have a right to ban cameras without further explanation. Private property is just that.
• On streets or highways where you may interfere with traffic.

Inside churches, at sporting events, on busy streets, in slums, in a neighbor's backyard, or wherever you're invited with a camera, take pictures when your creativity is challenged by opportunity. Don't allow the occasional need for model releases to inhibit you from shooting or from enjoying photography. Learn what type of publication is considered commercial, and realize that some standards are blurry. Confer with editorial clients about their need for releases before you do a job, to avoid surprises. *You* as well as your subjects have legal rights.

Required Releases. Many release problems fall under a legal umbrella labeled "right of privacy." Pictures require releases when used for "purposes of trade or advertising," which varies widely. Releases are also needed to protect you and your client when property, homes, or pets are involved (see Chapter 12).

Advertising. Releases are necessary for advertising photographs that are for "purposes of trade"—to sell goods or services in print or electronic media. Photographs on magazine and book covers, while they are editorial, are protected by the First Amendment of the Constitution. However some states, such as New York, make exceptions, so it's necessary to have releases for recognizable subjects, unless the people are celebrities.

Fiction. Releases are necessary for models used to illustrate fiction; hence the phrase, "posed by professional models."

Photographic distortions. When pictures are retouched physically or electronically, model releases are a must. Faces or figures may be distorted, and individuals may be transplanted from an innocuous location to a controversial one. These alterations can result in "compromising" conditions. When needed, be sure your release covers such distortions.

Company publications. When photographs are used in company magazines for distribution to a wide audience—such as *Friends* published for Chevrolet owners, and *Ford Times* published for Ford buyers—editorial matter may be considered commercial. For decades, *Friends* has required releases for recognizable people in its stories, whether or not Chevrolets are shown or mentioned, on the basis that the magazine constitutes a form of advertising. *Ford Times* serves the same goodwill purpose as *Friends* does, but does not ask for model releases. Perhaps Chevrolet is simply being cautious. Since company publications may require releases, get them whenever you shoot the type of feature stories such publications use.

Optional Releases. Under the First Amendment of the Constitution, photographs may be published in editorial portions of books, magazines, and newspapers without releases if they are related to the subject they illustrate and if they are of "public interest." Captions must also be related to the pictures. Photographs in nonfiction books need no releases if no one is distorted or placed in a potentially embarrassing situation. Books are in the broad category of educational materials.

Editorial. Since the First Amendment protects newspaper and newsmagazine photographs from everything but libel, they don't

require releases. Most newspaper libel suits reflect reactions to written words, not images. Pictures published in magazines don't need releases if they pertain to any newsworthy subject. Timeliness is not strictly defined in magazines, so a photograph taken six months ago can be used now without a release.

A notable exception to this is the *Arrington* v. *The New York Times* case. Arrington, a black man, was walking along a New York street and was photographed without his knowledge by a freelance photographer. Arrington's photograph was later used on the cover of the *New York Times Magazine* in connection with an article on whether the black middle class feels removed from the problems affecting less fortunate blacks. Arrington had not given permission for his photograph to be used. He didn't share the writer's views and later stated in court that people wondered if he had modeled for the magazine cover.

Arrington sued the newspaper, the photographer, and his agency for invasion of privacy. A judge ruled the picture was related to the article, and found the *New York Times* blameless. The judge determined, however, that the photographer and his agency did not have the same protection as a newspaper, and ruled in favor of Arrington because he had not signed a release. The judge also said the photographer and agency had "commercialized" the photograph since they operated independently of the newspaper.

This was an "ill-reasoned decision," according to attorney Tad Crawford in the *Legal Guide for the Visual Artist*. The ruling presumes that a freelance photographer can be liable in such a situation, but a staff photographer is not. ASMP and the Graphic Artists Guild formulated legislation that if passed in New York will prevent such violations of press freedom again.

Public figures. Pictures of movie, political, or other celebrities can be published without releases almost anywhere, except for advertising. Prominent names and faces are considered "news" and fair game for photographers. The captions, however, may not say anything about the public figure that is substantially false or in reckless disregard of the truth.

GUIDELINES FOR RELEASES

Model releases protect the photographer from problems in various situations, some of which can be tricky or unexpected. Keep these guidelines in mind.

- Ask other photographers if you can see their release forms before you prepare yours (see ASMP's sample release forms, reprinted in the Appendix). Include your name and address on your form. Photocopy it, and make sure that you carry some copies in your camera bag.
- Releases should be dated and keyed to both a specific roll of film and frame numbers. A release for pictures of a model shot

last year does not apply to pictures you take of her this year. Each set of pictures requires its own release.

- Stamp or mark your stock photographs with the letters "R" or "NR" to show when a model release is available. An agency and client will then know immediately if a picture can be used for advertising. Never indicate that you have a release if you do not.

- Generally, you do not have to pay a model to make a release legal but you may want to give amateur models prints or slides in return for their cooperation. If a shot has ad potential, I promise amateur models 10 percent of the net fee for any ad sales made. (Professional models are paid by the client.)

- Some magazines and book publishers may require releases for minors, especially younger children, even for normal editorial usage. Some parents may claim "exploitation" in nuisance suits, even when they cooperated when the shots were taken.

- In some states a minor is defined as someone under eighteen, and in others, under twenty-one. Know the law in your state. If in doubt about a young person's age, ask for a driver's license or some other form of identification. Some young people claim to be old enough to sign a release legally, and then ask for more money or threaten a suit, often through their parents, because they were underage and couldn't sign for themselves.

- When fine-art photographs are exhibited or published, you are usually protected without releases. Many of these pictures are of people in public places where the right of privacy does not apply to photographs.

- Pictures of recognizable nudes or scantily clad models require a release no matter how they are published. The release establishes that you have the model's permission to offer such pictures for publication. If you want to avoid releases for nudes, have a model turn his or her face away. With the model's identity unknown, you don't need a release. But I suggest that you get one anyway as insurance.

- When buildings are included in advertising pictures, you need a release signed by the owners or agents. This doesn't apply to a city street full of buildings; however, when you feature one home, you must have a signed release, for which you may have to pay a fee.

- When you exhibit photographs of people in awkward circumstances, ask a curator or gallery owner whether he or she feels a release is needed. Judges have decided that such pictures are art, and that certain facial expressions, poses, or settings contribute to the significance of the images.

- The term "publication" includes a display in a commercial situation. If a photographer shows a picture of someone in a shop window, a release should be signed.

- Some ASMP release forms allow the use of a person's likeness "in a composite, or distorted in character or form, without

restriction as to changes or alterations." This covers retouching and visual distortions, which may be needed for some types of advertising or fiction illustrations. In extreme cases, if you're worried about legal action over the editorial use of a picture, a face may be retouched to prevent recognition. You may wish to include such a clause if you devise your own release form.

- If someone contacts an editorial publication, stating that his or her picture was used without permission, the publication usually explains by letter that no release was required and no compensation is indicated under the circumstances. Such a response is aimed to avoid a nuisance suit. It suggests that the rights of the person in the picture were not infringed upon, and the person has been misinformed.

- When a person dies, his or her right of privacy ceases where use of photographs is concerned. But a picture of a deceased person may not be used in an ad without permission from his or her estate.

- Advertiser's Liability Insurance can help cover you regarding lack of model releases, inadvertent or otherwise. Weigh the cost of the insurance against the risks you may be taking.

UNAUTHORIZED USE OF PHOTOGRAPHS

An individual or publication may happen to reproduce your photograph for editorial or advertising purposes without your permission simply because the print or slide was on hand. This *may* happen in good faith when there's a misunderstanding, but more often it's unethical and illegal.

Suppose a client buys a picture for a brochure and later reuses it in a newspaper ad without informing the photographer or negotiating additional payment. Under these circumstances, the photographer may bill for the extra use plus a fee for unauthorized use—which is equivalent to the damages a court might award. The photographer will probably have to negotiate the final fee, and should at least double the usual fee for such usage. The photographer may hire an attorney, especially if enough money is involved.

In another situation, a photographer gives a client a photograph for limited use, marks it "not for reproduction," and finds it reproduced somewhere anyway. The client may hope that you will never discover your picture in print. The photographer should negotiate a fee and a bonus for unauthorized use. The photographer may even have to take legal action.

Some companies think a photographer can be exploited because they are big and have more clout. With the promise of future use, they suggest to the photographer to let this one pass. Don't be manipulated. In most cases of unauthorized use of pictures, or assumption of rights not agreed upon, taking a firm stand will often make clients negotiate suitable payment and rights. Assume you are being exploited deliberately to save money, no matter how cordial the client seems. Accidental use is possible, but should be rectified quickly.

Taking Legal Action. Before starting legal action regarding unauthorized use of your pictures, send a letter that details your complaint. You might start with a phone call, but you should follow up with a written record of your protest. Suggest a solution in terms of a payment, which, as penalty, may be or exceed the maximum for that usage.

Be prepared for promises of payment or settlement that are not honored. When you inform some offenders that they have used pictures without authorization, you may get a runaround or be ignored. Consult an attorney immediately. A legal-sounding letter may be all that's necessary. If not, arrange to sue for damages and legal fees and be firm. Some dishonest people will test the limits to which you will go to get funds and rights due you. Many suits are settled by compromise a short time before a court date.

You may also approach the problem of unauthorized use by hiring an attorney at the start if the amount you hope to collect is considerably more than the fees you might have to pay. Each infringement is serious, but the amount of money involved varies. Be tactful but resolute with the client. Moderate your indignation in favor of declaring your expectations.

LOST OR DAMAGED PICTURES

Experience shows that more slides and prints are damaged than are lost. You can help prevent these serious problems in several ways.

In Transit. Slides and prints that may be lost or damaged in transit to or from a buyer should be insured. Keep in mind that it is difficult to collect large sums from the Post Office, and perhaps from other carriers, without substantial evidence that your images have previously sold for the amounts you are claiming. As of this writing, private carriers insure packages for $100 as part of their basic charge, with a $25,000 limit for some. The Post Office will register packages for higher amounts and smaller fees than any private carrier.

The owner of a large picture agency told me that it insures or registers packages of pictures for only nominal sums, such as $250, even if the value of the contents is much more. Because few packages are lost by United Parcel (the agency's carrier) or the Post Office, he maintains, "The odds for safe delivery are strong. Insurance creates enough attention that parcels are cared for, and losses are very minimal. We pack everything well, to avoid damage. Insuring for the real value of transparencies would be prohibitive on a regular basis."

Get proof of delivery—a signed receipt—from the carrier to show you sent the work. You can also ask that your own delivery memo be signed and returned to you. A picture buyer with dubious ethics who misplaces or damages pictures might claim they never arrived. If this happens, you will have concrete evidence to support your claim. As an attorney told me, "Once you can show that the other party received the pictures, the burden of proof regarding negligence shifts to them."

In the Client's Possession. More often, pictures are lost or damaged through accidents, or the carelessness of editors, art directors, or color separators. Since your files are comparable to an annuity, pictures you can't lease again reduce your future income. For this reason, photographers have been awarded up to $1,500 in numerous court cases for each lost or damaged transparency.

In one such court case, an art director selected sixty-three transparencies from the files of a stock agency, signed for them, and accidentally lost his briefcase with pictures in it. When he reported the loss to the police, they didn't know why he was making such a fuss about a few lost slides. "How much could they cost, a buck-and-a-half each? They're just little cardboard mounts with film in them."

This dispute was settled by arbitration, as agreed to by the agency and the client on the back of the delivery memo. The ad agency for whom the art director worked felt that the award of $94,500—$1,500 each for the sixty-three lost slides—was totally unreasonable because there were substitutes for a number of them in the agency's files. To the photographers involved, however, the award represented the potential lifetime value of the lost images.

In another case of lost slides, a magazine had signed a receipt stating each was worth $2,000. A judge decided this figure was an "unreasonable penalty," and awarded the photographer $1,000 for each slide, plus $12,000 interest. Interestingly, the judge in this case wrote, "The value of a photo transparency is an abstract concept embracing numerous factors." Among them, he said, are: "technical excellence, the selective eye, the uniqueness of the subject matter, established sales prices, and the frequency of acceptance by users."

The *ASMP Book* states that under the law, there are three ways the value of a photograph is determined: its market value, based on prior use; its intrinsic value, a combination of how the pictures were made and the difficulty of replacing them; and its stipulated value, a price you and a client have agreed upon in advance that each shot would be worth if lost or damaged.

LEGAL MISCELLANY

In the last few decades, photographers have made considerable advances in protecting their legal rights. Both awareness and vigilance are reasons for this success. The following points can help you avoid unpleasant business surprises.

Unsolicited Work. A publication, ad agency, or publisher is not responsible for pictures sent to them *unsolicited*. If you wish to submit pictures to a potential client, write a letter first, asking if it would be interested. A positive response in writing reduces your risk. Now the client has asked to see your work, and is at least responsible for its loss or damage while in the company's possession. If you visit a potential client and wish to leave pictures that have not been solicited, get a signed receipt that includes a stipulation that the recipient

is responsible for loss or damage. The receipt should also say none of the work may be reproduced in any way without your written permission.

Collecting Fees. When you work with a number of magazines, book publishers, and advertising agencies, be patient about the often extended length of time it takes for you to be paid. Ad agencies have a payment schedule, such as thirty, forty-five, or sixty days. Magazines can be less organized. If your bill seems to have been ignored, you may have to write or call after thirty days, tactfully reminding an editor that you haven't been paid.

Mailing a second bill is also an effective way to remind someone that you haven't been paid. However, when a client is unresponsive for too long, you may need to consult an attorney or resort to small claims court, depending on the amount of money involved. Various states have their own limits for small claims suits. These cases can be tried and settled quickly, without an attorney. However, if you win a judgment and the client still fails to pay, you may need a sheriff or marshall to help you collect.

Get It in Writing. Having all the necessary paperwork can help prevent legal and collection problems. Use delivery memos for assignment pictures and stock photos as well. Get everything in writing from buyers, agencies, models, collaborators, and anyone with whom you do business, as well as friends and relatives. An agreement on paper is insurance if memory fails or goodwill dissolves.

Copycats. Some years ago, a friend noticed that a very realistic painting of a cat in a cat food ad looked a lot like a color photograph of his published in a photography magazine. He compared the ad image and his own photo and found them almost identical; the background in his shot had been eliminated to make room for ad copy. My friend contacted the ad agency and pointed out unequivocally that his color photograph had been plagiarized. The agency took the matter up with the artist, and my friend was paid $500. This amount represented the fee he might have been paid for the use of a stock photograph at that time as the basis for an advertising illustration.

You can't monitor all media looking for copies of your work, but you do have legal recourse, especially if the work is copyrighted.

Film Processing Damage. Most film processors who deal with professionals make the limits of their responsibility clear in case of loss or damage. Some processing receipts include a disclaimer that limits responsibility to replacement of the film. Unless you can prove negligence by the processor, which is difficult to do, you can't expect to win a lawsuit. The best way to avoid situations that may lead to legal problems is to be professional, informed, and wary.

13

Methods of
Communication

Your ability to communicate clearly with clients, curators, agencies, art directors, editors, and anyone else you do business with is important to protecting your rights and maintaining professional rates. Shooting terrific photographs is not enough. You must be able to explain and promote yourself and to tactfully express your views about rates, rights, and other business subjects.

**BUSINESS
LETTERS**

Salesmanship is based in part on being articulate. Whether you are flamboyant, bold, or casual when you state your views and arguments, you must be convincing. Whatever your style, keep these guidelines in mind when writing letters to business associates:

- Be concise, but not abrupt.
- Be clear, specific, and thorough.
- Limit the number of superlatives and adjectives used to describe your goals.
- Don't make promises you can't keep.

Effective communication with a model can help photographers get the shots they want. This picture of a young boy running through a stream has been a consistent best-seller.

The first guideline is one of the most important. Busy editors, curators, and advertising agency personnel seem to prefer short letters. They are usually pressed for time and need to grasp the essentials immediately. How short then are the letters you write to clients? State your purpose directly and include the important facts and figures. Be friendly, even jocular, but remember that an economy of words is often appreciated. Allow your personality to guide your communications. Avoid overselling or phony enthusiasm. Save your own time as well as your client's, and make a favorable impression.

143

QUERY LETTERS

Some photographers frequently contact editors first through a phone call and follow up with a letter. Others write a letter first, outlining an idea for a book and soliciting a magazine assignment or book contract. Such communications fall under the broad category of query letters. More specifically, in a query letter you suggest a salable idea for a picture story, for a story you can illustrate, or for a book you want to create or collaborate on. You can also ask about the possibility of an exhibition of your work or of an assignment, such as the following year's annual report.

A query may be one page or a number of pages. It can be incorporated into a letter or can be a separate entity. Attaching a query to a letter saves time because you don't have to continually retype. Here is a typical query letter to a magazine editor.

Dear Editor:

In three weeks, an unusual gathering of Bugatti owners will take place at Parsons Corners, which is about thirty-five miles from my office. The Bugatti was and is one of the world's most valued cars, first built before World War I and always manufactured by hand. Expensive when new, they are now worth small fortunes in restored condition. One Bugatti limousine, used by Italian royalty, recently sold for $315,000.

More than fifty cars are expected at the Bugatti Club of America two-day meeting, and an auction on the second day will inevitably bring record prices. I am suggesting a picture story that focuses on the cars, elegant closeup details, animated collectors, and the drama of the auction. I have been promised full cooperation by club officers as well as exclusive magazine coverage. Only newspapers and wire services will be there, mainly for news of the auction. I estimate expenses for this story will be about $50 or $60 for film and processing; $40 for mileage; and $50 for food, telephone, and incidentals.

I would appreciate a response from you by May 20, which is ten days from now. If I haven't heard from you by this date, I will then feel free to offer the idea elsewhere. I look forward to any suggestions you have for tailoring this story to your needs. Thank you for your consideration.

Cordially,

Lou Jacobs, Jr.

This letter contains few aggrandizing adjectives, such as "exciting" or "colorful." As a professional, you realize that editors mistrust oversell, and if they know you or know of you, they presume you can shoot pictures with impact. Notice, too, that you do not have to mention equipment; you are expected to be adequately prepared. The idea is the important element, and it will not be difficult for an editor whose

magazine is appropriate for such a story to anticipate the type of pictures you will get. Your unique style will give those pictures their individuality.

Rates and Rights Queries. If you have worked for a publication previously, consider its day rate or page rate acceptable, and know that it buys first rights only, you won't have to discuss fees or rights in a query letter or over the phone. If you do have to negotiate rates and rights, keep in mind these suggestions:

- In a query letter, you need not mention your day rate to an unfamiliar client. When, however, you get an assignment, be sure to ask the editor, on the phone or in the letter, what the publication pays. If your rate is related to the client's figure and is close to what professionals are charging, you shouldn't have any problems. But if the publication's rate is lower, negotiate *before* you shoot.
- If you have any doubts about how a publication handles rights, let the editor or buyer know you are offering first rights only. Repeat this on your invoice. If the job is large, send a delivery memo (see the sample ASMP delivery memos reprinted in the Appendix) or write a letter stating your terms. You may send a copy of the letter along with the original and ask the editor to sign one and return it to you.
- In some query letters, you may need to clarify how long you expect the job to take. For longer jobs, estimate the number of days you expect to shoot, to avoid unpleasant surprises.
- Estimate expenses in a query letter, even when they are modest. The longer the story, the more likely it is the editor will want to know what costs will be.

The way you handle rates and rights in a query letter is an expression of your experience and professional attitude. It is wise to incorporate details about fees and rights within a query, to help explain what you expect to shoot and the terms under which you wish to work.

Multiple Queries. While many editors and book publishers may prefer receiving ideas for pictures, stories, and books exclusively, you can investigate several markets at the same time. Query letters about magazine stories may read as follows:

Since this (affair, auction, event) takes place only occasionally, and we have only a one-month lead time, I am sending a similar query to three other publications as a matter of expedience. I will be happy to discuss any details with you and accept an assignment for exclusive coverage, and of course, I'll respond to whomever contacts me first. I regret if this seems to create a sense of competition; that is not my purpose. In such unusual circum-

stances, when I have to make preparations as do you, simultaneous queries are necessary to sensible business practice.

The tactful style of this query letter illustrates the importance of direct communication in achieving success in the photography field. In any business, diplomacy pays off, and there's a definite difference between being a diplomat and being a doormat.

Occasionally, you may want to propose an idea to several publishers at the same time through a query letter. In it, state that you are contacting other publishers. You may otherwise send a two- or three-page proposal for a book, along with several sample photographs. Essentially, you are simply asking if the editor is interested in seeing more, not committing yourself. You need only respond to the first interested party. If, after you send a detailed proposal to the first respondent, two others say they would like to know more, tell them you'll get the material to them as soon as possible. From the outset, they knew you were querying other markets at the time you contacted them.

WRITING

Letter and query writing may seem to be formidable tasks to you. But you can—and must—learn to communicate effectively. You can accomplish this in several ways:

- Take a class in business writing.
- Hire a tutor for a crash course in business writing.
- Hire a secretary who can express your thoughts in persuasive language.
- Enlist the aid of a business partner who writes well and will enjoy doing your communications.
- Ask a friend or relative to improve his or her writing skills and to do your business writing.
- Practice writing regularly and often.
- Read one of the business writing handbooks on the market.

TELEPHONE COMMUNICATIONS

Obviously, direct, one-to-one contact with a client is often preferable to communication by letter. Telephone communication can also be rewarding: you get immediate feedback. And, even if decisions are delayed, you are aware of the problem at once. Speaking on the telephone makes you feel more involved with a client and the job at hand. Here are some pointers for protecting your business interests when speaking on the phone.

- Try not to be pushy. Editors and buyers need time to ponder and consult.
- Be prepared to put in writing ideas you have discussed over the phone. Clients want to pass the ideas around and talk about them. In addition, you are at risk until you have something on paper. If you develop a rapport with an editor, you may think that oral

communication alone is safe. Consider, however, the consequences of abrupt personnel changes in the marketplace. An oral agreement with that editor or a picture buyer may no longer be valid.

- Use the phone to remind clients about neglected queries, payments, and other issues.
- Keep in touch with clients via the phone whether or not you have business to discuss. This reminds buyers of your availability and your interest in their needs, and may lead to another job or more stock sales.
- Record each call in an informal logbook, noting telephone numbers, details of a conversation, rates, and schedules. When you write to the client, your log can serve as a concise, reliable reference.

Communicating with business associates, proposing ideas, and negotiating rates and rights are all critical to a successful career in photography. Never underestimate the power of well-chosen words.

14

The Art of Negotiation

Negotiating rates and rights, a primary concern of photographers, requires practice and clear thinking, but can be mastered.

In the *Legal Guide for the Visual Artist*, Tad Crawford says,

> Negotiation is integral to the process of making a contract.... The purpose of negotiation is not to defeat the other party. The purpose is for both parties to be benefitted and feel satisfied their needs have been met.

Prior to beginning any negotiation, the artist should have his or her goals clearly in mind. These goals include money, but reach beyond this to issues of artistic control, authorship credit and other factors that may also have importance for the artist.

Crawford suggests that a creative person has to be willing to compromise, knowing how much to give in and where to draw the line. You must also be willing to lose a job or abandon a deal for a book or an exhibition in order to negotiate from a position of strength. Maintaining a professional attitude is also important to successful negotiation. Being treated like a professional means being respected by the clients you deal with.

PERSONALITY AND RESPONSIBILITY

The best photographers see expertly through a viewfinder and without one. They are creative, resourceful, intuitive, diplomatic, disciplined, and reliable.

Personality. A photographer's personality affects both his or her associates and business negotiations. A persuasive and engaging personality also makes it easier for you to protect your rights and improve professional fees. Sincerity is also integral to business communications. Getting along with and influencing people are integral to the business of photography. Photography schools may tend to avoid such ambiguous topics as personality, but you should be aware of how yours colors everything you do behind a camera and everything you say when making business arrangements.

An adaptable personality is welcomed by clients, few of which enjoy the company of grouches. If you are timid about presenting your portfolio, meeting people, or expressing your ideas before and during an assignment, you may find a course in self-realization or salesmanship valuable. You can alter your personality and limit your weaknesses to better use your talent as a photographer.

Responsibility. There are hotshot photographers who seem to come on strong, but too often fail to deliver. And there are more moderate types who seem sensible and even modest, but who follow directions, exercise imagination, and don't complain or boast excessively. Whether photographers appear glamorous or colorless, they must be dependable. This means maintaining schedules, staying within budgets, shooting pictures that please, and delivering photos on time. When photographers are known to be reliable, to get along with people, and to have a sense of humor as well as a good eye, they have fewer problems about getting their requested fees or protecting their rights. Dependable photographers who build solid reputations with satisfying, often exciting pictures are successful in business.

At the same time you are negotiating fees and rights, keep in mind that every photographer has responsibilities to the client, including:

- Never lease or sell advertising photographs that are the same as or similar to those you have been paid for, to competitive clients.
- Keep your word, written or oral, about deadlines, fees, and other business arrangements.
- Do not undercut the competition: you don't want to be known as a cheap photographer and you don't want to be undercut yourself.

NEGOTIATING TECHNIQUES

Negotiating is a significant step in the selling process. Your business success depends in large part on your ability to make agreements that satisfy both yourself and the client. Though one key to negotiation is being perceived as resolute, it's much more important to master the art of creative compromise—the art of give and take to reach an agreement that is advantageous to both parties. Negotiating should not be a contest; if there is a clear winner and loser, the negotiations have failed you or the client in some way.

You can negotiate anything: money, rights, expenses, time schedules, locations, and benefits. Negotiation requires knowing all you can about the client and the assignment. Review the facts and evaluate their meaning. Negotiate each item separately. Discuss the easiest questions, setting a pattern of agreement thereby that smooths the way for more difficult points, such as rates. If possible, discuss money last. Also, never discuss money by itself; relate it to aspects of the job. You might ask, as photographer Richard Weisgrau suggests, "Suppose you had to put a dollar figure on all of this?" It's best, however, when the client first mentions money. You may be surprised if the figure is higher than the one you were going to propose.

If the first offer is too low, work toward a better figure. If an offer is absurdly low, make believe you appreciate the humor. You may also mention other recent impressive assignments. You may even reveal how much you were paid if the jobs are comparable, and the fees were suitable. This becomes a challenge in disguise. It gets your point across without making the other party too defensive.

Negotiate Backward. Negotiation requires psychology. Try to determine the clients' opinions about the rates for and features of the job. At what point will they compromise and still feel that they came away with enough to be satisfied? One way to accomplish this is to imagine trading places. If you were the other party, how badly would you want this deal, and how important would *you* seem to the client? What do the client's real limits seem to be? What are the client's options if the negotiations fall apart? Will the client have to answer to colleagues and perhaps the advertiser or publisher? Is the client considering you for the job because you are talented, or because you are indecisive and easily swayed? Asking yourself how the other person sees his goals and bargaining position can clarify your negotiations.

Show Empathy. When appropriate, acknowledge the client's needs, and then modify your appreciation of them. For example, if agency representatives ask you for a buyout because their clients are putting pressure on them, you might respond, "I understand how you feel. It's uncomfortable when the company that's paying the bills pressures you for something like that. However, your client doesn't have an appreciation of all the facts and options. Why don't we have a joint meeting and explain the ins and outs of our business practice?"

Disarm with a Question. When you don't like a client's comment, ask why it was said. Sometimes this helps someone gain perspective and soften a stance. It may also keep the client talking. If you listen carefully, you might find a needed weak point in the client's position.

Don't Ignore a Position. If you purposely don't respond to a position a client takes, it may frustrate the person, which could mean trouble. If you want to delay discussing a point, suggest putting it off until later. If you don't understand something, say so. Never fail to respond.

Speak Candidly. Reveal your real feelings or give actual facts. If you say, "I really want this assignment," you are not saying you will do anything to get it. You may also say frankly, "It's very important to me to retain the rights to this set of photographs because. . . ." Candor and conciliation frequently go hand in hand.

Express Anger. Do not be afraid to show your anger, but never react in anger. Emotion is a forceful tool when used in a calculated way, and like all tools, it works best when you're in control. If a client has an

emotional outburst, consider it a loss of control. If you then remain composed, you have control of the situation. Don't lose it through a counterreaction. Suggest you talk about the topic later, and move on to another issue.

Consider Time Constraints. Never let the client know that you are facing a time limit, that you may give in just to conclude the negotiations if the client holds out or if there is a delay. Conversely, if you have some insight into the client's time constraints, use it to your advantage.

Settling. If you feel you are ultimately going to settle for whatever the other party offers just to get the job, save yourself the time, trouble, and embarrassment. Don't negotiate. Just thank the client for the work and try to feel satisfied.

POINTS OF NEGOTIATION

Photographer Richard Weisgrau offers the following points about the art of negotiation.

- Negotiation is a normal business process, and those who refuse to enter into the process are being unreasonable.
- Regard any dispute as the beginning of negotiations, but you don't need a dispute to get started.
- Understanding a reasonable viewpoint is the key to compromise; you must have reasonable answers for each position you take.
- If you work out an agreement, praise the client. This will make negotiation easier the next time.
- If you fail to resolve differences, commiserate with the client; express your disappointment that the two of you can't get together. This may help in the future, and it may even inspire renegotiation.
- Try to put the client in an agreeable frame of mind by asking him or her questions that will elicit a positive response—an automatic "yes." Then when you ask difficult questions, the "yes" to them may also be automatic.
- Use a red herring—make a big deal about a small point—in order to have an item to trade off later in the negotiation.
- The law may be on your side, but the loopholes are on the client's side. Never base your reasoning on legal reference. You must have a good business reason for everything you want.
- Never take credit for your success, or the blame for the client's loss. Negotiation is a mutual operation.

Negotiating business agreements for any type of media photography requires knowing how to compromise. This can win your point and satisfy the client's. Flexibility, conviction, and awareness are a winning combination in negotiation.

SUMMARY

Some types of negotiation are indirect. For example, corporate specialist Bill Rivelli and his rep, Cynthia Rivelli, have a smart approach to clients that they generously agreed to share. The Rivellis use a letter that summarizes the negotiation to help establish Bill as a businessperson. Here is the letter in condensed form:

Dear Client:

We are delighted that you are considering Bill for your current project. We hope that this outline of terms and conditions under which we accept and execute corporate assignments will lead to a fruitful working relationship.

Our current fees are based on the following schedule:

$_____ per eight-hour photography day. Travel time is billed at one-half the day rate.

If Bill is kept aware of planning, or better, if he's included in it, he can advise on the most efficient way to handle the photography. Once subjects and locations are decided, we would be able to give a fairly accurate estimate of the time and cost involved.

We edit every take and deliver the best of every situation covered. These transparencies are marked with our copyright stamp. We retain the copyright to all the pictures Bill creates for an assignment, while giving the client the reproduction rights he has contracted for, and as much use as he requires of the images for his internal public relations effort.

What we are selling, simply stated, is the technical and artistic ability to illustrate an idea photographically and the right to reproduce those illustrations in a given context. We state these terms of sale in a postscript on each invoice we submit, with appropriate expense documentation attached.

The letter continues to clarify rights, resale of images (after one year) that will not conflict with company policy, cancellation fees, and other arrangements. It ends with the Rivellis' hope that they have "paved the way for a more detailed discussion of your assignment" and "that most of our clients appreciate knowing in advance exactly what they are buying and approximately how much it will cost." The Rivellis state that they, too, want to understand all the terms so Bill can concentrate on the job. This kind of diplomacy helps cover all the bases.

Appendix

ASMP ASSIGNMENT OF COPYRIGHT FORM

For good and valuable consideration, receipt of which is hereby acknowl-
edged, _____("Assignor"), a corporation organized
(publisher's name)

and existing under the laws of the State of _____,
hereby grants and assigns to _____("Assignee")
all of its right, title, and interest in and to the copyright (and any renewal
thereof) of the following photographs(s): _____
(titles of photographs)

photographed by Assignee and published in the _____ issue of
_____, which issue was or will be registered in the Copyright Office
of the United States by Assignor. Assignor hereby warrants that it has not
heretofore made any grant, encumbrance, or other disposition to others
of any right, title, or interest in said photograph(s) or the copyright (and any
right to renewal) therein.

In witness whereof, Assignor has executed this assignment on this
_____ day of _____, 19_____.

(publisher's name)

By _____
(name and title of corporate officer)

ASMP PHOTOGRAPHER'S BOOK AGREEMENT FORM

This is an agreement from the photographer's point of view. It is not suggested that this is the only one you can sign, and should be modified as needed. *The percentages and other figures used in this example are for illustration purposes and are all subject to individual negotiation.* However, you might want to keep this one handy as the basis for any "reasonable" deal.

AGREEMENT made this _____ day of _____, 19_____, by and between _____, a _____ corporation (hereinafter referred to as "the Publisher") and _____ (hereinafter referred to as "the Photographer").

WITNESSETH:

The Photographer hereby grants to the Publisher, and the Publisher hereby accepts, a limited license to reproduce, publish, and vend a hardcover edition of a book presently entitled _____ (hereinafter referred to as "said Book"), containing certain photographs by the Photographer (hereinafter referred to as "said photographs") upon the following terms and conditions:

1. Photographs Involved

On or before _____ 19_____, the Photographer shall submit to the Publisher _____ photographs (whether black-and-white or color, or any combination). The Publisher shall then have ___ month(s) from the receipt of said photographs within which to select the photographs to be used in said Book. Those photographs not selected will be returned immediately to the Photographer together with the notice of those selected. A list of such photographs to be used shall then be incorporated in this agreement by reference thereto. All photographs not selected shall be excluded from the scope of this agreement, and the Photographer shall have the right to utilize such photographs in any manner whatsoever without restriction.

All photographs so selected by the Publisher for use in said Book will be returned to the Photographer no later than thirty (30) days after the plates are made. Such plates are to be made by _____, 19_____. Said Book is to be published no later than _____, 19_____, with a minimum of _____ copies so published and distributed.

The Publisher shall not acquire any right, title, or interest in or to said photographs and shall not make, authorize, or permit any use of said

ASMP PHOTOGRAPHER'S BOOK AGREEMENT FORM *(continued)*

photographs other than as specified herein. Without limiting the generality of the foregoing, said photographs may not be used in any way, including, without limitation, projection, layouts, sketches, and photostats, except on the terms specified herein.

2. Use and Return of Photographs

The Publisher shall be responsible for the safe return of all photographs to the Photographer and shall indemnify the Photographer against any loss or damage to such photographs (including those not selected for use in said Book) in transit or while in possession of the Publisher, its agents, employees, messengers, printer, or assigns.

The monetary figure for loss or damage of an original transparency or photograph shall be determined by the value of each individual photograph. The Publisher and Photographer agree that the fair and reasonable value of such lost or damaged transparency shall be One Thousand Five Hundred ($1,500) Dollars for a color transparency or black-and-white negative. The Publisher shall be liable for all acts of its employees, agents, assigns, messengers, printer, and freelance researchers for all loss, damage, or misuse of the materials submitted by the Photographer hereunder. Any such payment shall not, however, be construed transfer to the Publisher of any right, title, or interest in or to said materials so lost or damaged.

3. Term

The publisher's rights hereunder shall be for a period commencing _____ and ending _____, unless sooner terminated as provided herein.

4. License and Territory

The license granted to the Publisher hereunder is solely for the Publisher's hardcover edition of said Book. The license granted hereunder is for one-time, nonexclusive, reproduction use of said photographs in English-language printings in the following countries: _____ .

5. Publication

The Publisher shall publish and distribute said Book at its own expense, in the style and manner and at the price which it shall deem best suited to its sale. However, the Photographer shall have final approval of said Book and, in that respect, before publication, said Book shall be submitted in its entirety to the Photographer, including, without limitation, the text, its

ASMP PHOTOGRAPHER'S BOOK AGREEMENT FORM *(continued)*

title, its photographs, and the contents of its covers, and said Book shall only be published in the form approved by the Photographer. Any approval by the Photographer, however, shall not in any way limit, negate, or affect the provisions of paragraph 14 hereof.

6. Advance

The Publisher shall pay to the Photographer, or his duly authorized representative specified in writing by the Photographer, upon the execution of this agreement, the following nonreturnable advance, which shall be charged against the Photographer's royalties set forth in paragraph 7 hereof: _____ .

7. Royalties

The Publisher shall pay to the Photographer the following percentages of the Publisher's U.S. suggested retail list price:
Ten (10%) percent on the first 5,000 copies sold;
Twelve-and-One-Half (12½%) percent on the next 5,000 copies sold;
Fifteen (15%) percent on all copies sold in excess of the aforesaid 10,000 copies.
It is understood that the suggested retail list price shall be deemed to be not less than $_____ for the purpose of computing the royalties to be paid hereunder.

8. Copyright

Said Book shall be published with due notice of copyright in the name of the Photographer and shall be duly registered in the Copyright Office of the United States of America. Without limiting the foregoing, all copyrights under the Berne Convention, the Universal Copyright Convention, and the Buenos Aires Treaty will be secured; it being specifically agreed that in no event shall said Book be published without a copyright of the photographs in the name of the Photographer. The Publisher shall take all steps necessary, without cost to the photographer, to effect such copyrights, including any renewal copyrights, if applicable, as well as to prosecute or defend any infringement actions (subject to paragraph 15 below).

9. Photographer's Free Copies

The Publisher agrees to furnish the Photographer with twenty (20) copies of said Book as published, free of any cost or charge to the Photographer whatsoever, for the Photographer's own use. If the Photographer requires

ASMP PHOTOGRAPHER'S BOOK AGREEMENT FORM *(continued)*

copies in addition to the above, the Publisher agrees to furnish such additional copies to the Photographer at a discount of forty (40%) percent from the retail selling price or at the Publisher's actual publishing cost for same, whichever is less.

10. Credit

The Photographer shall receive credit on the dust jacket, cover, title page, and interior of said Book, as well as in advertising under the control of the Publisher, all in size, type, and prominence not less than that afforded any other person or party appearing thereon, and all subject to the Photographer's final and absolute approval. It is a material part of this agreement that no books or other matter be issued without the Photographer's credit as approved by him.

11. Accounting

Payment of accrued royalties, accompanied by detailed statements of all sales, licenses, accrued royalties, and deductions, will be made to the Photographer semiannually, within thirty (30) days after June thirtieth and December thirty-first in each calendar year. The Publisher shall keep books of accounts containing true and accurate records of all transactions in its place of primary business, involving the subject matter of this agreement and of all sums of money received and disbursed in connection therewith. The Photographer or his duly authorized representative shall have the right at any time and without limitation to check, inspect, and audit the Publisher's books, records, and accounts in order to verify or clarify any and all such statements, accountings, and payments. The expense of such examination shall be borne by the Photographer unless errors of accounting amounting to five (5%) percent or more of the total sums paid or payable to the Photographer shall be found to his disadvantage, in which case the expense of such examination shall be borne by the Publisher.

Anything in this paragraph to the contrary notwithstanding, any sum of One Thousand ($1,000) Dollars or more which may become due to the Photographer (after the Publisher shall have recouped its advance hereunder) shall be paid by the Publisher to the Photographer within thirty (30) days after the Publisher shall have received such sum.

Publisher shall pay Photographer any advances or royalties received by Publisher from book clubs or other licensees (if applicable) within thirty (30) days after Publisher receives such payments, accompanied by a copy of the statement of account provided by such licensee to Publisher.

ASMP PHOTOGRAPHER'S BOOK AGREEMENT FORM *(continued)*

12. Notices

All notices which either party may desire to or be required to send to the other shall be sent by prepaid registered mail and addressed to the parties as follows:

Publisher: _____

Photographer: _____

13. Discontinuance

If, after the inital printing and distribution of said Book, the Publisher decides to discontinue any further publication of said Book, it shall give immediate notice of such determination to the Photographer, and the Photographer shall have the option of purchasing from the Publisher the plates for said Book at one-fourth ($\frac{1}{4}$) of the original cost, including the original compositions, and the Publisher's stock at one-quarter ($\frac{1}{4}$) of the list price thereof. If the Photographer shall not take over the said plates, engravings, illustrations, and/or copies of said Book and pay for same within ninety (90) days, then the Publisher shall destroy the items not taken and shall furnish the Photographer with an affadavit of destruction thereof. In any event, the Publisher's obligation for payments hereunder to the Photographer shall nevertheless continue.

For the purposes of this agreement, said Book shall be deemed "in print" only when copies are available and offered for sale in the U.S. through normal retail channels and listed in the catalog issued to the trade by the Publisher. The Book shall not be deemed "in print" by virtue of the reproduction of copies by reprographic processes or if it is available by any medium or means other than the hardcover edition referred to above.

If Publisher fails to keep the Book in print, the Photographer may at any time thereafter serve a request on the Publisher that the Book be placed in print. Within sixty (60) days from receipt of such request, Publisher shall notify Photographer, in writing, whether it intends to comply with said request. If Publisher fails to give such notice or, having done so, fails to place the Book in print within six (6) months after receipt of said request by Photographer, then, in either event, this agreement shall automatically terminate and all rights granted to Publisher shall thereupon automatically revert to Photographer.

14. Indemnity

The Publisher's acceptance of the photographs hereunder shall indicate its agreement and understanding that the Photographer makes no warranty, express or implied, and that the Publisher shall and hereby agrees to indemnify, defend, save, and hold harmless the Photographer, his suc-

ASMP PHOTOGRAPHER'S BOOK AGREEMENT FORM *(continued)*

cessors and assigns, against any and all claims losses, costs, damages, or expenses, including reasonable counsel fees and expenses, which shall accrue or be asserted against the Photographer or his successors and assigns, or any others, by reason of the use of said photographs hereunder or other conduct by the Publisher in connection with any rights granted by the Photographer hereby.

15. Infringements
If there is an infringement by a third party of any rights granted to Publisher hereunder, Photographer and Publisher shall have the right to participate jointly in an action for such infringement. If both participate, they shall share the expenses of the action equally and shall recoup such expenses from any sums recovered in the action. The balance of the proceeds shall be equally divided between them. Each party will notify the other of infringements coming to its attention. If the Photographer declines to participate in such action, the Publisher will proceed and will bear all costs and expenses which shall be recouped from any damages recovered from the infringement, and the balance of such damages shall be divided equally between the parties.

16. Arbitration
Any controversy or claim arising out or relating to this agreement or the breach thereof shall be settled by arbitration in _____, in accordance with the rules of the American Arbitration Association, and judgment upon the award rendered by the Arbitrator(s) may be entered in any court having jurisdiction thereof.

17. Assignment
This agreement may not be assigned by the Publisher, either voluntarily or by operation of law, without the prior written consent of the Photographer. Any such assignment, if consented to by the Photographer, shall not relieve the Publisher of its obligations hereunder. The Photographer may freely assign his right to receive income under this agreement.

18. Miscellaneous
(a) Nothing contained in this agreement shall be deemed to constitute the Publisher and the Photographer as partners, joint venturers, or fiduciaries, or to give the Publisher a property interest, whether of a legal or an equitable nature, in any of the Photographer's assets.
(b) A waiver by either party of any of the terms and conditions of this agreement shall not be deemed or construed to be a waiver of such terms or conditions for the future, or of any subsequent breach thereof. All remedies, rights, undertakings, obligations, and agreements contained in

ASMP PHOTOGRAPHER'S BOOK AGREEMENT FORM *(continued)*

this agreement shall be cumulative, and none of them shall be in limitation of any other remedy, right, undertaking, obligation, or agreement of either party.

(c) All rights not specifically granted herein to the Publisher are reserved for the Photographer's use and disposition without any limitations whatsoever, regardless of the extent to which same are competitive with the Publisher or the license granted hereunder. This includes, without limitation, all individual uses of the photographs hereunder.

(d) In case of the Publisher's bankruptcy, receivership, or assignment for benefit of creditors, the rights of publication shall revert to the Photographer.

(e) This agreement and all its terms and conditions, and all rights herein, shall insure to the benefit of, and shall be binding upon, the parties hereto and their respective legal representatives, successors and assigns.

(f) Time is of the essence in the performance by the Publisher of its obligations hereunder. If the Publisher fails to pay promptly the royalties hereunder, or if the Publisher fails to conform or comply with any other terms or conditions hereunder, the Photographer shall have the right, either personally or by his duly authorized representative, to advise the Publisher of such default; and if fourteen (14) days elapse after the sending of such notice without the default's having been rectified, this license shall thereupon terminate without affecting the Photographer's rights to compensation or damages in connection with any claims or causes of action the Photographer may have.

(g) The titles of the paragraphs of this agreement are for convenience only and shall not in any way affect the interpretation of any paragraph of this agreement, or of the agreement itself.

(h) This agreement and all matters or issues collateral thereof shall be interpreted under, and governed by, the laws of the State of _____. This agreement constitutes the entire agreement between the parties hereto and cannot be changed or terminated orally; and no changes, amendments or assignments thereof shall be binding except in writing signed by both parties.

This agreement is not binding on the Photographer unless and until a copy thereof actually signed by both the Photographer and the Publisher is delivered to the Photographer and payment of the advance is made.

IN WITNESS WHEREOF, the parties hereto have executed this agreement as of the day and year first above written.

By _____

Title _____

(publisher)

(photographer)

ASMP PRODUCTION REPORT FORM

Photography

_____ _____
_____ _____
_____ _____
_____ _____

Total $ _____

Pre-production

_____ _____
_____ _____
_____ _____

Total $ _____

Weather delays

_____ _____
_____ _____
_____ _____

Total $ _____

Casting
Fee _____
Film _____
Casting from files _____
Total $ _____

Crew
Assistants _____
Home economist _____
Prod. coordinator _____
Stylists: hair _____
 makeup _____
 props _____
 wardrobe _____
Trainer/animals _____
Welfare/teacher _____
Total $ _____

Film lab charges
Editing _____
Polaroid _____
Prints _____
Roll film _____
Sheet film _____
Total $ _____

ASMP PRODUCTION REPORT FORM *(continued)*

Insurance
Liability
Photo Pac
Riders/binders
Total $ _____

Location
Scout
Film
Research
Location fee
Permits
Travel
Total $ _____

Messenger/shipping
Messengers
Out-of-town
Trucking
Total $ _____

Props
Purchase
Rental
Food
Total $ _____

Rental
Camera
Grip truck
Lenses
Lighting
Special effects
Special equipment
Total $ _____

Sets
Carpenter/painter
Hardware/lumber
Paint/wallpaper
Set design/research
Backgrounds/backdrops
Studio materials
Surfaces
Total $ _____

ASMP PRODUCTION REPORT FORM *(continued)*

Studio
Build days _____
Shoot days _____
Overtime _____
Strike _____
Total $ _____

Travel
Air fares _____
Excess baggage _____
Cabs _____
Car rental/mileage _____
Truck/car rental _____
Motor home/dressing room _____
Parking/tolls/gas _____
Lodging, per diems (est.) _____
Hotel _____
Meals _____
Total $ _____

Wardrobe
Costume design _____
Seamstress _____
Purchase _____
Rental _____
Special makeup/wigs _____
Total $ _____

Miscellaneous
Gratuities _____
Long distance phone _____
Non-professional talent _____
Working meals _____
_____ _____
_____ _____
_____ _____
_____ _____
_____ _____
Total $ _____

Model details

	Number	Hours	Total time
Adults	_____	_____	_____
Children	_____	_____	_____
Extras	_____	_____	_____

ASMP CORPORATE AND EDITORIAL ASSIGNMENT
ESTIMATE/CONFIRMATION/INVOICE FORM

To: Date:
 Shoot Date:
 Studio Job #:
 Client P.O. #:
 A.D.:
 Editor:
 Client:

☐ Bid ☐ Estimate ☐ Confirmation ☐ Change ☐ Invoice # _____

Description/Rights granted/Period of use/Media usage

Fees
Photography _____
Pre-production ($ _____ per day) _____
Travel ($ _____ per day) _____
Weather delay ($ _____ per day) _____
Subtotal A $ _____

ASMP CORPORATE AND EDITORIAL ASSIGNMENT ESTIMATE/CONFIRMATION/INVOICE FORM *(continued)*

Production expenses

Assistant _____

Crew/special assistance _____

Film/lab charges _____

Location _____

Messengers/shipping _____

Rental _____

Sets/props/wardrobe _____

Talent _____

Transportation _____

Travel _____

Miscellaneous _____

Subtotal B $ _____

Other

Space or use rate _____

Product or subsidiary photo _____

Postponement/cancellation/reshoot _____

Subtotal C $ _____

Expense markup _____ %

Subtotal D $ _____

Subtotal (A, B, C, & D) $ _____

Sales Tax $ _____

Advance $ _____

BALANCE DUE $ _____

Terms

Invoice payable upon receipt:

Finance charge _____ % per month after 30 days;

Rights granted only upon full payment;

Subject to terms and conditions on reverse side.

_____ _____
(client signature) *(date)*

_____ _____
(photographer signature) *(date)*

ASMP CORPORATE AND EDITORIAL ASSIGNMENT ESTIMATE/CONFIRMATION/INVOICE FORM *(continued)*

Terms and Conditions

1. "Photograph(s)" means all photographic material furnished by Photographer hereunder, whether transparencies, negatives, prints or otherwise.

2. Except as otherwise specifically provided herein, all photographs remain the property of Photographer, and all rights therein are reserved to Photographer. Any additional uses require the prior written agreement of Photographer on terms to be negotiated. Unless otherwise provided herein, any grant of rights is limited to one (1) year from the date hereof for the territory of the United States.

3. Client assumes insurer's liability (a) to indemnify Photographer for loss, damage, or misuse of any photographs, and (b) to return all photographs prepaid, fully insured, safe and undamaged, by bonded messenger, air freight, or registered mail, within thirty (30) days after the first use thereof as provided herein, but in all events (whether published or unpublished) within _____ after the date hereof. Client will supply Photographer with two free copies of each use of the photographs.

4. Reimbursement by Client for loss or damage of each original transparency shall be in the amount of $1,500, or such other amount set forth next to said item on the front hereof. Reimbursement by Client for loss or damage of each other item shall be in the amount set forth next to said item on the front hereof. Photographer and Client agree that said amount represents the fair and reasonable value of such item, and that Photographer would not sell all rights to such item for less than said amount.

5. Adjacent credit line for Photographer, and the copyright line "© [YEAR OF FIRST PUBLICATION] [PHOTOGRAPHER'S NAME]" must accompany each use, or invoice will be tripled.

6. Client will not make or permit any alterations, additions, or subtractions in respect of the photographs, including without limitation any digitalization or synthesization of the photographs, alone or with any other material, by use of computer or any other method or means now or hereafter known.

7. Client will indemnify and defend Photographer against all claims, liability, damage, costs, and expenses, including reasonable legal fees and expenses, arising out of the use of any photographs for which no release was furnished by Photographer, or which are altered by Client. Unless so furnished, no release exists.

8. All expense estimates are subject to normal trade variance of 10%.

**ASMP CORPORATE AND EDITORIAL ASSIGNMENT
ESTIMATE/CONFIRMATION/INVOICE FORM** *(continued)*

9. Time is of the essence for receipt of payment and return of photographs. No rights are granted until timely payment is made.

10. Client may not assign or transfer this agreement or any rights granted hereunder. This agreement binds Client and its advertising agency hereunder. Client and its advertising agency hereunder are jointly and severally liable for the performance of all of its payment and other obligations hereunder. No waiver of any terms is binding unless set forth in writing and signed by the parties. However, the invoice may reflect, and Client is bound by, oral authorizations for fees or expenses which could not be confirmed in writing because of immediate proximity of shooting.

11. Any dispute regarding this agreement shall be arbitrated in [PHOTOGRAPHER'S CITY AND STATE] under rules of the American Arbitration Association and the laws of [STATE OF ARBITRATION]. Judgment on the arbitration award may be entered in any court having jurisdiction. Any dispute involving $ _____ [LIMIT OF LOCAL SMALL CLAIMS COURT] or less may be submitted without arbitration to any court having jurisdiction thereof. Client shall pay all arbitration and court costs, reasonable legal fees and expenses, and legal interest on any award or judgment in favor of Photographer.

12. This agreement incorporates by reference Article 2 of the Uniform Commercial Code and the Copyright Law of 1976, as amended.

13. *Cancellations and postponements:* Client is responsible for payment of all expenses incurred up to the time of cancellation, plus 50% of Photographer's fee. If notice of cancellation is given less than two (2) business days before the shoot date, Client will be charged 100% fee. *Weather postponements:* Unless otherwise agreed, client will be charged 100% fee if postponement is due to weather conditions on location and 50% fee if postponement occurs before departure to location.

14. In the event a shoot extends beyond eight (8) consecutive hours, Photographer may charge for such excess time of assistants and freelance staff at the rate of one-and-one-half their hourly rates.

15. *Reshoots:* (a) Client will be charged 100% fee and expenses for any reshoot required by Client. (b) For any reshoot required because of an act of God or the fault of a third party, Photographer will charge no additional fee and Client will pay all expenses. (c) If Photographer charges for special contingency insurance and is paid in full for the shoot, Client will not be charged for any expenses covered by insurance. A list of exclusions from such insurance will be provided on request.

ASMP ADVERTISING ASSIGNMENT
ESTIMATE/CONFIRMATION/INVOICE FORM

To: Date:
 Studio Job #:
 Agency P.O. #:
 Agency Job #:
 A.D.:
 Buyer:
 Client:

☐ Bid ☐ Estimate ☐ Invoice # _____

Description/Rights granted/Period of use/Media usage

Fees
Photography _____
Pre-production ($ _____ per day) _____
Travel ($ _____ per day) _____
Weather delays ($ _____ per day) _____
Subtotal A $ _____

ASMP ADVERTISING ASSIGNMENT
ESTIMATE/CONFIRMATION/INVOICE FORM *(continued)*

Production expenses
Casting _____
Crew _____
Film/lab charges _____
Insurance _____
Location _____
Messengers/shipping _____
Props _____
Rental _____
Sets _____
Studio _____
Travel _____
Wardrobe _____
Miscellaneous _____
Subtotal B $ _____

Expense markup _____ %
Subtotal C $ _____

Subtotal (A, B, & C) $ _____
Sales Tax $ _____
Advance $ _____
BALANCE DUE $ _____

Models *(billed direct)*

Terms
Invoice payable upon receipt;
Finance charge _____ % per month after 30 days;
Rights granted only upon full payment;
Subject to terms and conditions on reverse side.

Signed by _____ Date _____
(client if estimate, studio if invoice)

ASMP ADVERTISING ASSIGNMENT
ESTIMATE/CONFIRMATION/INVOICE FORM *(continued)*

Terms and Conditions

1. "Photograph(s)" means all photographic material furnished by Photographer hereunder, whether transparencies, negatives, prints or otherwise.

2. Except as otherwise specifically provided herein, all photographs remain the property of Photographer, and all rights therein are reserved to Photographer. Any additional uses require the prior written agreement of Photographer on terms to be negotiated. Unless otherwise provided herein, any grant of rights is limited to one (1) year from the date hereof for the territory of the United States.

3. Client assumes insurer's liability (a) to indemnify Photographer for loss, damage, or misuse of any photographs, and (b) to return all photographs prepaid, fully insured, safe and undamaged, by bonded messenger, air freight, or registered mail, within thirty (30) days after the first use thereof as provided herein, but in all events (whether published or unpublished) within _____ after the date hereof. Client will supply Photographer with two free copies of each use of the photographs.

4. Reimbursement by Client for loss or damage of each original transparency shall be in the amount of $1,500, or such other amount set forth next to said item on the front hereof. Reimbursement by Client for loss or damage of each other item shall be in the amount set forth next to said item on the front hereof. Photographer and Client agree that said amount represents the fair and reasonable value of such item, and that Photographer would not sell all rights to such item for less than said amount.

5. Adjacent credit line for Photographer, and the copyright line "© [YEAR OF FIRST PUBLICATION] [PHOTOGRAPHER'S NAME]" must accompany each use, or invoice will be tripled.

6. Client will not make or permit any alterations, additions, or subtractions in respect of the photographs, including without limitation any digitalization or synthesization of the photographs, alone or with any other material, by use of computer or any other method or means now or hereafter known.

7. Client will indemnify and defend photographer against all claims, liability, damage, costs, and expenses, including reasonable legal fees and expenses, arising out of the use of any photographs for which no release was furnished by Photographer, or which are altered by Client. Unless so furnished, no release exists.

8. All expense estimates are subject to normal trade variance of 10%.

ASMP ADVERTISING ASSIGNMENT
ESTIMATE/CONFIRMATION/INVOICE FORM *(continued)*

9. Time is of the essence for receipt of payment and return of photographs. No rights are granted until timely payment is made.

10. Client may not assign or transfer this agreement or any rights granted hereunder. This agreement binds Client and its advertising agency hereunder. Client and its advertising agency hereunder are jointly and severally liable for the performance of all of its payment and other obligations hereunder. No waiver of any terms is binding unless set forth in writing and signed by the parties. However, the invoice may reflect, and Client is bound by, oral authorizations for fees or expenses which could not be confirmed in writing because of immediate proximity of shooting.

11. Any dispute regarding this agreement shall be arbitrated in [PHOTOGRAPHER'S CITY AND STATE] under rules of the American Arbitration Association and the laws of [STATE OF ARBITRATION]. Judgment on the arbitration award may be entered in any court having jurisdiction. Any dispute involving $ _____ [LIMIT OF LOCAL SMALL CLAIMS COURT] or less may be submitted without arbitration to any court having jurisdiction thereof. Client shall pay all arbitration and court costs, reasonable legal fees and expenses, and legal interest on any award or judgment in favor of Photographer.

12. This agreement incorporates by reference Article 2 of the Uniform Commercial Code and the Copyright Law of 1976, as amended.

13. *Cancellations and postponements:* Client is responsible for payment of all expenses incurred up to the time of cancellation, plus 50% of Photographer's fee. If notice of cancellation is given less than two (2) business days before the shoot date, Client will be charged 100% fee. *Weather postponements:* Unless otherwise agreed, client will be charged 100% fee if postponement is due to weather conditions on location and 50% fee if postponement occurs before departure to location.

14. In the event a shoot extends beyond eight (8) consecutive hours, Photographer may charge for such excess time of assistants and freelance staff at the rate of one-and-one-half their hourly rates.

15. *Reshoots:* (a) Client will be charged 100% fee and expenses for any reshoot required by Client. (b) For any reshoot required because of an act of God or the fault of a third party, Photographer will charge no additional fee and Client will pay all expenses. (c) If Photographer charges for special contingency insurance and is paid in full for the shoot, Client will not be charged for any expenses covered by insurance. A list of exclusions from such insurance will be provided on request.

ASMP DELIVERY MEMO FORM

To: Date:
 Shoot Date:
 Studio Job #:
 Client P.O. #:
 A.D.:
 Buyer:
 Client:

Photographs to be returned by

Description Value $

Total color: TOTAL
Total black & white: VALUE $

Kindly check count and acknowledge by signing and returning one copy. Count shall be considered accurate and quality deemed satisfactory for reproduction if said copy is not immediately received by return mail with all exceptions duly noted. This delivery memo is subject to all Terms and Conditions on reverse side.

(acknowledged and accepted by)

ASMP DELIVERY MEMO FORM *(continued)*

Terms of Delivery

1. After 14 days, the following holding fees are charged until return: Five Dollars ($5.00) per week per color transparency and One Dollar ($1.00) per week per print.

2. Submission is for examination only. Photographs may not be reproduced, copied, projected, or used in any way without (a) express written permission on Photographer's invoice stating the rights granted and the terms thereof and (b) payment of said invoice. The reasonable and stipulated fee for any other use shall be three times Photographer's normal fee for such usage.

3. Client assumes insurer's liability (a) to indemnify Photographer for loss, damage, or misuse of any photographs and (b) to return all photographs prepaid, fully insured, safe, and undamaged, by bonded messenger, air freight, or registered mail. Client assumes full liability for its employees, agents, assigns, messengers, and freelance researchers for any loss, damage, or misuse of the photographs.

4. Reimbursement by Client for loss or damage of each original transparency shall be in the amount of $1,500, or such other amount set forth next to said item on the front hereof. Reimbursement by Client for loss or damage of each other item shall be in the amount set forth next to said item on the front hereof. Photographer and Client agree that said amount represents the fair and reasonable value of such item, and that Photographer would not sell all rights to such item for less than said amount.

5. Any dispute regarding this agreement shall be arbitrated in [PHOTOGRAPHER'S CITY AND STATE] under rules of the American Arbitration Association and the laws of [STATE OF ARBITRATION]. Judgment on the arbitration award may be entered in any court having jurisdiction. Any dispute involving $ _____ [LIMIT OF LOCAL SMALL CLAIMS COURT] or less may be submitted without arbitration to any court having jurisdiction thereof. Client shall pay all arbitration and court costs, reasonable legal fees, and expenses, and legal interest on any award or judgment in favor of Photographer.

6. Client may not assign or transfer this agreement, or any rights granted hereunder. Objection to above terms must be made in writing within ten (10) days of the Memo's receipt. Holding of materials constitutes acceptance of above terms, which incorporate by reference Article 2 of the Uniform Commercial Code and the Copyright Law of 1976, as amended. No amendment or waiver is binding unless set forth in writing and signed by the parties.

ASMP STOCK PICTURE DELIVERY/INVOICE FORM

To: Date:
 Subject:
 Purchase Order #:
 Client:
 A.D./Editor:
 Shooting Date(s):
 Our Job #:

☐ Assignment confirmation ☐ Job estimate ☐ Invoice # _____

Rights granted

One-time, nonexclusive reproduction rights to the photographs listed below, solely for the uses and specifications indicated; and limited to the individual edition, volume, series, show, event, or the like contemplated for this specific transaction (unless otherwise indicated in writing).

Specifications (if applicable)

Placement (Cover, inside etc.)

Size (½ pg., etc.) _____

Time limit on use _____

Use outside U.S. (specify, if any) _____

Copyright credit: © 19____ _____

ASMP STOCK PICTURE DELIVERY/INVOICE FORM *(continued)*

Media usage

Advertising
☐ Animatic
☐ Billboard
☐ Brochure
☐ Catalog
☐ Consumer Magazine
☐ Other

☐ Newspaper
☐ Packaging
☐ Point of Purchase
☐ Television
☐ Trade Magazine

Corporate/Industrial
☐ Album Cover
☐ Annual Report
☐ Brochure
☐ Other

☐ Film Strip
☐ House Organ
☐ Trade Slide Show

Editorial/Journalism
☐ Book Jacket
☐ Consumer Magazine
☐ Encyclopedia
☐ Film Strip
☐ Newspaper
☐ Other

☐ Sunday Supplement
☐ Television
☐ Text Book
☐ Trade Book
☐ Trade Magazine

Promotion & Miscellaneous
☐ Booklet
☐ Brochure
☐ Calendar
☐ Other

☐ Card
☐ Poster
☐ Press Kit

ASMP STOCK PICTURE DELIVERY/INVOICE FORM *(continued)*

Description of photographs	Format	Use fees ($)

Total black & white:
Total color:

Total use fees	$ _____
Miscellaneous	_____
Service Fee	_____
Research Fee	_____
Other	_____
TOTAL	$ _____
Deposit	_____
BALANCE DUE	$ _____

If this is a delivery kindly check count & acknowledge by signing & returning one copy. Count shall be considered accurate & quality deemed satisfactory for reproduction if said copy is not immediately received by return mail with all exceptions duly noted.

Subject to terms on reverse side pursuant to Article 2, Uniform Commercial Code and the 1976 Copyright Act

Signature _____
(acknowledged and accepted)

Terms and Conditions

1. Except where outright purchase is specified, all photographs and rights not expressly granted remain the exclusive property of Photographer without limitation. Client acquires only the rights specified and agrees to return all photographs by the sooner of thirty (30) days after publication or four (4) months after invoice date, or pay thereafter Five Dollars ($5.00) per week per transparency and One Dollar ($1.00) per week per print.
2. Submission and use rights granted are specifically based on the condition that client assumes insurers liabilty to (a) indemnify photographer for

ASMP STOCK PICTURE DELIVERY/INVOICE FORM *(continued)*

loss, damage, or misuse of any photograph(s) and (b) return all photographs prepaid and fully insured, safe and undamaged, by bonded messenger, air freight, or registered mail. Client assumes full liability for its employees, agents, assigns, messengers, and freelance researchers for any loss, damage, or misuse of photographs.

3. Reimbursement by Client for loss or damage of each original transparency shall be in the amount of One Thousand Five Hundred Dollars ($1,500), or such other amount set forth next to said item on the front hereof. Reimbursement by Client for loss or damage of each other item shall be in the amount set forth next to said item on the front hereof. Photographer and Client agree that said amount represents the fair and reasonable value of each item, and that Photographer would not sell all rights to such item for less than said amount.

4. Adjacent credit line for Photographer, and the copyright credit line "©[YEAR OF FIRST PUBLICATION] [PHOTOGRAPHER'S NAME]" must accompany each use, or invoice will be tripled.

5. Client will indemnify Photographer against all claims, liability, damages, costs, and expenses, including reasonable legal fees and expenses, arising out of the use of any photograph(s) unless a model or other release was specified to exist, in writing, by Photographer. Unless so specified no release exists. Photographer's liability for all claims shall not exceed, in any event, the amount paid under this invoice.

6. Time is of the essence for receipt of payment and return of photographs. No rights are granted until payment is made. Payment required within thirty (30) days of invoice; 2 percent per month service charge on unpaid balance is applied thereafter. Adjustment of amount of terms must be requested within ten days of invoice receipt.

7. Client shall provide two free copies of uses appearing in print and a semi-annual statement of sales and subsidiary uses for photographs appearing in books.

8. Client may not assign or transfer this agreement or any rights granted hereunder. Holding or use of the photographs constitutes acceptance of the above terms, which incorporate by reference Article 2 of the Uniform Commercial Code and the Copyright Act of 1976, as amended. No amendment or waiver is binding unless set forth in writing and signed by the parties.

9. Any dispute regarding this invoice, including its validity, interpretation, performance, or breach shall be arbitrated in [PHOTOGRAPHER'S CITY AND STATE] under rules of the American Arbitration Association and the laws of [STATE OF ARBITRATION]. Judgment on the Arbitration Award may be entered in the highest Federal or State Court having jurisdiction. Any dispute involving One Thousand Five Hundred Dollars ($1,500) or less may be submitted, without arbitration, to any court having jurisdiction thereof. User shall pay all arbitration and court costs, reasonable legal fees and expenses, plus legal interest on any award or judgment.

ASMP PROPERTY RELEASE FORM

For good and valuable consideration herein acknowledged as received, the undersigned, being the legal owner of, or having the right to permit the taking and use of photographs of, certain property designated as _____ , does grant to [PHOTOGRAPHER], his/her heirs, legal representatives, agents and assigns the full rights to use such photographs and copyright same, in advertising, trade, or for any purpose.

The undersigned also consents to the use of any printed matter in conjunction therewith.

The undersigned hereby waives any right that he/she/it may have to inspect or approve the finished product or products, or the advertising copy or printed matter that may be used in connection therewith, or the use to which it may be applied.

The undersigned hereby releases, discharges, and agrees to save harmless [PHOTOGRAPHER], his/her heirs, legal representatives, and assigns, and all persons acting under his/her permission or authority, or those for whom he/she is acting, from any liability by virtue of any blurring, distortion, alteration, optical illustion, or use in composite form, whether intentional or otherwise, that may occur or be produced in the taking of said picture or in any subsequent processing thereof, as well as any publication thereof, even though it may subject me to ridicule, scandal, reproach, scorn, and indignity.

The undersigned hereby warrants that he/she is of full age and has every right to contract in his/her own name in the above regard. The undersigned states further that he/she has read the above authorization, release, and agreement, prior to its execution, and that he/she is fully familiar with the contents thereof. If the undersigned is signing as an agent or employee of a firm or corporation, the undersigned warrants that he/she is fully authorized to do so. This release shall be binding upon the undersigned and his/her/its heirs, legal representatives, successors, and assigns.

Date _____ _____
 (name)

_____ _____
 (witness)

 (address)

ASMP ADULT RELEASE FORM

In consideration of my engagement as a model, and for other good and valuable consideration herein acknowledged as received, I hereby grant to [PHOTOGRAPHER], his/her heirs, legal representatives and assigns, those for whom [PHOTOGRAPHER] is acting, and those acting with his/her authority and permission, the absolute right and permission to copyright, in his/her own name or otherwise, and use, re-use, publish, and re-publish photographic portraits or pictures of me or in which I may be included, in whole or in part, or composite or distorted in character or form, without restriction as to changes or alterations, in conjunction with my own or a fictitious name, or reproductions thereof in color or otherwise, made through any medium at his/her studios or elsewhere, and in any and all media now or hereafter known for illustration, promotion, art, advertising, trade, or any other purpose whatsoever. I also consent to the use of any printed matter in conjunction therewith.

I hereby waive any right that I may have to inspect or approve the finished product heirs, or products and the advertising copy or other matter that may be used in connection therewith or the use to which it may be applied.

I hereby release, discharge and agree to save harmless [PHOTOGRAPHER], his/her heirs, legal representatives and assigns, and all persons acting under his/her permission or authority or those for whom he/she is acting, from any liability by virtue of any blurring, distortion, alteration, optical illusion, or use in composite form, whether intentional or otherwise, that may occur or be produced in the taking of said picture or in any subsequent processing thereof, as well as any publication thereof, including without limitation any claims for libel or invasion of privacy.

I hereby warrant that I am of full age and have the right to contract in my own name. I have read the above authorization, release, and agreement, prior to its execution, and I am fully familiar with the contents thereof. This release shall be binding upon me and my heirs, legal representatives, and assigns.

Date _____ _____
 (name)

_____ _____
 (witness)

 (address)

ASMP MINOR RELEASE FORM

In consideration of the engagement as a model of the minor named below, and for other good and valuable consideration herein acknowledged as received, upon the terms hereinafter stated. I hereby grant to [PHOTOGRAPHER], his/her legal representatives and assigns, those for whom [PHOTOGRAPHER] is acting, and those acting with his/her authority and permission, the absolute right and permission to copyright and use, re-use, publish, and re-publish photographic portraits or pictures of the minor or in which the minor may be included, in whole or in part, or composite or distorted in character or form, without restriction as to changes or alterations from time to time, in conjunction with the minor's own or a fictitious name, or reproductions thereof in color or otherwise, made through any medium at his/her studios or elsewhere, and in any and all media now or hereafter known, for art, advertising, trade, or any other purpose whatsoever. I also consent to the use of any printed matter in conjunction therewith.

I hereby waive any right that I or the minor may have to inspect or approve the finished product or products or the advertising copy or printed matter that may be used in connection therewith or the use to which it may be applied.

I hereby release, discharge, and agree to save harmless [PHOTOGRAPHER], his/her legal representatives or assigns, and all persons acting under his/her permission or authority or those for whom he/she is acting, from any liability by virtue of any blurring, distortion, alteration, optical illusion, or use in composite form, whether intentional or otherwise, that may occur or be produced in the taking of said picture or in any subsequent processing thereof, as well as any publication thereof, including without limitation any claims for libel or invasion of privacy.

I hereby warrant that I am of full age and have every right to contract for the minor in the above regard. I state further that I have read the above authorization, release, and agreement, prior to its execution, and that I am fully familiar with the contents thereof. This release shall be binding upon me and my heirs, legal representatives, and assigns.

Date _____

_____ _____
(minor's name) (father, mother, guardian)

_____ _____

_____ _____
(minor's address) (address)

(witness)

ASMP INSURANCE PROTECTION INFORMATION

The following is an outline, at the surface of an extremely complex subject.

As a professional photographer, you are best off leaving insurance to the experts. Find an independent insurance agent or broker with whom you can develop a long-term relationship, as you do with an accountant or attorney, and discuss your specific situation or need with him. As in anything else, there are agents or brokers who specialize in the insurance needs of the professional photographer. If you already have one, make him aware of your business and its intricacies. The better he knows you and your business, the better he can advise you on how your insurance dollars will be best spent—or saved.

The professional photographer's insurance needs generally fall into two areas. The first covers the basic personal needs that everyone has for insurance, while the second covers those needs that arise specifically from the business activities of a photographer.

Experienced practitioners in the insurance field believe that the severity of loss, rather than the frequency of loss, should establish the order of importance for various coverages. For example, automobile liability insurance certainly takes precedence over physical damage to the vehicle; collision and comprehensive coverage is limited to the value of the car; and liability judgments have virtually no ceiling.

When possible, high limits of liability insurance should always be purchased. By the same token, general liability insurance should be purchased before camera coverage. Again, camera loss, while severe, can be lived with whereas liability loss might be catastrophic. It is better to take a fairly high deductible (if available) on the camera policy, if the funds saved can thereby make feasible the purchase of general liability.

In the personal areas, medical and disability income insurance and life insurance are most important because of the potential for catastrophic loss in these areas. If someone has Blue Cross (or a similar plan that covers only basic hospital fees), he should also obtain major-medical coverage because that protects against the most substantial additional medical expenses.

It is best by far to view insurance as protection against major problems, as opposed to minor ones. Policies with low or nonexistent deductibles push the cost of insurance well beyond what many can normally afford and in many cases may make certain coverages unavailable. The recommended technique is to expand the area of coverage by accepting the highest practical deductible in each area covered. For example, take disability income insurance that protects against income loss due to sickness, accident, and the like: Some policies begin income replacement after 7 days, whereas others start only after 30 days. The difference

ASMP INSURANCE PROTECTION INFORMATION *(continued)*

in cost may be as much as 25 percent less for the plan with the longer waiting period. Because the purpose of the insurance is to protect against illness that might last many months or years (the true disaster), it makes little sense to cover the short-term problem at a greatly added cost. (The saving thus obtained might, for instance, cover the premiums on a major-medical insurance policy with a suitable deductible.) In a similar vein, a $200 deductible (recently mandated in New York State), as opposed to a $50 deductible, may mean a cost saving of 20 percent or more on automobile collision or "comprehensive" coverage.

In short, where difficult choices sometimes have to be made, it is advisable, when necessary, to save insurance dollars by minimizing coverage of the minor problems that the photographer can probably afford to absorb. Money saved can then be used to cover the major situations that, should they arise, could lead to crippling financial liabilities for the person left unprotected.

The insurance described here offers protection against loss of the individual's own property or earnings. Also discussed are the liabilities or obligations that may be owed to third parties, arising out of personal or professional activities. Use the headings as a checklist of the broad categories of essential coverage every photographer should consider in discussion with a professional insurance expert or business advisor.

PERSONAL LIFE AND HEALTH INSURANCE

1. Disability Income
Payments to the insured to replace loss caused by accident or serious illness:
- An Individual Disability Income Policy protects your personal living expenses.
- An Overhead Expense Policy covers the overhead of a business for one to two years. After this period has elapsed, the business is usually disposed of.

2. Hospitalization and Major Medical
Covers expenses arising from medical treatment for oneself or one's family: Blue Cross, Blue Shield, or the like, for basic hospitalization and medical coverage, plus a major-medical policy for substantial medical expenses arising from surgery, extended illness, etc.

3. Life Insurance
Provides reimbursement to family or business associates for loss of earnings upon death of insured in dependency or business situations (should be approximately five times your annual income).

4. Annuities or Pre-Funding Retirement
Providing income for later years to supplement Social Security and other income (e.g., Keogh plans, IRAs; for the self-employed).

ASMP INSURANCE PROTECTION INFORMATION *(continued)*

5. Accidental Death and Dismemberment
Pays for loss of life or limbs and/or eyesight from an accident.

PERSONAL INSURANCE

1. Homeowner's or Tenant's Insurance
Provides coverage for personal belongings, as well as the residence itself. (Pay attention to limitations on jewelry, furs, silverware: usually $250–$500.)
2. Comprehensive Personal Liability (CPL)
Bodily injury or property damage to others due to your negligence. This coverage is most commonly included as part of a homeowner's or tenant's policy, rather than being a separate policy. It does not include your liability as a professional photographer.
3. Automobile Insurance
Bodily injury and property damage to others resulting from the operation of an automobile (required by law in most states). Physical damage to vehicle includes (a) comprehensive (fire, theft, and vandalism) and (b) collision.
4. Floater Policies
Usually cover personal belongings, such as jewelry, furs, fine arts, antiques, etc., which are limited or excluded by homeowner's or tenant's policies. Some companies will add these coverages to the homeowner's or tenant's; others require a separate policy. (A popular misconception is that camera equipment can be added to a personal policy, like jewelry or furs. This is generally not true for the professional photographer. Very few companies will knowingly provide the professional with coverage under a homeowner's or tenant's policy because of the increased exposure resulting from professional utilization.)
5. Workers' Compensation
For personal employer-employee relationships, such as assistants, housekeepers, gardeners, etc.

INSURANCE FOR THE PHOTOGRAPHER AS A PROFESSIONAL

1. Studio Contents and "Improvements and Betterments"
Can usually be written either as part of a package policy on an "all-risk" basis or as "fire" policy, which generally excludes theft coverage. Distinction between all-risk and fire policies is important both as to cost and as to availability. Generally, all-risk is more difficult to get but provides greater coverage, particularly with things like water damage.
2. Camera Floater
An all-risk policy, but equipment must be specifically listed. May be

ASMP INSURANCE PROTECTION INFORMATION *(continued)*

purchased on a "replacement cost" or "stated amount" basis (the two are *not* the same). More common is the "actual cash value" basis, i.e., depreciated value. "Replacement value" refers to the actual costs involved in replacing the item at today's prices.

3. Valuable Papers, Transparencies, and Negatives Coverage

Protection against loss of original chromes, transparencies, and valuable papers, which is not covered in a suitable manner under contents policy. Coverage is often difficult to obtain, and probably the best solution is to create duplicates or store originals in a bank vault or at a separate place. (If the work is not recreated, or coverage is not available on an agreed value basis, you will usually collect the blank value of the transparency.)

4. Bailee Floater

Covers articles and merchandise belonging to others while in the custody of the photographer. Usually has severe restrictions or exclusions on certain types of items, such as jewelry, furs, automobiles, etc. Coverage may also be restricted to studio only, meaning that no location work is covered. This is important coverage for the professional photographer but requires careful attention to detail.

5. Time Element Coverages

The cost of continuing business after a major claim (fire, water damage, etc.) to your premises can be insured with Business Interruption/Extra Coverage. Any expenditures resulting from damage to your premises, such as rental of a temporary office or studio, advertising, extra help, and the like, can be insured.

6. Negative Film, Faulty Stock, Camera and Processing

This coverage is important and covers the cost of reshooting a job that has been lost or destroyed as a result of things like camera malfunction, laboratory error, and lost or stolen film. (Not included in "Prosurance.")

7. Fidelity Coverages

For losses caused by employee dishonesty. This is sometimes difficult coverage to obtain, and somewhat impractical. Settling a fidelity claim can often be a challenging situation. Few professional photographers carry this coverage, but the risk should not be overlooked.

8. General Liability

Covers bodily injury and property damage against third parties who may be injured on premises or on location assignment. This is a vast subject, but there are some important fine points to consider as it relates to the professional photographer; an example: exclusions that deal with the use of aircraft or watercraft. Most general-liability policies exclude lawsuits brought in countries other than the U.S. If you work outside the U.S., special coverage may be required by foreign law.

9. Errors and Omissions, or Professional Liability

Covers lawsuits arising from such things as plagiarism, invasion of privacy, unauthorized use of your work, slander, and libel. This coverage is sometimes difficult to obtain and is generally expensive. The less control

ASMP INSURANCE PROTECTION INFORMATION *(continued)*

the photographer has over his or her types of subject matter, the more difficult the availability and the higher the cost. (Recently available in some states as part of a program called "Photopac.")

10. Workers' Compensation

Covers employees for injuries connected with on-the-job employment; required in all states. Coverage is also normally required for freelance people working with a photographer. Be sure your policy protects you if you hire people outside your home state. Some companies cannot or will not provide this coverage; most will do it for the asking. Also, take note of rules if you hire people in any of the following six states: Nevada, North Dakota, Ohio, Washington, West Virginia, and Wyoming. These states require you to purchase coverage from the state itself. All standard workers' compensation policies will exclude those states. As with general liability, working outside the U.S. may require special coverage, depending upon the country.

11. Disability Benefits Law

Required in some states, including New York, Rhode Island, Hawaii, New Jersey, and California, plus Puerto Rico. Covers loss of wages due to injuries or illnesses off the job for staff members, and may in some cases apply to freelance personnel as well.

12. Employee Benefits

For staff and photographer: group insurance and long-term disability, various qualified pension plans, Keogh and IRA retirement plans. This is a vast area. Once considered optional, employee benefits are becoming more necessary to offer as fringe benefits, especially for full-time staff.

"PROSURANCE"

After a year of effort, ASMP announced that the "Prosurance" plan was now operational and available to all ASMP members. This is a complete insurance program for the professional photographer, a national program that offers special services at low group rates. In effect, it is one-stop shopping to cover such needs as camera equipment on a replacement-cost basis (including rentals and loaners), expenses to reshoot a job on which the film was lost or stolen, and a number of other new areas. Basically, the plan covers the following features:

1. Contents and Improvements and Betterments.

2. Extra Expense: Expenses incurred when the location covered is made unusable and temporary space must be obtained.

3. Camera Replacement: Expenses incurred when replacing camera with the latest model.

4. Valuable Papers: Expenses to reshoot if the film is lost or stolen or destroyed by fire.

5. Portfolio: Twenty photos at $100 each.

ASMP INSURANCE PROTECTION INFORMATION *(continued)*

6. Comprehensive General Liability: Provides coverage for the premises and operations of the insured's business. For example: personal injury and advertising injury, contractual liability, medical payments, fire damage, legal liability, host liquor liability, incidental malpractice, employees as additional insured, limited world-wide liability, broadform property damage, watercraft liability (under 26 feet in length), etc.

7. Non-Owned and Hired Automobile: Employee using own or hired vehicle.

8. Transit: Covers goods of the insured or for which the insured is responsible during transport until the goods arrive at destination.

9. Accounts Receivable: Covers all sums due the insured from customers, provided the insured is unable to effect collection as the direct result of loss or damage of records.

10. Bailee: Covers property of others while on the insured's premises for the purpose of photography.

11. Fine Arts: Covers antiques and art objects that are the property of the insured or the property of others while in the custody of the insured.

12. Tools: Covers miscellaneous items, such as hammers, saws, etc.

Suggested Readings

Assigning Advertising Photography. Advertising Photographers of America, New York Chapter (45 E. 20th St., New York, NY 10003).

The Business of Photography. Robert M. Cavallo and Stuart Kahan. Crown Publishers (One Park Ave., New York, NY 10016).

The Legal Guide for the Visual Artist. Tad Crawford. Madison Square Press (10 E. 23rd St., New York, NY 10010).

The Perfect Portfolio. Henrietta Brackman. Amphoto (1515 Broadway, New York, NY 10036).

Photobulletin, Photoletter, and *Photomarket.* Photosource International (Osceola, WI 54020). Subscription newsletters.

The Photographer's Market. Robin Weinstein. Writer's Digest Books (9933 Alliance Rd., Cincinnati, OH 45242).

Photography and the Law. Christopher Du Vernet. TAB Books, Inc. (Blue Ridge Summit, PA 17214).

Professional Business Practices in Photography. American Society of Magazine Photographers (205 Lexington Ave., New York, NY 10016). Available for $27.50 plus $2.00 postage and handling.

The Professional Photographer's Business Guide. Frederic W. Rosen. Amphoto (1515 Broadway, New York, NY 10036).

Sell and Re-Sell Your Photographs. Rohn Engh. Writer's Digest Books (9933 Alliance Rd., Cincinnati, OH 45242).

Selling Your Photography. Arie Kopelman and Tad Crawford. St. Martin's Press (175 Fifth Ave., New York, NY 10010).

Stock Picture Handbook. American Society of Magazine Photographers (205 Lexington Ave., New York, NY 10016). Available for $24.50 plus $2.50 postage and handling.

Index